高校专门用途英语（ESP）系列教材

ART ENGLISH

美术英语

3RD EDITION
第三版

沈一鸣 张文霞 编

U0331420

清华大学出版社
北 京

内 容 简 介

本教材主要选取有关美术及艺术设计的经典英文文章。全书共有 18 个单元，涉及一些著名艺术家介绍，重要设计理念、艺术风格和元素，设计与其他学科的关系以及艺术设计史上的重大事件。每单元以中文导读开篇，并配有清华大学美术学院的学生创作的插图作品或一些与课文内容相关的图片。各单元的两篇课文后均附有生词和练习，Part A 课文后面还讲解了相关的语法问题。本书配套的教学资源（电子课件、相关图片等），可通过以下方式索要：shenym@mail.tsinghua.edu.cn；010-62781189。

本书适用于美术及艺术专业的学生，同时也适用于美术及艺术设计爱好者。

图书在版编目（CIP）数据

美术英语 = Art English / 沈一鸣，张文霞编. —3版. —北京：清华大学出版社，2022.9（2025.2重印）

高校专门用途英语（ESP）系列教材

ISBN 978-7-302-61806-5

Ⅰ.①美… Ⅱ.①沈… ②张… Ⅲ.①美术—英语—高等学校—教材 Ⅳ.①J

中国版本图书馆CIP数据核字（2022）第167845号

责任编辑：刘细珍
封面设计：子　一
责任校对：王凤芝
责任印制：沈　露
出版发行：清华大学出版社
　　　　　网　　　址：https://www.tup.com.cn，https://www.wqxuetang.com
　　　　　地　　　址：北京清华大学学研大厦A座　　邮　　编：100084
　　　　　社 总 机：010-83470000　　　　　　　　邮　　购：010-62786544
　　　　　投稿与读者服务：010-62776969，c-service@tup.tsinghua.edu.cn
　　　　　质量反馈：010-62772015，zhiliang@tup.tsinghua.edu.cn
印 装 者：涿州汇美亿浓印刷有限公司
经　　销：全国新华书店
开　　本：170mm×230mm　　印　　张：19.25　　字　　数：323千字
版　　次：2014 年 9 月第 1 版　　2022 年 9 月第 3 版　　印　　次：2025 年 2 月第 3 次印刷
定　　价：79.00元

产品编号：097096-01

前　言
PREFACE

　　《美术英语（第三版）》一书适用于美术及艺术设计专业学生，以及广大美术爱好者。本书旨在通过使用与美术专业相关的教学内容来提高学生学习英语的兴趣，并以语言为媒介拓展学生的专业知识，使语言教学与专业教学更具连续性和整体性。同时，本书的内容和目标也充分体现了教育部高等教育司制定的《大学英语教学指南》所倡导的教学理念和教学模式，即因材施教，以学生为本的个性化教学。

　　本书文章的选择尽量做到涵盖美术相关专业的各个主要学科，文字力求准确、优美、实用。全书共 18 个单元，每个单元包含两个部分（Part A，Part B），以 Part A 为主，Part B 为 Part A 的延续及拓展。在每个单元的开头，有一段中文导读，文字上方是清华大学美术学院的学生创作的插图作品或一些与课文内容相关的图片。教材的每个单元都含语法部分，主要以本书课文中的句子作为例句，集中讲解一个语法问题。课后练习的设置尽量与课文内容或美术专业知识相关联，并注重趣味性和实用性。每个单元的结尾，有一处插图空间，供学生根据课文画插图，意在引发对于课文内容的思考，同时，这也是一种将文字视觉化的学习方式。另外，本书结尾处还有"漫话单词"部分，以助力读者结合词根、词缀掌握更多的英文词汇。

　　此外，为弘扬中国传统文化和"讲述中国故事"，全书 18 个单元中有 4 个单元的内容与中国书画相关，分别为第 3、8、9 和第 18 单元。

　　本书的前身是出版于 2014 年 9 月的《美术英语》。经过近 10 年来的不断完善和提升，2022 年 9 月修订出版的第三版较 2014 年时有了较大的改观：所选文章更加专业、实用、精练，相关性强；练习更加专业化、系统化；配套资源更加完善；语言、配图、练习、词汇等各方面进一步精雕细琢，更加经得起推敲。我们力求打造一本具有充分专业性、实用性和文化性的美术专业专门用途英语教材。

　　对于选用此书的老师，我们建议分两个学期使用本教材。第一个学期可

以第 1、2、3、8、9、10 单元为主干；第二个学期可以第 11、14、15、16、17、18 单元为主干；其他单元作为拓展阅读（例如，第 7 单元可以作为第 1 单元的拓展阅读）。这样就形成了以"艺术家—艺术原理—中国传统艺术—艺术/设计的历史和文化"为脉络的教学路径和构架，有利于在短时间内以较为精练、概括的方式使学生对于美术领域有较为宏观和系统的了解和把握。当然，根据各学校的要求和实际情况，也可以设计其他教学方式。此外，我们特地为选用此教材的读者提供了配套教学资源（电子课件、相关图片等），可向本书编辑或作者索要，联系方式：shenym@mail.tsinghua.edu.cn；010-62781189。

　　本教材由清华大学外国语言文学系罗立胜教授审校。在教材的编写过程中，清华大学美术学院的师生和清华大学出版社的同仁们给予我们热情的支持和帮助，在此表示衷心的感谢。

<div align="right">

编　者

2022年5月于清华大学

</div>

目 录

CONTENTS

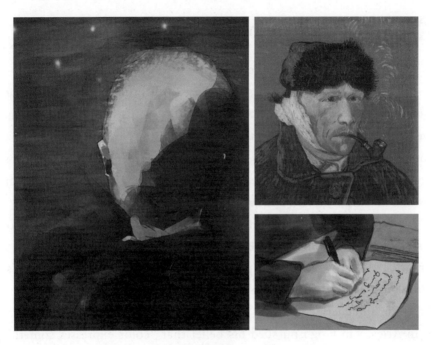

插图作者：清华大学美术学院 美911班 王依然

　　凡·高的一生，只有37年，他的绘画生涯也只占10年，而这10年中的华彩乐章则是在阿尔勒地区度过的15个月。这是绝无仅有的15个月。在此期间，法国南部的光耀和色彩与凡·高相遇了，那种感受充盈而激昂；于是有了《向日葵》《收获》和《播种者》中的色彩表现。当生命与色彩合而为一的时候，对于颜色的感知则不仅限于白昼，还延伸到了夜晚，于是有了《夜间露天咖啡馆》这样的作品。

　　在阿尔勒地区的创作标志着凡·高作为印象主义画家的巅峰。或许，这也是这个坎坷的生命最为快乐的一段日子。1889年5月，他进入位于圣雷米的休养院，而他的画风也逐渐趋向于表现主义和象征主义，最具代表性的正是那幅《星夜》。

Vincent van Gogh
文森特·凡·高

Part A The Southern Sun of Arles

The brilliant light of southern France flooded into van Gogh's life—and art—at Arles. He arrived in Arles from Paris in February, 1888, just before the **almond** trees **burst into bloom**. After the grays of his native Holland and the **muted** colors of Paris, van Gogh was stunned with pleasure **at the sight of** the colorful countryside. The fields **were alive with** green of growing crops, the **azure** skies were deep and wide, and the magnificent sun caused the land to glow and **vibrate** with rich and subtle **hues**.

During his 15-month stay at Arles, van Gogh worked **feverishly** in one of the most **prolific** and inspired bursts of artistic **creativity** ever recorded. From February 1888 to May 1889, he produced some 200 paintings, as well as **scores of** drawings. Many of these **canvases** are **undisputed masterpieces**; all reflect light, color, and energy.

In Arles, van Gogh pursued his belief that "color expresses something in itself". To achieve this end, he began to make an almost arbitrary use of color while painting everyday scenes of the south.

One of the artist's best-known works, *Sunflowers*, conveys the warmth of color Vincent found at Arles. He made many of these sunflower **studies** as decorations for his rooms, and each **radiates** his passion for light, color and simplicity. *The Harvest* is a **comparatively tranquil** painting, a subtle **blend** of **lush green** and yellow fields **offset** by violet shadows on the **wagons**, houses and hillsides. **By contrast,** *The Sower* **pits the powerful violet of a freshly plowed field against** the bright yellows of standing wheat and a sun-filled sky. The sower himself seems a bridge between these strong colors; his body **blends with** the field while his eyes are at the level of the yellow horizon. The short, almost harsh, brush **strokes** heighten the **tensions** created by the colors. Using a heavily loaded brush, van Gogh filled the sky with brilliant colors.

Few Arlesiens would **sit for** portraits by van Gogh; they distrusted the

stranger from the north. Some did **befriend** him, however, one of whom is the postman Joseph Roulin. As a **solid** citizen, **posed** in full uniform, Roulin was an **engaging** man. This manner is transmitted by his expression; his eyebrows are raised as though he was constantly startled, yet amused, by the world around him.

Van Gogh worked throughout the **broiling** Arles summer, painting under the sun. Then, instead of resting, he often set up his **easel** outdoors at night and painted until dawn, using candles stuck in his hat to provide him with light. Van Gogh enjoyed the hours after dark. "The night is more alive and more richly colored than the day," he once wrote. In several **oils**, including *Café **Terrace** at Night*, he caught the easy **conviviality** of the southern summer evenings. The **lantern** of the café glows **hospitably**; **townspeople** sip drinks, chat and stroll under the stars, which hang like lamps in the **royal blue** sky.

New Words

almond *n.* [植] 扁桃树

bloom *n.* 花，花朵；开花期；最盛期

mute *v.* 减弱；使……变哑 *n.* 哑巴

alive *adj.* 活着的；活泼的，有生气的

azure *adj.* 蔚蓝的

vibrate *v.* （使）振动，（使）颤动

hue *n.* 色度，色相

feverishly *adv.* 兴奋地

prolific *adj.* 多产的

creativity *n.* 创造力，创造性

canvas *n.* 帆布；油画，油画布

undisputed *adj.* 无可置辩的，无异议的

masterpiece *n.* 杰作，名著

study *n.* 试作，习作

radiate *v.* 放射，辐射

comparatively *adv.* 比较地，相对而言地

tranquil *adj.* 安静的

blend *n.* 混合，混合色 *v.* 混合

lush green *n.* 青绿色

offset *v.* 弥补，抵消

wagon *n.* 四轮马车，货车

sower *n.* 播种者，播种机

plow *n.* 犁 *v.* 耕，犁，犁耕

stroke *n.* 笔触

tension *n.* 紧张（状态）；张力；矛盾

befriend *v.* 待人如友，把……当朋友

solid *adj.* 固体的；可靠的，可信赖的

pose *n.* 姿势，姿态 *v.* 摆姿势

engaging *adj.* 动人的，有魅力的

broiling *adj.* 酷热的，炽热的

easel *n.* 画架，黑板架

oil *n.* 油；油画

terrace *n.* 露台；阳台；柱廊

conviviality *n.* 欢宴；高兴，欢乐

lantern *n.* 灯笼，提灯，壁灯

hospitably *adv.* 亲切地

townspeople *n.* 市民，镇民

royal blue *adj.* 品蓝色的，藏蓝色的

Phrases

burst into 突然开始（某事），突然进入（某种状态）

at the sight of 看见……（时）

be alive with 充满着；洋溢着

scores of 大量的，许多的

by contrast 相比之下，相形之下

pit against 使与……相斗

blend with 混合

sit for 这里指"做模特"

Notes

Vincent van Gogh 文森特·凡·高

Arles 阿尔勒（法国地名）

Arlesien 阿尔勒人（法语）

Sunflowers《向日葵》（凡·高作品）

The Harvest《收获》（凡·高作品）

The Sower《播种者》（凡·高作品）

Joseph Roulin 约瑟夫·鲁林（凡·高肖像画模特）

Café Terrace at Night《夜间露天咖啡馆》（凡·高作品）

Grammar

介词（The Preposition）

介词不能独立存在。介词与介词后的名词或代词一起构成介词短语。介词后面的词语称为介词宾语，因此后面如果是人称代词就应该用宾格。

我们要把介词短语看作一个整体，考虑它在句子中充当什么成分。

介词短语在句子结构中充当的成分：

1. 状语

In Arles, van Gogh pursued his stated belief that "color expresses something in itself".

What others might have viewed as a placid scene, van Gogh has rendered **in heaving and churning waves**.

2. 定语

Why shouldn't the shining dots **of the sky** be as accessible as the black dots **on the map of France**?

Vincent van Gogh was a patient **in an asylum at Saint-Rémy in the south of**

France.

But van Gogh was not just painting an image **of what he saw**.

3. 表语

Vincent van Gogh was **in an asylum**.

Van Gogh is **of strong Christian faith**.

介词与其他词类的搭配（固定词组）：

1. 与动词搭配

Looking at the stars always makes me dream...

Just as we take the train to **get to** Tarascon or Rouen...

He **wrote to** his brother Theo.

2. 与形容词搭配

The fields **were alive with** green of growing crops…

The church spire here **is typical of** Holland.

注意：

1. 有些词既是介词又是副词，要在具体的语境中判断。一般来说，该词后面如果不跟名词或代词，则应是副词。例如：

Look **out** on a summer's day.

They flow **on** one after another.

2. 英语中有两种宾语：动词宾语和介词宾语。

3. 介词短语作定语时，需要放在所修饰词后面，即定语后置。

Exercises

I Discuss the following questions (pair work).

1. When did van Gogh arrive in Arles? When did he leave?

2. In *The Harvest* and *The Sower*, what are the two complementary colors that balance and enhance each other?

3. Besides being richly colored, what does the work *Café Terrace at Night* convey?

Ⅱ **Fill in the blanks with the words given below, changing the form when necessary.**

easel	stroke	mute	vibrate	hue
prolific	masterpiece	study	tranquil	offset

1. To _____ a color means to lower the intensity of it, or to reduce the contrast between this color and the others in the picture.

2. Rodin made a lot of _____ of hands, with *The Hands of God* being the most famous one.

3. Standing aloof from society, he spent the rest of his life in _____ hermitage.

4. In the art supply shop you could find whatever you want: frames, canvas, _____, brushes, pigments...

5. When we say a color is _____ by another one or other ones, we mean they subtly balance each other in the composition.

6. The _____ in oil painting came to be visible in the second half of the 19th century, while they had been quite invisible before.

7. In Monet's paintings, colors seem to be _____ in the air.

8. Rockwell is a(n) _____ illustrator, and he painted numerous covers for *Saturday Evening Post*.

9. Most of van Gogh's _____ were produced from 1888 to 1890, in Arles and Saint-Rémy.

10. Black and white may be considered as colors, but not _____; they are just achromatic.

Ⅲ **Choose the best word to fill in the blanks, changing the form when necessary.**

1. live (*adj.*), life, alive
 a. It's obvious that this statue is casted from a(n) _____ model.
 b. Have you ever read van Gogh's biography entitled *Lust for* _____?
 c. The everyday stuff came _____ in the picture as the artist worked.

2. create, creation, creative, creativity
 a. The photographer found _____ possibilities in light and shadows.
 b. The goal of education is to release students' _____.

 c. He regards his _____ as his children.

 d. We've _____ a lovely studio from out of an old factory building.

3. radio, radiate, radium, radioactivity

 a. People had no idea of _____ before the Curies (居里夫妇)

 discovered _____.

 b. Nowadays, computer and internet have replaced the _____.

 c. Railways _____ from Beijing in every direction.

4. compare, comparable, comparison, comparatively

 a. Wang Xizhi reached a position in Chinese calligraphy _____

 to that of Confucius in Chinese philosophy.

 b. It will be interesting to make a _____ between Russian

 realism and French realism.

 c. The scholars _____ the copy with the original, and found that

 it was no less excellent.

 d. _____, Germany was less advanced than other capitalist

 powers in the first half of the 19th century.

5. friend, friendly, befriend

 a. Most of his models are his _____ and neighbors.

 b. The designers are using renewable and environmentally _____

 materials.

 c. The local people _____ the young artist who travelled there.

6. tension, intensive, intensity

 a. Pure hues have the highest _____.

 b. Through _____ investigation, they arrived at conclusion

 beyond all expectations.

 c. There is a balanced _____ between the azure sky and the

 orangish desert.

IV Translate the following sentences into English.

1. "千树万树梨花开。"（burst into）

2. 看到凡·高的作品，人们都会有成为艺术家的冲动。（at the sight of）

3. 星星缀满夜空，宛如"天上的街市"。（alive with）
4. 19世纪，许多年轻艺术家从世界各地涌向巴黎。（scores of, flood into）
5. 相比之下，拉丁民族对于色彩更加敏感。（by contrast）
6. 对于市场与资源的需求使这两个民族你争我夺。（pit against）

Ⅴ Cloze.

Vincent van Gogh is _____1_____ considered the greatest Dutch painter _____2_____ Rembrandt, and a powerful influence on expressionist art. He turned _____3_____ 800 oil paintings and 600 sketches, but in his lifetime only _____4_____ of them was sold. However, nearly 100 years after his death, his painting _____5_____ "Sunflower" was auctioned off _____6_____ 240 million francs, the highest price ever paid for a work of art at auction.

1. A. general B. generally C. generate D. gene
2. A. after B. before C. than D. with
3. A. in B. to C. off D. out
4. A. one B. two C. three D. four
5. A. entitled B. entitle C. entitling D. to entitle
6. A. in B. at C. with D. of

Part B Van Gogh & *The Starry Night*

"... looking at the stars always makes me dream... Why, I ask myself, shouldn't the shining dots of the sky be as **accessible** as the black dots on the map of France? Just as we take the train to get to Tarascon or Rouen, we take death to reach a star."

—Vincent van Gogh

When Vincent van Gogh was a patient in an **asylum** at Saint-Rémy in the south of France, he wrote to his brother Theo: "This morning I saw the country from my window a long time before sunrise, with **nothing but** the morning star,

which looked very big." The morning star is another name for Venus, and it may be the large white **pulsating** form. Van Gogh **stayed up** three nights **in a row** to paint the view from his window in the asylum, because, as he said, "the night is more alive and more richly colored than the day."

But van Gogh was not just painting an image of what he saw. In fact, the church **spire** here **is typical of** Holland, the artist's native country. So this is a picture rooted in his imagination and memory as well—a **fantastic, apocalyptic vision** of the night sky. What others might have viewed as a **placid** scene, van Gogh has **rendered** in **heaving** and **churning** waves. Each stroke of paint is more than a **dab** of color—it's a field of energy, as well.

The contrast between the **chaos** of the heavens and the quiet order of the village below is remarkable. The **cypress** tree—**known as** the tree of death for its traditional associations with graveyards and **mourning**—creates a flame-like connection between the earth and sky. But for van Gogh, a man of strong **Christian** faith, death was not **ominous**; it was the path to heaven.

Vincent van Gogh is generally considered the greatest **Dutch** painter after Rembrandt; he **powerfully** influenced the **current** of **expressionism** in modern art. Among his masterpieces is the well-known *The Starry Night.*

New Words

starry *adj.* 布满星星的，繁星满天的

accessible *adj.* 易接近的，可到达的；可理解的

asylum *n.* 救济院，精神病院

pulsate *v.* 搏动，跳动，有规律地跳动

spire *n.* 尖顶

fantastic *adj.* 幻想的，奇异的

apocalyptic *adj.* 启示录的，天启的

vision *n.* 视力，视觉；幻想，幻影；景象

placid *adj.* 平静的

render *v.* 表现，描写

heave *v.* 举起

churn *v.* 搅拌，搅动

dab *n.* 少量，一抹

chaos *n.* 混乱，混沌

cypress *n.* 柏树，丝柏

mourning *n.* 哀悼，服丧

Christian *n.* 基督徒，信徒 *adj.* 基督教的

ominous *adj.* 预兆的，恶兆的，不吉利的

Dutch *adj.* 荷兰的

powerfully *adv.* 有力地，强烈地

current *n.* 潮流，趋势

expressionism *n.* 表现主义

Phrases

nothing but 只，只不过
stay up 不睡，熬夜
in a row 成一排，连续

be typical of 是……的特点
be known as 被认为是

Notes

The Starry Night《星夜》（凡·高作品）
Tarascon, Rouen, Saint-Rémy 法国地名
Theo 提奥（凡·高的弟弟）

Venus [罗神]维纳斯；[天]金星
Holland 荷兰
Rembrandt 伦勃朗（荷兰画家）

Exercises

Ⅰ **Discuss the following questions (pair work).**

1. Why did van Gogh prefer to paint in the night when he was in the asylum?

2. How did van Gogh represent the scene outside of asylum window?

3. What role does the cypress tree play in van Gogh's painting?

4. What do you think about van Gogh, both as an artist and as a man?

Ⅱ **Translate the following sentences into Chinese.**

1. "The night is more alive and more richly colored than the day."

2. What others might have viewed as a placid scene, van Gogh has rendered in heaving and churning waves.

3. Vincent van Gogh is generally considered the greatest Dutch painter after Rembrandt; he powerfully influenced the current of expressionism in modern art.

Space for Illustration

Use your imagination and creativity, and draw an illustration for Part A or B, after which you are supposed to explain in English why you draw it in the way you do.

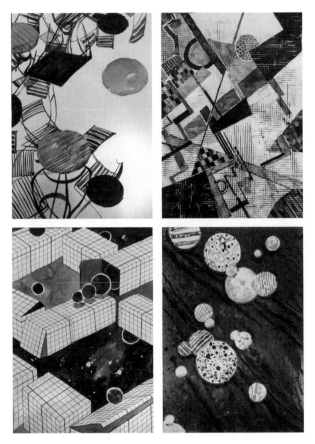

插图作者：清华大学美术学院　美84班　邵文沁

构成或构图（composition）是视觉艺术的重要内容。关于构成或构图的研究可称为画面语言，它是从视觉出发的感知和表达体系，不同于文字语言。画面语言包含画面元素和画面原理两方面。在这里，我们主要介绍画面元素。

Part A 介绍线条、形状及色彩这三个画面元素。涉及与之相关的视觉引领、运动、方向、空间分割、重量分配、纯度、明度、色相等概念。

Part B 介绍明暗、肌理和空间这三个元素。

这两篇文章能够将所讲述的概念或知识点彼此联系，并把它们放在美术史的坐标上，以融会贯通，文章中包含许多美术方面的基本词汇，可以成为学习本书其他内容的必要准备。

Unit 2 Pictorial Elements
画面元素

These are not separate, but are all interrelated in the image.

Part A Line, Shape, and Color

Line—Lines can be straight, **curved**, or **organic**, and can vary in **thickness**, and **value**. They can be very important in providing directional movement in the work, leading the eye through the image. Together, they can form shapes, **patterns**, and texture, and can help lead the eye back into space in an image. They can form empty or filled shapes. Lines, or strokes, can be used in **hatching** and **cross-hatching** to **shade** forms. (Hatching is a series of parallel lines in one direction; cross-hatching is another series of parallel lines **superimposed** over the first series, usually in a different direction than the first.) As well as **shading**, these strokes can also provide directional movement in a work. When there is one layer of parallel lines, the movement will be the direction the lines are pointing; when a **perpendicular** second set is put **on top of** the first set, this can **neutralize** the **directional** movement of the first set, and cause an all-over movement, **rather than** just one direction. **Unity** in an image can be obtained by the **orchestration** of these strokes, in one direction, two or more, or **in an all-over manner**.

Shape—Shapes can be organic or **geometric** in nature, and can be solid or empty. They can be used alone, or as **units** in another, larger shape. They can also form patterns, and be used in the division of space in an image (their **placement** divides up the picture surface), and **distribute** the "weight" in the composition, and determine the balance of left and right **picture plane**, and top and bottom. They can also vary in size, which helps to establish **spatial** depth; and in value (light or dark) or color. Using similar shapes can help **unify** a composition; varying the shapes adds variety and interest.

Color—As an important element, color can be used to create color harmonies, contrasts, unity and variety in images, as well as **delineate** space (colors **tend to** come forward or **recede** in space, relative to one another). Color is affected by light—and color can help **portray** light, as the impressionists

found. The three primary colors are red, blue, and yellow; **secondary** colors are green, violet and orange. Colors have different **intensities** (brightness) and values (lightness and darkness). The term "hue" means the actual color, like red, green, etc. **Complementary** colors placed **next to** one another will make one another appear brighter; mixed together, they can form **neutral** colors. Generally, warm colors are those with more yellow in them; cool colors generally have more blue in them. But the most important thing about colors is that they affect each other greatly, and colors appear to change **relative to** the color(s) around them, in an often **unpredictable** manner, forming **optical** illusions at times. Color can be **applied** traditionally, in blended areas, or in a "broken" manner, like the impressionists, in dabs or **patches** of **unblended** color. Blended colors and tones generally appear in work which attempts to depict the illusion of depth and three-dimensional **modeling**, whereas broken color appears in work done after 1850, through the period of early **modernism**.

New Words

curve *n.* 曲线，弯曲 *v.* 弯，使弯曲

organic *adj.* 有机的

thickness *n.* 厚度；粗细

value *n.* 明度（色彩）；明暗（素描）

pattern *n.* 图案，图式

hatching *n.* 排线，排线法

cross-hatching *n.* 交叉排线法

shade *n.* 暗部，暗影；暗色，低色度 *v.* 使阴暗，涂暗影

superimpose *v.* 叠加；重置

shading *n.* 画阴影，描影法，明暗法

perpendicular *adj.* 垂直的，正交的 *n.* 垂线

neutralize *v.* 中和

directional *adj.* 方向的

unity *n.* 团结；统一，一致

orchestration *n.* 管弦乐作曲法；交响

geometric *adj.* 几何的，几何学的

unit *n.* 个体；（计量）单位

placement *n.* 放置，布置

distribute *v.* 分发，分配，分布

picture plane *n.* 画面

spatial *adj.* 空间的

unify *v.* 统一，使成一体

delineate *v.* 描绘，用线条画

recede *v.* 后退；变得模糊，减退

portray *v.* 画，描绘

secondary *adj.* 次要的，二级的，中级的

intensity *n.* 强度，亮度；纯度（色彩）

complementary *adj.* 补充的，补足的

neutral *adj.* （颜色等）中性的

unpredictable *adj.* 不可预知的

optical *adj.* 眼的，视力的；光学的

apply *v.* 申请；应用；上（涂）颜色

patch *n.* 片，块，补缀，碎片

unblended *adj.* 未调和的　　　　　　　**modernism** *n.* 现代风，现代主义
modeling *n.* 塑造，造型；[计] 建模

Phrases

on top of 在……之上　　　　　　　**tend to** 趋向于，易于
rather than 而不是　　　　　　　　**next to** 毗连的，紧邻的
in a... manner 以……的方式　　　　　**relative to** 相对于

Grammar

宾语从句（The Object Clause）（Ⅰ）

在复合句中担任宾语成分的从句，称为宾语从句。

1. 由从属连词 that, if, whether 引导的宾语从句

that 在此种语境中无词义，常用在 believe, hear, hope, know, say, tell, think 等动词后面。that 在口语中往往省略。例如：

Please note **that the word "art" is included in the definition of graphic design**.

if 与 whether 都作"是否"解，往往引出带有疑问含义的从句，常用在 ask, care, find out, know 等动词后面。

2. 由连接代词 who, whom, whose, which, what 引导的宾语从句

这些连接代词有词义，除了引导从句外，还在从句中担任一定的成分。例如：

I want to know **who is the monitor**.（who 在从句中作主语。）

I don't know **whose work this is**.（whose 在从句中作定语。）

Tell me **what your favorite color is**.（what 在从句中作表语。）

Now I understand **what you tried to say to me**.（what 在从句中作宾语。）

3. 由连接副词 when, where, how, why 引导的宾语从句

这些连接副词有词义，除了引导从句外，还在从句中担任状语。例如：

I wonder **when you started to like sculpture**.

Now I understand **how you suffered for your sanity**.

Van Gogh asks himself **why the shining dots of the sky shouldn't be as accessible as the black dots on the map of France**.

注意：所有从句的语序都应是陈述句语序。

Exercises

I **Discuss the following questions (pair work).**

1. What are the functions of line as a pictorial element?
2. Why is the word "weight" in the second paragraph in quotation marks?
3. Ordinarily, what kind of colors tend to come forward, and what kind of colors tend to recede in space?

II **Fill in the blanks with the words given below, changing the form when necessary.**

patch	spatial	orchestration	perpendicular	placement
geometric	optical	value	organic	modernism

1. The key to interior design is _____ logic.
2. In his eyes, these are not wares, fruits and fabrics, but a(n) _____ of lines, shapes and colors.
3. OP Art is the abbreviation of _____ Art.
4. The form of products became more and more _____ after the First World War, so as to be adaptable to mass production.
5. Seurat's paintings are composed of small _____ of unblended color.
6. Among all hues on the color wheel, yellow is of the highest _____, while violet is of the lowest.
7. In pictorial language, _____, arrangement, and composition are more or less the same in meaning.
8. Both line and shape can be _____, which means natural or vital.
9. One of the features of _____ is breaking away from the tradition.

10. Seldom do painters use directions that are absolutely _____ to each other in their compositions.

Ⅲ Choose the best words to fill in the blanks, changing the form when necessary.

1. curve, curved, cursive

 a. _____ Script (草书) is the most illegible among the four basic scripts of Chinese calligraphy.

 b. The crossbeam looks straight, but in fact it is slightly _____.

 c. The arch forms a beautiful _____ against the blue sky.

2. line, underline, delineate

 a. Do you have the habit of _____ the words that interest you when you are reading?

 b. There are a variety of ways to _____ space, such as linear perspective and atmospheric perspective.

 c. A(n) _____ can be defined as "a moving dot".

3. portray, portrayal, portrait

 a. This novel can be considered as a _____ of Victorian life.

 b. *A* _____ *of the Artist as a Young Man* is a novel by James Joyce.

 c. In that long scroll, Zhang Zeduan（张择端）_____ the urban life in Song Dynasty.

4. neutral, neutralize, neutralization

 a. The water basin can visually _____ the stiffness and geometry of the modern architecture.

 b. The _____ in composition should be dialectical and interesting.

 c. _____ color is often called "gray color"; it is of very low intensity.

5. direct, director, direction, directional

 a. Perspective lines can _____ our eyes toward a focal point (vanishing point) in the distance.

 b. The strokes are compositional, due to the fact that they have their forms and _____.

　　　c. In the composition, the _____ movement and visual leading
　　　　are "the two sides of one coin".

　　　d. Have you ever tried to be a movie _____?

　6.　unit, unite, unity, unify

　　　a. " _____ we stand; divided we fall."

　　　b. In the composition, what we seek for is the _____ with variety.

　　　c. Cézanne tended to render objects as geometric forms, which in a way helps
　　　　to _____ the picture.

　　　d. He took apart the complex (复合体) into various _____.

Ⅳ Translate the following sentences into English.

　1.　这个酒吧的室内（环境）是以一种怀旧风格设计的。(in a... manner)

　2.　在室内，在自然光下，物体暗面的颜色总会偏暖。(tend to)

　3.　在天空（的色彩）的辉映之下，那房子的颜色显得更为鲜亮了。(relative
　　　to)

　4.　只有使背景推远，你才能充分描绘出空间感。(recede)

　5.　这是对色彩感觉的培养，而不是塑造能力的训练。(rather than)

　6.　把羽毛和陶罐放在桌子上面，它们则不再仅仅是羽毛、陶罐和桌子了。
　　　(on top of)

Ⅴ Cloze.

　　　Artists such _____1_____ Cézanne, Picasso and Matisse in the early 20th
century continued the inquiry into the question of _____2_____, which resulted
_____3_____ fauvism and cubism, and even less dependence on external reality.
In 1910, Kandinsky created one of the first completely abstract _____4_____, and
wrote his _____5_____, *Concerning the Spiritual in Art* (《论艺术的精神》).
He wrote that painting, like music, does not exist to describe external reality,
but _____6_____ realities, emotions, spiritual concerns: what he called the inner
necessity of the artist. Soon after followed Mondrian's pure _____7_____, and all
the other abstractions of the 20th century.

1. A. in	B. on	C. to	D. as
2. A. compose	B. composition	C. composed	D. competition
3. A. up	B. of	C. in	D. as
4. A. pain	B. paintings	C. painting	D. painter
5. A. novel	B. poem	C. thesis	D. prose
6. A. internet	B. international	C. interactive	D. internal
7. A. geology	B. geometry	C. geography	D. algebra

Part B Value, Texture, and Space

Value (light and dark)—Lights and darks are used in shading and modeling of forms in traditional art, as well as to delineate space; in both traditional and contemporary art, they are used as spatial **cues**, where areas of most contrast (of dark and light) seem to come forward in space. Compositions can be unified with **orchestrated** distribution of lights and darks, and directional movement can also be directed with values, in smooth transition or **abrupt** changes. Colors have values of varying lightness and darkness; it takes a little practice to see these values separately from the color identity sometimes. Value, as color, is also **relative**—when something is dark, it is dark in relation to something else which is lighter; "dark" in itself doesn't **indicate** the actual darkness. That is, a medium dark object, when placed next to a black object, will appear lighter, but next to a lighter tone will appear darker.

Texture—In two-dimensional images, texture means the pattern seen in the visual elements—a patterning of dots, lines, shapes, etc. Visual textures can vary in value, in space. In modern and contemporary art, visual textures have been used in a "**flat**" type of composition, that is, not **illusional** space, like previous art had been. **Specifically, frottage** and collage made great use of visual textures in images. Van Gogh also made great use of texture in his ink drawings, **particularly** of landscapes. The use of texture can also form visual rhythms in an image, as in music, with same or varying intervals between marks in a pattern.

Visual texture can add a great deal of interest and **dynamic** energy to images.

Space—Many types of space have been used throughout the history of art—"primitive", Renaissance, Cézanne's combination of Renaissance and modern, and late modern "allover" space (as in Pollock's drip paintings). More traditional images use **linear** and **atmospheric perspective** to depict the illusion of spatial depth in images, **i.e.**, parallel lines appearing to meet in the distance, and forms and colors becoming less distinct and more faded as they recede in space, **respectively**. Traditional, modern and contemporary images also use spatial cues to indicate spatial depth, although modern and contemporary work does not often use linear perspective, and is generally less interested in depicting "real" space. These artists are often more interested in the "flat" reality of the picture plane, than in the imitation of "real" space. This essential **flatness**, or "**integrity**" of the picture surface, has been a **dominant** idea in two-dimensional art since the second half of the 19th century.

▌New Words

cue *n.* 暗示，提示
orchestrate *v.* 编管弦乐曲
abrupt *adj.* 突然的；陡峭的；生硬的
relative *adj.* 有关系的；相对的，比较而言的
indicate *v.* 指示，暗示
flat *adj.* 平坦的，扁平的；平面的，二维的
illusional *adj.* 错觉的，幻影的
specifically *adv.* 特定地，明确地
frottage *n.* 擦，摩擦；擦印画法
particularly *adv.* 独特地，显著地，尤其地

dynamic *adj.* 动力的，动力学的；动态的
linear *adj.* 线的，直线的，线性的
atmospheric *adj.* 大气的，空气的
perspective *n.* 透视法，透视图
i.e. *adv.* 也就是
respectively *adv.* 分别地，各个地
flatness *n.* 平面性，平面感
integrity *n.* 完整，完整性
dominant *adj.* 有统治权的，占优势的，支配的

▌Notes

Pollock 波洛克（美国抽象表现主义画家）　　**drip painting** 滴画（波洛克绘画风格）

Exercises

I **Discuss the following questions (pair work).**

1. How are values used as spatial cues?
2. Who made great use of texture in his ink drawings according to the text?
3. How do traditional images depict the illusion of spatial depth?

II **Translate the following sentences into Chinese.**

1. Colors have values of varying lightness and darkness; it takes a little practice to see these values separately from the color identity sometimes.
2. In modern and contemporary art, visual textures have been used in a "flat" type of composition, that is, not illusional space, like previous art had been.
3. These artists are often more interested in the "flat" reality of the picture surface, or picture plane, than in the imitation of "real" space.

Space for Illustration

Use your imagination and creativity, and draw an illustration for Part A or B, after which you are supposed to explain in English why you draw it in the way you do.

插图作者：清华大学美术学院 美11班 耿立嘉 李毅方 黄丹红

　　南朝（宋）时的画家、文艺理论家王微在其画论《叙画》中写道："目有所极，故所见不周。于是乎以一管之笔，拟太虚之体。"中国古代山水画并不是像西方风景画那样去呈现某个视角下的自然的一隅，也不是像现代山水画那样着意表现山势的雄伟和空间的广阔，而是要借助山水图像来呈现虚灵悠远的"道的世界"，隐喻个体生命在宇宙大化之中的舒张与安顿。这种表达植根于古人的的哲学观念，源于他们理解世界的方式。

　　Part A 的文章以董源的《平林霁色图卷》为范例，对中国山水画进行了较为全面的介绍。作者以西方人的视角，借助空间、结构、形体、质感、图式等概念，较为全面、深入地描述了传统山水画的审美意趣和表现方式。

　　Part B 对中国画进行了整体的概述，包括历史沿革、门类等。文章中有许多关于中国画的英文词汇和表达。

Unit 3 Chinese Landscape Painting
中国山水画

Part A Chinese Landscape Painting

To the Chinese of the Song Dynasty (960—1279), landscape art was much more than a stage **prop**. Nature itself was the **protagonist** of a drama in which humans were merely **minor** actors. By the tenth century, Chinese artists had **translated their feeling for nature into** a **pictorial** language that produced glowing images of landscape.

With just ink and water Dong Yuan created *Clear Weather in the Valley*, a landscape that **evokes sensations** of **boundless** space. **Indications** of human life—fisherman, **strollers**, and buildings—are barely **discernible** in the **vastness**. The effect **is not due to** a system of one-point perspective but to the artist's skillful use of ink **washes** with which he suggested mountains, forests, and **shrouds** of mist. In places he used areas of empty paper to **hint at** the deepest layers of mist and the **plane** of the lake. This kind of landscape and the feelings it evokes can be related to the traditional **oriental** attitude of respect for and cooperation with nature. Even the making of the picture required respect and cooperation; and ink wash cannot be forced.

However, *Clear Weather in the Valley* is more than just a collection of **nebulous vapors**. Its ink washes **are endowed with** structure by a system of lines and details. Lines also **complement** the **tonal** areas in defining the **craggy** land **formations** and the textures of leaves and rocks.

In addition to the realism of the picture, the lines are also responsible for rhythmic, abstract patterns. Artistic use of line was a tradition in ancient China where **calligraphy**, like painting, was looked on as a fine art. Chinese artists received extensive training in calligraphy, and Chinese painting was **nurtured** by the freedom and fluency of Chinese **script**.

Rather than directly copying a section of nature, Chinese artists gathered impressions while walking. They absorbed the subject matter from many angles,

in the process **savoring** it and mentally translating it into forms for trees, water, and mountains learned earlier from their masters. Everything was stored in the memory, to be released later during an act of creativity. Like a stage performer, the artist felt the need for mental preparation before the act. According to documents of the time, some Chinese artists depended on wine for this creative release. But the artist Guo Xi, who lived in the eleventh century, **relied on** a private ritual that was described by his son:

Whenever he began to paint he opened all the windows, cleared his desk, burned **incense** *on the right and washed his hands, and* **cleansed** *his ink-stone; and by doing so his spirit was calmed and his thought* **composed**. *Not until then did he begin to paint.*

The **absorption** and **filtering** of reality before **transferring** to paper was an artistic habit founded on a philosophy of life. The goal of Chinese artist was to reveal the essentials of nature rather than to record its outward appearance.

New Words

landscape *n.* 风景，景观；风景画，山水画

prop *n.* 道具，衬景

protagonist *n.*（戏剧、故事、小说中的）主角

minor *adj.* 较小的，次要的

pictorial *adj.* 绘画的，画面的

evoke *v.* 唤起，引起，博得

sensation *n.* 感觉，感受

boundless *adj.* 无限的，无边无际的

indication *n.* 指示，迹象，暗示

stroller *n.* 散步者

discernible *adj.* 可辨别的

vastness *n.* 广阔，广袤

wash *n.* 洗，洗涤；渲染，笔墨

shroud *n.* 覆盖物

plane *n.* 水平面；平坦或水平的表面

oriental *adj.* 东方的

nebulous *adj.* 云雾状的；模糊的，朦胧的

vapor *n.* 水汽，水蒸气

complement *v.* 补足，互补

tonal *adj.* 音调的；色调的

craggy *adj.* 嶙峋的，崎岖的

formation *n.* 构成，结构，形成物

calligraphy *n.* 书法

nurture *v.* 养育，给予营养物，滋养

script *n.* 字体；书写

savor *n.* 滋味；口味，品位 *v.* 品味，品尝

incense *n.* 熏香

cleanse *v.* 使纯净

compose *v.* 组成；写作，作曲；构图；（使）安定

absorption *n.* 吸收

filter *v.* 过滤；体悟

transfer *v.* 转移，转至

▎Phrases

translate... into... 翻译成，转化为　　　**endow... with...** 赋予
be due to 由于，应归于　　　　　　　**in addition to** 除……之外
hint at 暗示　　　　　　　　　　　　**rely on** 依赖，依靠

▎Notes

Dong Yuan 董源（北宋画家）　　　　名有待商榷。）
Clear Weather in the Valley《平林霁色图　**Guo Xi** 郭熙（北宋画家）
卷》（董源作品，波士顿美术馆；作品英译　**stage prop**（舞台）衬景

Grammar

句子（Sentence）

一个句子就是一个主谓结构所构成的意群。

学艺术的同学对于结构都有比较深刻的认识。一般来说，两个或三个不同维度的东西对接在一起，就形成结构。主语和谓语实则是两个不同维度的东西。当然，所谓主谓结构并不只限于名词和动词所构成的主语和谓语，还包括主语和系动词、there be和主语。换句话说，主谓宾、主系表、there be句型都体现了主谓结构。

句子类型（Types of Sentences）

1. 从形态上划分，句子可以分为主谓宾、主系表、there be三种。

主谓宾：主体发出一个动作，这个动作着落于客体之上。

主系表：把主体的属性或状态表述出来。

there be：上述两种句型都是由主体出发的，除此之外，还有一种抛开主体出发，表现空间或时间内的客观存在的句型，就是there be句型。

2. 英语中的句子按其结构可分为简单句、并列句和复合句三种。

简单句：只含有一个主谓结构的句子。例如：

Landscape art was much more than a stage prop.

Indications of human life are barely discernible in the vastness.

并列句：含有两个或两个以上互不依存的主谓结构的句子。并列句中的各分句常用并列连词and, but, or等连接。例如：

Even the making of the picture required respect and cooperation; and ink wash cannot be forced.

Chinese artists received extensive training in calligraphy, and Chinese painting was nurtured by the freedom and fluency of Chinese script.

复合句：含有两个或两个以上主谓结构的句子，即含有从句的句子。从句在该句子中充当某一成分。充当何种成分，就称为何种从句。例如：

Nature itself was the protagonist of a drama in which humans were merely minor actors.

Whenever he began to paint he opened all the windows, cleared his desk, burned incense on the right and washed his hands, and cleansed his ink-stone.

Exercises

I **Discuss the following questions (pair work).**

1. When did the pictorial language of Chinese landscape painting come into being?
2. What are the "functions" of lines in Chinese landscape painting?
3. What is the relation between Chinese calligraphy and Chinese painting?

II **Fill in the blanks with the words given below, changing the form when necessary.**

| landscape | pictorial | evoke | boundless | nebulous |
| oriental | calligraphy | indication | craggy | shroud |

1. Chinese _____ is considered as a basic training for Chinese painting.
2. In art, sometimes, _____ is better than elaborate depiction.
3. He came to realize that an individual is nothing but a tiny grain in the _____ sea.
4. The _____ rocks and cliffs are veiled by a stretch of cloud.

5. The cultural connotation of Chinese _____ painting is very different from the Western one.

6. *Jie Zi Yuan* is a special book that introduces the _____ language of Chinese painting.

7. These posters are likely to _____ a strong response among the public.

8. Impressed by the misty and _____ riverscape, Su Shi (苏轼) produced the famous *Chi Bi Fu* (《赤壁赋》).

9. "Life is elsewhere"; this proverb illustrates European people's taste for _____ culture.

10. The train pulled into the station, giving off _____ of steam.

Ⅲ Choose the best word to fill in the blanks, changing the form when necessary.

1. fineness, refine, refinement

 a. The porcelain is prized for its exceptional _____ and delicacy.

 b. The crude oil must be _____ before being used.

 c. People are amazed at the _____ of his diction and syntax.

2. complement, complete, complementary

 a. When two _____ colors are mixed together, the outcome is a neutral color, like brown or gray.

 b. No artwork is absolutely _____.

 c. In this Chinese painting, the inscriptions and the images enhance and _____ each other.

3. tone, tonal, total, tonality

 a. The _____ price of the brushes, ink, rice papers and ink-stones is 500 Yuan.

 b. The cold _____ of the painting is due to the use of blue and its adjacent colors.

 c. There is subtle _____ variation in this watercolor painting.

 d. Gradation and rhythm can produce beautiful _____.

4. nurture, nature, natural

 a. The idea of identifying man with _____ runs deep in Chinese culture.

 b. _____ in a literati family, his painting works showed a good taste.

 c. Chinese painting uses mineral or _____ pigments.

5. clean, clear, cleanse

 a. In Tibet, he felt that his soul was _____.

 b. Please _____ the windows as they are too dirty to see through.

 c. "Wilds so vast, the sky stoops to the trees; the river so _____, moon close to man." (野旷天低树，江清月近人。)

6. compose, composition, compositional

 a. The _____ of this picture is bold and unique.

 b. The strokes are expressive and _____, which makes them very important in art expression.

 c. The flower is _____ of seven petals.

 d. The young chairman tried to _____ his mood before speaking.

Ⅳ Translate the following sentences into English.

1. 在他看来，宋代绘画的繁荣是由于人口的迁移。(be due to)
2. "留白" 是不着墨的，但却是着意的。(endow... with...)
3. 除了画家的身份外，他还是一位书法家、诗人和音乐家。(in addition to)
4. 西方绘画依赖于造型与色彩，而中国画依赖于笔墨。(rely on)
5. 这幅画以打水的老僧来暗示深山中庙宇的存在。(hint at)
6. 将文字转化为图像是一个有趣的过程。(translate into)

Ⅴ Cloze.

If, around 1900, one had entered the ____1____ of a Chinese artist—even the rare artist who painted by electric light—one would ____2____ discovered no hint of foreign influence in his painting. He would have been astonished at

the suggestion that there was something lacking in his art, that his forms were not always _____3_____ drawn, that his perspective was false, that there was no shading or cast shadows... He would have replied that these technical devices had _____4_____ to do with _____5_____ art, which was an expression of the feeling and _____6_____ of the artist, and of a generalized view of the world of experience.

1. A. studio B. study C. office D. workshop

2. A. having B. had C. has D. have

3. A. accuracy B. accurate C. accurately D. accurating

4. A. something B. nothing C. everything D. thing

5. A. really B. reality C. real D. realism

6. A. personality B. personal C. person D. people

Part B Chinese Painting

Chinese painting is done by using a brush on paper or silk, often with black ink alone.

The roots of Chinese painting can be traced back to Chinese **Neolithic pottery** about 6,000 years ago. The **excavated** colored pottery with painted human faces, fish, deer and frogs indicates that the Chinese began painting **as far back as** the age. Paintings were mainly painted on silk or walls before the Tang Dynasty, and **mural** paintings were particularly popular. During the Yuan Dynasty the "Four Great Painters" —Huang Gongwang, Ni Zan, Wu Zhen and Wang Meng—represented the highest level of landscape painting in that period. Their works **immensely** influenced landscape painting of the Ming and Qing dynasties. The Ming Dynasty saw the rise of the Wumen Painting School, which emerged in Suzhou on the lower **reaches** of the Yangtze River. When the **Manchus** came to power in 1644, the then-best painters showed their **resentment** to the Qing **court** in many ways. The "Four Monk Masters"—Zhu Da, Shi Tao, Kun Can and Hong Ren—had their heads shaved to demonstrate their **determination** not to serve the new dynasty, and they soothed their sadness by painting tranquil nature scenes.

Classical Chinese painting can be **divided into** three categories: landscapes, **figures** and bird-and-flower.

Landscape painting mainly had two separate styles, "blue-and-green" and "ink-and-wash" landscapes. The blue-and-green landscape used bright blue, green and red pigments derived from **minerals** to create a richly decorative style. The ink-and-wash landscape relied on vivid brushwork with varying degrees of density of ink to express the artist's **conception** of nature, his own emotions and individuality.

The Tang Dynasty was considered the golden age of figure painting. **Historical** subjects and scenes of **courtly** life were popular. Also, the **techniques** were **refined**.

Bird-and-flower painting was separated from **decorative** art and formed an independent **genre** around the 9th century. Many well-known artists painted in this genre during the Song Dynasty and their themes included a rich variety of flowers, fruits, **insects** and fish. Many of the scholarly painters working with ink and brush used a great **economy** of line. They produced paintings illustrating things such as **plum blossoms, orchids**, bamboo, **chrysanthemums**, pines and cypresses which reflect their own **ideals** and characters.

New Words

Neolithic *adj.* 新石器时代的

pottery *n.* 陶器

excavate *v.* 挖掘，开凿；出土

mural *n.* 壁画，壁饰

immensely *adv.* 无限地，广大地，庞大地

reach *n.* 区域，河段

Manchu *n.* 满人；满族

resentment *n.* 怨恨，愤恨

court *n.* 法院；庭院；朝廷，宫廷

determination *n.* 决心

figure *n.* 人物，人物画

mineral *n.* 矿物，矿石

conception *n.* 观念，概念

historical *adj.* 历史（上）的，有关历史的

courtly *adj.* 王室的，宫廷的

technique *n.* 技术，技巧

refined *adj.* 精制的；优雅的

decorative *adj.* 装饰的

genre *n.* （艺术的）类型

insect *n.* 昆虫

economy *n.* 经济；节约；简约

plum *n.* [植]李子，梅

blossom *n.* 花，花开的状态

orchid *n.* [植]兰，兰花

chrysanthemum *n.* 菊花

ideal *n.* 理想

Phrases

as far back as 远在，早在 **divide into** 分成

Notes

Four Great Painters 课文中指"元四家" **Zhu Da** 朱耷
Huang Gongwang 黄公望 **Shi Tao** 石涛
Ni Zan 倪瓒 **Kun Can** 髡残
Wu Zhen 吴镇 **Hong Ren** 弘仁
Wang Meng 王蒙 **bird-and-flower** 花鸟画
Wumen Painting School 吴门画派 **blue-and-green** 青绿山水
Four Monk Masters 课文中指"清初四僧" **ink-and-wash** 水墨山水

Exercises

I **Discuss the following questions (pair work).**

1. What are the three categories of classical Chinese painting?

2. What are the respective features of "blue-and-green" and "ink-and-wash" landscapes?

3. What are the major subject matters of the bird-and-flower paintings in Song Dynasty?

II **Translate the following sentences into Chinese.**

1. The "Four Monk Masters"—Zhu Da, Shi Tao, Kun Can and Hong Ren—had their heads shaved to demonstrate their determination not to serve the new dynasty, and they soothed their sadness by painting tranquil nature scenes.

2. The ink-and-wash landscape relied on vivid brushwork with varying degrees of intensity of ink to express the artist's conception of nature, his own emotions and individuality.

3. Many well-known artists painted in this genre during the Song Dynasty and their themes included a rich variety of flowers, fruits, insects and fish.

Space for Illustration

Use your imagination and creativity, and draw an illustration for Part A or B, after which you are supposed to explain in English why you draw it in the way you do.

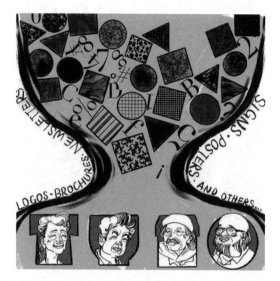

插图作者：清华大学美术学院 美硕 213 班 焦万程

平面设计是一种应用面极广的设计门类，它几乎无处不在。虽然是设计，但又有很大的艺术表现空间。平面设计的实质是以视觉手段来传达信息。

Part A 对平面设计做出了全面而又准确的界定，并论及"图像为基础的平面设计""字体为基础的平面设计"等范畴。语言清晰、明确、流畅，颇具"设计性"。文章中有许多平面设计常用的概念或词汇，对同学会有一定实用价值。

Part B 讨论了平面设计与纯艺术的区别。文章中另一些专业词汇可作为对 Part A 词汇的补充。

Unit 4 Graphic Design
平面设计

What Is Graphic Design?

Suppose you want to announce or sell something, amuse or persuade someone, explain a complicated system or demonstrate a **process**. In other words, you have a **message**, you want to **communicate**. How do you "send" it? You could tell people one by one or broadcast by radio or **loudspeaker**. That's **verbal communication**. But if you use any visual medium at all—if you make a **poster**; type a letter; create a business **logo**, a magazine ad. or an **album** cover; even make a computer **printout**—you are using a form of visual communication called **graphic** design.

Graphic designers work with drawn, painted, **photographed**, or computer-generated images (pictures), but they also design the **letterforms** that make up the **typography** found in books, magazines, and menus; and even on computer screens. Designers create, choose, and organize these elements—typography, images, and the so-called "white space" around them—to communicate a message. Graphic design is a part of your daily life. From **humble** things like **gum wrappers** to huge things like **billboards** to the T-shirt you're wearing, graphic design informs, persuades, organizes, stimulates, **locates**, **identifies**, attracts attention and provides pleasure.

Graphic design is a creative process that combines art and technology to communicate ideas. The designer works with **a variety of** communication tools in order to **convey** a message from a **client** to a particular **audience**. The main tools are image and typography.

Image-based design

Designers develop images to represent the ideas their clients want to communicate. Images can be **incredibly** powerful and **compelling** tools of communication, conveying not only information but also moods and emotions.

In the case of image-based design, the images must carry the entire message; there are few **if any** words to help. Image-based design is employed when the designer determines that, in a **particular** case, a picture is indeed worth a thousand words.

Type-based design

In some cases, designers rely on words to convey a message, but they use words differently from the ways writers do. To designers, what the words look like is as important as their meaning. The visual forms perform many communication functions. They can arrest your attention on a poster, identify the product name on a package, and present running text as the typography in a book does. Designers are experts at presenting information in a visual form in **print** or on film, **packaging**, or **signs**.

Image and type

Designers often combine images and typography to communicate a client's message to an audience. They explore the creative possibilities presented by words (typography) and images (photography, **illustration**, and fine art). It is up to the designer not only to find or create appropriate letterforms and images but also to establish the best balance between them.

Symbols and logos

Symbols and logos are special, highly **condensed** information forms or **identifiers**. They are abstract **representation** of a particular idea or identity.

| New Words

process *n.* 过程，流程	**loudspeaker** *n.* 扩音器，喇叭
message *n.* 消息，信息	**verbal** *adj.* 口头的；文字的
communicate *v.* 传达	**communication** *n.* 传达

poster *n.* 海报，招贴

logo *n.* 标志

album *n.* 集邮本，照相簿，签名纪念册

printout *n.* [计]打印输出

graphic *adj.* 图形的，图解的 *n.* 图形

photograph *n.* 照片 *v.* 拍照，摄影

letterform *n.* 字形

typography *n.* 字体；版式

humble *adj.* 低微的，谦逊的

gum *n.* 口香糖

wrapper *n.* 包装材料，包装纸

billboard *n.*（户外）布告板，揭示栏，广告牌

locate *v.* 查找……的地点 *v.* 定位；位于

identify *v.* 识别，鉴别

convey *v.* 传达

client *n.* 客户

audience *n.* 听众，观众，受众

incredibly *adv.* 难以置信地

compelling *adj.* 强制的，强迫的；引人注目的

particular *adj.* 特殊的，特定的

print *n.* 版；印刷物；版画 *v.* 印刷，出版，打印

packaging *n.* 包装

sign *n.* 标记，标识，标牌

illustration *n.* 插图，图解

condense *v.*（使）浓缩，精简

identifier *n.* 识别方式，识别工具

representation *n.* 表示，表现

Phrases

a variety of 多种的，各种各样的

in the case of 在……的情况下

if any 即便

Note

running text 滚屏文字

Grammar

状语从句（The Adverbial Clause）

在复合句中担任状语成分的从句，称为状语从句。状语从句又可分为时间、地点、原因、条件、方式、让步、目的、结果、比较九种。

1.时间状语从句

时间状语从句常用从属连词when, while, as, after, before, since, until, as soon

as等引导。例如：

When Vincent van Gogh was a patient in an asylum at Saint-Rémy in the south of France, he wrote to his brother Theo...

Whenever he began to paint he opened all the windows, cleared his desk, burned incense on the right and washed his hands...

2. 地点状语从句

地点状语从句常用连接副词where或wherever引导。例如：

Just stay **where you are**.

Wherever you go, I will be right here waiting for you.

3. 原因状语从句

原因状语从句常用从属连词because, as, since等引导。例如：

Van Gogh stayed up three nights in a row to paint the view from his window in the asylum, **because, as he said, "the night is more alive and more richly colored than the day."**

4. 条件状语从句

条件状语从句常用从属连词if, unless, as long as等引导。例如：

If style becomes too "loud" in graphic design, the work loses effectiveness and turns into noise, interrupting the communication.

5. 方式状语从句

方式状语从句常用as, just as, as if等从属连词引导。例如：

Just as we take the train to get to Tarascon or Rouen, we take death to reach a star.

Just as her parents had feared, she fell in with the wrong crowd—the impressionists.

6. 让步状语从句

让步状语从句常用though, although, even if, even though, as, whether... or...等从属连词引导。例如：

They knew they were forging a new vision, and continued to create their new work, **though it meant struggle and hardship for those without economic means**.

7. 目的状语从句

目的状语从句常用that, so that, in order that, lest等从属连词引导。例如：

The philosophy of sustainable design leads to a way of life and products that protect the earth and sustain its resources **so that it can continue to provide humans**

with sufficient resources.

8. 结果状语从句

结果状语从句常用so... that, such... that引导。例如：

The trend of fashion is changing **so fast that I feel at a loss**.

9. 比较状语从句

比较状语从句常用as... as, not so... as, more... than, less... than, the..., the...引导。例如：

David and his pupils, on the contrary, were **as good anatomists as they were painters**.

注意：

在时间状语从句和条件状语从句中，本来该用一般将来时的地方要用一般现在时来代替。例如：

When I **have** $100, 000, I will help all those in trouble.

If you **touch** that button, the whole building will be destroyed.

Exercises

I Discuss the following questions (pair work).

1. How many forms of graphic design are mentioned in the first paragraph? What are they?

2. What are the main tools of graphic design?

3. How do the designers use words differently from the writers?

II Fill in the blanks with the words given below, changing the form when necessary.

letterform	poster	album	particular	loudspeaker
gum	wrapper	billboard	audience	message

1. Sometimes, it's necessary for the designer to make a study on the psychology of the _____.

2. The boy is pasting on the wall the _____ that he designed.

3. How many text _____ do you send through Wechat every day?

4. Printed on the product _____, Japanese woodcuts were exported to Europe.

5. The title of the newspaper advertisement is designed with noticeable _____.

6. Hey, why don't you make a(n) _____ of your design works?

7. A diagonal crossing a(n) _____ represents sound muting or quiet.

8. Have you seen the complete series of the advertising film of "Extra"'s (益达) _____.

9. Every client may have his _____ taste.

10. Do you think that the big _____ damages the landscape of the campus?

Ⅲ Choose the best words to fill in the blanks, changing the form when necessary.

1. graphic (*n., adj.*), calligraphy, photography, typography

 a. In ancient Europe, the word _____ means "beautiful writing".

 b. In the term "CG", "C" stands for computer, and "G" stands for _____.

 c. The function of _____ design lies in communication.

 d. He is fascinated with _____; let's give him a digital camera as a gift.

 e. Being an art editor, he has the right to choose an appropriate _____ for the magazine.

2. sign, design, designer

 a. The fashion _____ is always keeping an eye on international trend.

 b. Systematic _____ education was initiated and developed in Bauhaus.

 c. The "no smoking" _____ is common everywhere in the world.

3. communicate, communication, communicative

 a. Visual _____ is the essential of graphic design.

 b. That poster _____ people's expectation for peace.

c. Our client is a _____ person, and easy to get along.

4. identity, identify, identifier

 a. CIS is the abbreviation of "Corporate _____ System".

 b. People can hardly _____ it, for the design is so modern.

 c. That logo is simple, clear and elegant, functioning as an _____
 of their group.

5. present, represent, representation

 a. That painting is a _____ of the bourgeoisie life in Paris.

 b. Can these works _____ the highest level of graphic design in
 our country?

 c. What is _____ in this poster is people's antiwar passion.

6. print, printer, printout

 a. This book is going to be _____ at 10,000 copies, so we have
 to design a good cover for it.

 b. There is a _____ over there; go to make a _____ .

Ⅳ Translate the following sentences into English.

1. 他是一位经验丰富的设计师，设计过各种各样的字体。(a variety of)

2. 就标志设计而言，我们必须追求简洁。(in the case of)

3. 他强调手绘，即使使用电脑，也用得很少。(if any)

4. 他们依靠有限的设备制作出精美的图像。(rely on)

5. 我们要用图像、字体、版式等视觉手段传达信息。(communicate)

6. 这个公司的经营理念和企业文化似乎都被浓缩在这个标志之中。
 (condense)

Ⅴ Cloze.

 The ____1____ of printing in China during the Tang Dynasty led ____2____
the development of a new art form—woodblock prints. These included both
single sheet pictures intended to be ____3____ on a door or wall, or given away to
advertise a product, as well as ____4____ in books. Throughout the late imperial
period, these traditional graphic arts flourished. There were even illustrated manuals

_____5_____ how to paint and illustrated catalogues on where to buy art materials.

_____6_____ in the late nineteenth century, the graphic arts underwent rapid changes in order to adapt _____7_____ new political and commercial needs. Chinese artists, exposed to Western art and design, incorporated elements of foreign styles into their work. At the same time, with a growing awareness of China's identity in the world, artists also sought _____8_____ traditional art forms and apply them to new themes. The gradual transformation of Chinese visual culture had an impact _____9_____ almost everyone in the population, as periodicals reached larger and larger audiences and posters were distributed throughout the country.

1. A. invent B. invention C. invented D. invents
2. A. to B. up C. for D. in
3. A. past B. pasts C. pasted D. pastel
4. A. illustrates B. illustration C. illustrators D. illustrations
5. A. on B. as C. of D. /
6. A. Begin B. Beginning C. Begins D. Beginner
7. A. to B. in C. for D. as
8. A. reinterpret B. reinterpreting C. to reinterpret D. reinterpreted
9. A. in B. on C. for D. with

Part B Better Graphic Design

To make graphic design more **effective**, we need to change the way we **think of ourselves as** graphic designers. A typical definition of Graphic Design is:

Graphic Design is the art of combining text and graphics and communicating an effective message in the design of logos, graphics, **brochures**, **newsletters**, posters, signs, and other types of visual communication.

Please **note** that the word "art" is included in the definition of graphic design. People still think of graphic designers as artists. The **majority** of graphic designers even call themselves artists, despite the fact that nothing could be

further from reality.

Artists are all about self-expression. Their only **boundaries** are their own skills and imagination. They deal largely in **aesthetics** and have the **unfiltered** freedom to invent new visual **codes** to **deliver** their feelings or **perceptions**. They choose the message. Graphic designers select the right tools for the goals of their project. They are asked to translate and **transmit** their messages in a clear and clever way.

While expression is the foundation for artists, it is not a **priority** for graphic designers. In graphic design, self-expression becomes a **characteristic** that must blend with the message. If style becomes too "loud" in graphic design, the work loses **effectiveness** and **turns into** noise, **interrupting** the communication. While artists are often problem tellers, graphic designers must be problem solvers.

Many of us entered this career thinking of our practice as some kind of art and as a **vehicle** for self-expression. Instead, we have a greater responsibility as graphic designers to **merge into** our society and **participate in** making changes for the **betterment** of **humanity**. While this might require some self-control of our expression, it also requires that we share, discover, and explore with those around us—our co-workers and our clients. This sort of collaboration is certainly a beautiful thing to me.

A next-generation graphic designer is an accessible **professional** who is open to suggestion and collaboration with clients, account people, **copywriters**, **strategists**, and even other graphic designers. We must put ourselves into a larger **context**. A more dynamic, organic, and natural process will lead to better **solutions** and enable our profession to grow.

| New Words

effective *adj.* 有效的
brochure *n.* 小册子
newsletter *n.* 时事通讯；传单
note *n.* 笔记，注解，注释 *v.* 注意；记录，做笔记
majority *n.* 多数，大半
boundary *n.* 边界

aesthetics *n.* 美学，审美
unfiltered *adj.* 未滤过的
code *n.* 代码，代号，密码，编码
deliver *v.* 递送；传达
perception *n.* 感知，感觉
transmit *v.* 传输，转送；传达
priority *n.* 优先，首要之事

characteristic *n.* 特性，特征

effectiveness *n.* 效力，有效性

interrupt *v.* 打断（正在说话或做动作的人），妨碍

vehicle *n.* 交通工具，车辆；媒介物，传达手段

betterment *n.* 改良

humanity *n.* 人性；人类

professional *n.* 专业人员 *adj.* 专业的，职业的

copywriter *n.* 广告文字撰写人，文案

strategist *n.* 战略家

context *n.* 上下文，文章的前后关系，语境

solution *n.* 解决办法，解决方案

Phrases

think of... as 把……看作

turn into （使）变成

merge into 融入，混入

participate in 参加，参与

Note

account people 客服人员

Exercises

I **Discuss the following questions (pair work).**

1. Have you ever designed one of the things listed in the second paragraph?

2. According to the forth paragraph, what is the task of graphic designers?

3. Basically, what do you think is the difference (are the differences) between art and design?

II **Translate the following sentences into Chinese.**

1. Graphic Design is the art of combining text and graphics and communicating an effective message in the design of logos, graphics, brochures, newsletters, posters, signs, and other types of visual communication.

2. If style becomes too "loud" in graphic design, the work loses effectiveness and turns into noise, interrupting the communication.

3. This sort of collaboration is certainly a beautiful thing to me.

Space for Illustration

Use your imagination and creativity, and draw an illustration for Part A or B, *after which you are supposed to explain in English why you draw it in the way you do.*

《神奈川冲浪里》（葛饰北斋作品）

由于特殊的地理位置和历史进程，日本形成了独特的文化形态。我们难以用只言片语概括日本文化的特征，但总体而言，日本文化体现出某种中和、温润、晦涩的面貌，使得日本美术也显得中和、细巧，富于装饰性。

19世纪中期，日本艺术远播欧洲，随即受到欧洲中产阶级的青睐，同时它也为处于变革中的西方美术带来了灵感与启示。日本木刻版画的空间表达、用色方式、观察视角都为西方画家所利用。此外，日本艺术对于设计史上的工艺美术运动和新艺术运动都有很大的推动作用。

Part A 总体介绍日本艺术对西方的影响。

Part B 介绍日本版画对印象派画家德加的启示。

Unit **5** The Influence of Japanese Art
日本艺术的影响

Part A **Japonisme**

Despite Europe's and America's extensive **colonization** in Asia during the 19th century, Japan's interactions with the West were very limited until 1853—1854, when Matthew Perry and American **naval** forces **exacted** trading and diplomatic privileges from the Japanese court. Only then did Europeans **become familiar with** Japanese culture and Japanese art. The French **in particular became so intrigued with** Japan's everything that they **coined** a specific term—*Japonisme*—to describe the Japanese aesthetic, which, because of both its beauty and **exoticism**, greatly **appealed to** the fashionable **segment** of **Parisian** society. In 1867, at the Exposition Universelle in Paris, the Japanese pavilion **garnered** enormous interest. Soon, Japanese **kimonos**, fans, lacquer cabinets, tea **caddies**, folding screens, tea services and jewelry flooded Paris. As demand for Japanese **merchandise** grew in the West, the Japanese began to develop import-export businesses, and the foreign currency flowing into Japan helped finance much of its **industrialization**.

Artists in particular were great admirers of Japanese art. Among those influenced by the Japanese aesthetic were the impressionists and post-impressionists, especially Manet, Degas, Cassatt, Whistler, Gauguin, and van Gogh. Indeed, van Gogh collected and copied Japanese prints, which were more readily available in the West than any other Asian art form. The Japanese **presentation** of space in **woodblock** prints intrigued these artists. Because of the simplicity of the woodblock printing process, the Japanese prints **feature** broad areas of flat color. This flatness **captured the imagination of** impressionist painters, who were seeking ways to **call attention to** the picture surface. The right side of Degas's *The Tub*, for example, has this two-dimensional quality. Degas, in fact, owned a print by Japanese artist Torii Kiyonaga depicting eight women at a bath in various poses and states. That print inspired Degas's painting. A comparison between Degas's **bather** and Kiyonaga's print is striking,

although Degas did not closely copy any of the Japanese artist's figures. But he did **emulate** Japanese compositional style and the distinctive angles that Japanese **printmakers** employed in representing human figures.

The decorative quality of Japanese images also appealed to the artists **associated with** the Arts and Crafts movement in England. Artists such as William Morris and Charles Mackinstosh found Japanese prints attractive because those artworks **intersected** nicely with two **fundamental** Arts and Crafts principles: art should be **available** to the masses, and functional objects should be artistically designed.

Japanese woodblock prints

During the Edo period, woodblock prints with ukiyo-e themes became enormously popular. People with very modest incomes could collect prints in albums or paste them on their walls. A highly efficient production system made this wide **distribution** of Japanese graphic art possible.

The popularity of ukiyo-e prints extended to the Western world as well. Their **affordability** and the ease with which they could be transported facilitated **dissemination** of the prints, especially throughout Europe. Ukiyo-e prints appear in the backgrounds of a number of impressionist and post-impressionist paintings. Some Japanese prints inspired 19th-century European artists to produce near-copies.

| New Words

colonization *n.* 殖民，殖民地化
naval *adj.* 海军的，军舰的
exact *adj.* 精确的，确切的，严谨的 *v.* 勒索；迫使
intrigue *v.* 激起……的好奇心
coin *v.* 创造（新词语）
exoticism *n.* 异国情调，异国风味
segment *n.* 部分，段落

Parisian *n.* 巴黎人 *adj.* 巴黎的；巴黎人的
garner *v.* 获得；贮藏；积累
kimono *n.*（日本的）和服
caddy *n.* 茶叶罐；小盒子
merchandise *n.* 商品；货物
industrialization *n.* 工业化
presentation *n.* 描绘；呈现，展示
woodblock *n.* 木版，木刻版

feature *v.* 以……为特征；由……主演
bather *n.* 沐浴者
emulate *v.* 仿效，模仿
printmaker *n.* 版画家
intersect *v.* 相交，交叉
fundamental *adj.* 基础的

available *adj.* 可获得的；可购得的；买得起的
distribution *n.* 分配；分布；分销
affordability *n.* 廉价
dissemination *n.* 散播

Phrases

become familiar with （逐渐）熟悉……
in particular 尤其
be intrigued with 对……感兴趣
appeal to 对……有吸引力
capture the imagination of 吸引……的注意力；摄人魂魄

call attention to 引起（观者）对……的注意
associated with 与……有关

Notes

Japonisme 日本风，和风
Matthew Perry 马休·佩里（美国海军将军）
Exposition Universelle 巴黎国际博览会
lacquer cabinet 日本漆盒
tea services 茶具
Whistler 惠斯勒（美国画家）
The Tub 《浴盆》（德加作品）

Torii Kiyonaga 鸟居清长（浮世绘画家）
Charles Mackinstosh 查尔斯·马金托什（英国设计师）
woodblock print 木版画，木刻版画
Edo period 江户时期
ukiyo-e 浮世绘

Grammar

动词非谓语形式（The Non-finite Forms of the Verb）

　　当我们要用某个动词的含义而又不把它用作动词时，就会出现动词非谓语形式。动词非谓语形式有三种：动名词、动词不定式和分词。它们在句子中起到名词、形容词和副词的作用；或者说，动词非谓语形式是动词的名词化、形容词化和副词化。

动名词（The Gerund）（Ⅰ）

当我们要使用某个动词的含义，却又要把它当作名词使用的时候，便产生了动名词。例如，我们都知道paint是"画画"的意思，但当我们要表示"我喜欢画画（这件事）"的时候，我们就不能单纯地使用paint了。我们需要给它加上名词的外衣"ing"，将它"名词化"。于是就有了这样的句子："I like painting."

作为动词非谓语形式，动名词的作用相当于名词，在句子结构中充当主语、宾语、表语。它仍保留其动词的某些特征，如可以有自己的宾语、状语等。动名词连同其宾语、状语等一起构成动名词短语。

1. 形式：

> 动词原形 + ing

2. 动名词及动名词短语在句子结构中充当的成分：

1）作主语

Looking at the stars always makes me dream.

Using similar shapes can help unify a composition; **varying** the shapes adds variety and interest.

Using color harmonies of adjacent colors on the color wheel, and **mixing a color** common to others, i.e., **adding a certain** color to most other colors, will help produce unity.

2）作表语

The most important thing is **finding the witness**.

His hobby is **visiting** art museums.

3）作宾语

a. 作动词宾语

Chinese artists received extensive **training** in calligraphy.

Although they based their representation of the human body on observation, they could not resist **perfecting** it.

The excavated colored pottery with painted human faces, fish, deer and frogs indicates that the Chinese began **painting** as far back as the age.

b. 作介词宾语

They can be very important in **providing directional movement** in the work.

Contrast can be created by **using colors** far away, or opposite on the color wheel.

Knowledge of brushwork is a key to **understanding Chinese calligraphy**.

This controlled spatial effect is a system of **creating depth** known as scientific perspective.

4）作定语

Matthew Perry and American naval forces exacted **trading** and diplomatic privileges from the Japanese court.

Japanese kimonos, fans, lacquer cabinets, tea caddies, **folding** screens, tea services and jewelry flooded Paris.

Because of the simplicity of the woodblock **printing** process, the Japanese prints feature broad areas of flat color.

3. 动名词与现在分词作定语时的区别：

作定语时，动名词相当于名词，分词相当于形容词。"动名词 + 所修饰词" 表示 "用来做某事的某物体"，而 "分词 + 所修饰词" 表示 "正在做某事的某物体"。动名词起到标示作用，而分词起到形容、修饰作用。

dining hall （动名词） dining student （分词）

sitting room （动名词） moving dot （分词）

dying day （动名词） dying Spanish soldier （分词）

Exercises

I Discuss the following questions (pair work).

1. When did Europeans become familiar with Japanese culture and Japanese art?

2. What did Degas borrow from Japanese print?

3. Why were Japanese prints attractive to William Morris and Charles Mackinstosh?

4. What facilitated dissemination of Japanese prints in Europe?

Ⅱ Fill in the blanks with the words given below, changing the form when necessary.

ukiyo-e	coin (*v.*)	exoticism	garner	emulate
merchandise	woodblock	feature	flatness	album

1. Inspired by Japanese architecture, Frank Lloyd Wright's buildings show a kind of _____ .

2. _____ basically means "pictures of the floating world".

3. Rapid developments in the printing industry led to the availability of inexpensive _____ prints.

4. The term "Renaissance" was _____ to describe the conscious revival of classical art in Italy.

5. Exposed to Chinese culture, some Edo artists began to _____ Chinese painting.

6. The _____ in her work transports audience to a faraway and poetic locale.

7. The shop specialized in the _____ imported from Japan.

8. He _____ support from a wide range of people before holding his exhibition.

9. The best fan paintings were probably never used as fans. Collectors purchased them to store in _____ .

10. Japanese Zen temples often _____ gardens of the dry-landscape.

Ⅲ Choose the best words to fill in the blanks, changing the form when necessary.

1. colony, colonial, colonization

 a. The used-to-be military compound has become an artists' _____ .

 b. Western _____ began in the 16th century and reached its peak in the 19th century.

 c. Built in the _____ period, the architecture shows a combination of local characteristics and European style.

2. navy, naval, navigation

 a. According to some ancient accounts, the Colosseum（罗马斗兽场）was

 once flooded, so as to stage _____ battles.

 b. A great architectural achievement as it is, the Summer Palace was built with funds raised by public subscription to construct a _____ .

 c. People will benefit from the latest _____ system.

3. exact (*v.*), exact (*adj.*), exactly

 a. Archeologists have still not confirmed the _____ purpose of this utensil.

 b. This is _____ what they criticized about the architecture.

 c. The kidnappers _____ ransoms for their hostages.

4. industry, industrial, industrialize, industrialization

 a. Modern _____ led to the rise of cities, and the increase of urban population, which required lots of low-cost living or working spaces.

 b. _____ kept changing man's life, as well as our visual environments, and accordingly changed our aesthetic consciousness.

 c. Mechanical aesthetics is also called _____ aesthetics.

 d. Germany _____ after the Franco-Prussian War, which was much later than other European countries.

5. section, intersect, intersection

 a. The painting depicts a bustling _____ .

 b. All kinds of paintings _____ in terms of formal language.

 c. Studios, classrooms and administrative spaces are distributed throughout the three _____ of the Art Building.

6. present (*adj.*), represent, presentation, representational

 a. As an art historian, you must have systematic knowledge of art, past and _____ , foreign and Chinese.

 b. The perfect _____ of the human body is based on accurate anatomy.

 c. What modernists _____ in their works are structure, movement and material, rather than the 3D form.

 d. Most sculptures, whether abstract or _____ , show the voluminosity and density of things.

Ⅳ Translate the following sentences into English.

1. 日本开埠通商之后，西方人逐渐熟悉了江户时期的浮世绘。（become familiar with）

2. 他对一切都兴趣盎然，包括建筑、机械装置、艺术。（be intrigued with）

3. 日本制造的漆盒尤其吸引欧洲人。（in particular, appeal to）

4. 这本小册子引起（人们）对这位版画家的关注。（call attention to）

5. 德加的作品总是与剧院、芭蕾、洗衣妇等题材有关。（associated with）

Ⅴ Cloze.

During the Edo period, woodblock prints were the primary visual means of _____1_____ daily life. Artists such as Suzuki Harunobu（铃木春信）, Kitagawa Utamaro（喜多川歌麿）, and Katsushika Hokusai（葛饰北斋）_____2_____ the courtesans, actors, and landscapes of Edo Japan. The prints were known _____3_____ ukiyo-e or "pictures of the floating world". Generally, artists made the initial drawings, _____4_____ transferred them to wooden blocks, and then printers produced the multicolored prints. Their style, which later influenced artists in the West, was _____5_____ by several qualities: asymmetric compositions with ample space around the dominant figures, strong black _____6_____ around the forms, and a combination of flat colors that were printed from separate blocks.

1. A. documents B. document C. to document D. documenting

2. A. portray B. portrait C. portrayed D. portrayal

3. A. up B. of C. in D. as

4. A. carver B. carving C. carvers D. curves

5. A. characterized B. character C. characterize D. characteristic

6. A. underlines B. outlines C. deadlines D. guidelines

Part B Edgar Degas

Dancing of a very different kind—ballet—was one of the favorite subjects of Edgar Degas (1834—1917), the eldest son of a wealthy banker, who

studied painting with a pupil of Ingres, attended the Ecole des Beaux-Arts, and traveled **extensively** in Italy, but eventually rejected classicism in favor of impressionism—or, at least, in favor of impressionist subject matter. Unlike Monet, who **personifies** impressionism for most museum-goers, Degas was not concerned with outdoor light and atmosphere. Indeed, he specialized in indoor subjects and made many preliminary studies for his finished paintings. Degas's interests were primarily recording body movement and exploring unusual angles of viewing. He **was fascinated by** the **formalized** patterns of motion of the classical ballet performed at the Paris Opera and with the training of **ballerinas** at its ballet school.

The Rehearsal is perhaps Degas's finest painting of this genre. In it and other similar works, he recorded with care the postures of the ballerinas, who stretch, bend, and **swivel**. But most of the dancers are hidden from the viewer by other figures or by the spiral stairway at the left. *The Rehearsal* is the **antithesis** of a classically balanced composition. The center is empty, and the floor takes up most of the canvas surface. At the margins, Degas arranged the ballerinas and their teachers in a seemingly random manner. As in other impressionist paintings, the **cutting off** of figures at the left and right enhances the sense that the viewer is witnessing a **fleeting** moment. The **implied** position of that viewer is in a balcony looking down at the figures, **as opposed to** the head-on views of **statuesque** figures that were the norm in traditional paintings.

Because of his interest in patterns of movement, Degas became fascinated by photography and regularly used a camera to make preliminary studies for his works. Japanese woodblock prints, such as those by Suzuki Harunobu, were another **inspirational** source for paintings such as *The Rehearsal*. Japanese artists used **diverging** lines not only to organize the flat shapes of figures but also to direct the viewer's attention into the picture space. The impressionists, and later the post-impressionists, who **became acquainted with** these prints as early as the 1860s, greatly admired the spatial organization, familiar and intimate themes, and flat un-modeled color areas of the Japanese prints, and Degas and others **avidly incorporated these features into** their own paintings.

New Words

extensively *adv.* 广泛地

personify *v.* 使人格化；是……的典范

formalize *v.* 使形式化

ballerina *n.* 芭蕾舞女演员

swivel *v.* （使）旋转；在枢轴上转动

antithesis *n.* 对立，对立面

fleeting *adj.* 飞逝的，稍纵即逝的

implied *adj.* 暗示（出）的

statuesque *adj.* 雕塑般的；轮廓优美的

inspirational *adj.* 给予灵感的，带有灵感的

diverge *v.* 分开，叉开

acquaint *v.* 使熟悉，使了解

avidly *adv.* 渴望地，热心地

Phrases

be fascinated by 为……着迷

cut off 剪（切，砍）下

as opposed to 与……相对

become acquainted with（逐渐）熟悉……

incorporate into 使成为……的一部分，并入

Notes

Edgar Degas 埃德加·德加（法国画家）

Ingres 安格尔（法国画家）

museum-goer 博物馆参观者；博物馆迷

Paris Opera 巴黎歌剧院

The Rehearsal《排练》（德加作品）

Exercises

I Discuss the following questions (pair work).

1. What made Degas different from Monet?

2. What is the composition of *The Rehearsal* like?

3. Besides photography, what was another inspirational source for Degas' paintings?

II Translate the following sentences into Chinese.

1. He was fascinated by the formalized patterns of motion of the classical ballet

performed at the Paris Opera and with the training of ballerinas at its ballet school.

2. As in other impressionist paintings, the cutting off of figures at the left and right enhances the sense that the viewer is witnessing a fleeting moment.

3. Because of his interest in patterns of movement, Degas became fascinated by photography and regularly used a camera to make preliminary studies for his works.

Space for Illustration

Use your imagination and creativity, and draw an illustration for Part A or B, after which you are supposed to explain in English why you draw it in the way you do.

"巴塞罗那世博会德国馆"（米斯·凡德罗作品）

　　好的品位与格调是难以界定的，尤其是在我们这个文化失语的时代。然而，无论是出于本能还是出于文化责任感，我们都要去辩难，去澄清品位与格调的问题，即审美的问题。

　　Part A 论述设计的品位和格调。文章中有许多有关审美的概念和词汇，可以引发我们的思考。

　　Part B 是一篇关于"美"的散论。

Taste and Style
品位与格调

Part A Good Taste and Style in Design

The development of **discernment** will eventually **lead to** what we call good taste or style. When we say that certain people have good taste, we mean that they exhibit **sound aesthetic** judgment and thoroughly understand the needs of their **individual** lifestyle. It appears that people with good taste always make good choices and that perhaps it **comes easy to** them. From the clothes we wear, the things we buy to the books we read, the films we see and the food we eat— all are aspects of living that are **governed** by taste.

Although many of us are uncertain about our taste, we can be educated, we can **elevate** our tastes, and we can learn to judge good design.

It is important to note that although people with great taste do things that are totally unexpected and **out of the ordinary**, perhaps ahead of their time— seeming to abandon all **trends** and **fads in favor of** their own good choices— it is never done to shock, amaze, or impress anyone. True style is **tuning into** and following what is naturally right. It **has little to do with** what is in fashion, although an **awareness** of fashion is always evident in people with taste. "Fashions passes, style remains." Style **abhors** the **cliché**, the **cuteness**, and **consciously**, abhors **conformity** (doing it because everyone else is doing it) in favor of an **uncompromising** approach to first-class design quality and **individuality**.

People with style seem to know when to stop just short of **excess**. They often **intuitively** know that "less is more", that as Plato said, "beauty of style depends on **simplicity**." Perhaps the first step toward **evolving** a personal style is to **pare** back to the **essentials** before piling on any **extraneous** additions.

Style is most importantly an individual matter. You cannot copy another's style, even as we cannot copy another's personality. For example, to create or copy an **interior for the sake of** correctness often falls short of style and **appropriateness**.

In today's instant society, we are often impatient to have style developed

immediately, but this is often not the way real beauty is made. Just as with nature who **took time to create** her masterpieces, it is worth waiting to find just the right **accessory, fabric**, or piece of **furniture** to fit your style. And in the process of **looking**, we develop a **distinctive** personal style. Certainly there are many **nonresidential** interiors that reflect good taste and great style, but it is in the home where these are most **personally** evident.

New Words

discernment *n.* 识别力，眼力，洞察力

sound *adj.* 健全的；可靠的；合理的

aesthetic *adj.* 美学的，审美的，有审美感的 *n.* 美学观念，美感

individual *n.* 个人，个体 *adj.* 个人的

govern *v.* 统治，支配

elevate *v.* 举起；提拔；振奋；提升

trend *n.* 倾向，趋势，走向，趋向

fad *n.* 一时流行的狂热，一时的爱好

awareness *n.* 知道，晓得

abhor *v.* 憎恶，痛恨；拒绝

cliché *n.* 陈词滥调

cuteness *n.* 装腔作势，矫揉造作

consciously *adj.* 有意识地，有知觉地；故意地

conformity *n.* 一致，符合

uncompromising *adj.* 不妥协的，不让步的

individuality *n.* 个性，个人的特性

excess *n.* 过度，无节制

intuitively *adv.* 直觉地；直观地

simplicity *n.* 简单，简易，朴素

evolve *v.*（使）发展，（使）进化，（使）逐渐形成

pare *v.* 削，削减

essential *adj.* 本质的，实质的；基本的 *n.* 本质，实质；要素，要点

extraneous *adj.* 支节的；无关主题的

interior *adj.* 内部的，室内的 *n.* 室内设计；室内环境

appropriateness *n.* 适当，适宜

accessory *n.* 附件，零件；附加物，饰物

fabric *n.* 织品，织物，布

furniture *n.* 家具

look *v.* 寻找

distinctive *adj.* 与众不同的，有特色的

nonresidential *adj.* 非居住的，非住宅的

personally *adv.* 亲自，个人地

Phrases

lead to 导致；通向

come easy to 对……是轻而易举的

out of the ordinary 不平常的，非凡的

in favor of 为有利于……，出于对……的偏爱

tune into 与……协调（一致）

have little to do with 与……没什么关系

for the sake of 为了

take time to do 从容地做某事

Note

Plato 柏拉图（古希腊哲学家）

Grammar

动词不定式（The Infinitive）（Ⅰ）

作为动词非谓语形式，动词不定式可以在句子中作各种成分。它仍保留其动词的某些特征，如可以有自己的宾语、状语等。动词不定式连同其宾语、状语等一起构成不定式短语。

1. 形式：

to + 动词原形

2. 不定式或不定式短语在句子结构中充当的成分：

1）作主语

It is our task **to provide** our clients with the best solution, not just offer one that looks better.

It is important **to note** that although people with great taste do things that are totally unexpected and out of the ordinary, perhaps ahead of their time...

2）作宾语

Whenever he began **to paint** he opened all the windows.

To make graphic design more effective, we need **to change** the way we think of ourselves as graphic designers.

We can learn **to judge** good design.

3）作表语

Often, our main priority is **to feed** our client's fascination for originality.

Perhaps the first step toward evolving a personal style is **to pare** back to the essentials before piling on any extraneous additions.

People with style seem **to know** when to stop just short of excess.（在这里 when to stop 是不定式复合结构作逻辑上的宾语。）

4）作定语

There is no need **to imitate** the mechanics of vision and view a scene from only one spot.

There had to be a ready standard **to judge** bad or good examples.

5）作状语

Just as we take the train **to get to Tarascon or Rouen**, we take death **to reach a star**.

It is never done **to shock, amaze, or impress** anyone.

It is worth waiting **to find** just the right accessory, fabric, or piece of furniture **to fit** your style.

注意：

1. 当动词成为动词非谓语形式时，就已经失去了动词的属性，不可以再作谓语。

2. 动词不定式作主语时，往往要后置，用it来作形式主语，放在主语的位置上；动词不定式作定语时，一定是后置定语，放在所修饰词的后面。

Exercises

I **Discuss the following questions (pair work).**

1. How can people with good taste be defined?

2. What is the main idea of the third paragraph?

3. What is the key word of the fourth paragraph?

II **Fill in the blanks with the words given below, changing the form when necessary.**

abhor	cliché	fad	conformity	sound
accessory	distinctive	furniture	essential	extraneous

1. It's our responsibility to establish a(n) _____ cultural system.

2. These reports are full of _____; no one wants to read them.

3. He thinks that the use of lighting in the exhibition is _____ and

unnecessary.

4. His unique thoughts enabled his design to be _____.

5. The fashion designer is good at using _____.

6. That kind of shirt was once a kind of _____, which could be seen everywhere, but now it has faded from popularity.

7. He _____ the cuteness and vanity of that circle, so he quitted it without hesitation.

8. In his works, you can never find any _____, but independence, individuality and rebelliousness.

9. The _____ do not go with the interior, for they are too old-styled.

10. He demonstrated the _____ of automobile design in his debut lecture.

Ⅲ **Choose the best word to fill in the blanks, changing the form when necessary.**

1. aesthetic, aesthetics, aestheticism

 a. Confucianism and Taoism constitute the foundation of our traditional _____.

 b. In his works, we can find some inclination of _____.

 c. From this design, we can see that his _____ perspective has changed.

2. elevate, elevator, elevation

 a. Good product design can certainly _____ the image of the brand.

 b. All these show the _____ of people's democratic consciousness.

 c. He decided to install an _____ in his big studio.

3. tuition, intuition, intuitive, intuitively

 a. The detective often relies on his own _____ in dealing with the case.

 b. _____, he knew that the accessory was the one that he wanted.

 c. The government partly lowered the _____ of students.

 d. Her _____ judgment is always right.

4. simple, simplify, simplicity

 a. Naturalness and _____ are the features of IKEA.

 b. The artist enjoys his _____ life.

 c. We suggest that the government of school _____ the procedures.

5. conscious, consciously, consciousness

 a. He is _____ trying to protect the historical relics in his landscape design.

 b. There is abundant _____ of the use of space in the words of Lao Zi.

 c. We must pay _____ effort to help the poor with our design work.

6. resident, residence, residential, nonresidential

 a. Peter is interested in talking with the local _____.

 b. Le Corbusier (勒·柯布西埃) designed Chandigarh (昌迪加，印度城市) into certain _____ zones and _____ zones.

 c. It's said that the house is the _____ of the president.

IV Translate the following sentences into English.

1. 过于注重形式可能会导致一种机械的形式主义。（lead to）

2. 由于 3D 打印的发明，设计的实施对他们来说变得容易了。（come easy to）

3. 这种设计理念是不同凡响的，打破了人们对于设计的一般性认识。（out of the ordinary）

4. 出于对法国的偏爱，她申请到那里的分部去工作。（in favor of）

5. 他们成功地使新图书馆与旧馆协调一致。（tune into）

6. 为了设计的整体性，他们删除了这些装饰。（for the sake of）

V Cloze.

A successful business is based on products and brands, both of _____1_____ are built by and for people. People must need and/or desire the products (or services) that a company offers. _____2_____, products must be designed to meet those needs and desires. They must also be positioned, promoted and communicated in

a way that bridges the gap between what the company and product really are and what people need and desire. And _____3_____, people are doing the designing, production, manufacturing and distribution.

It is really pretty simple: you must understand people to design and brand a successful _____4_____. You must understand people to create a healthy organization that inspires _____5_____ and productivity. In order to create revenue, you must understand people. In order to operate an _____6_____ organization with low costs you must understand people.

1. A. that B. which C. when D. where
2. A. Thus B. But C. Yet D. Although
3. A. intimately B. intimate C. ultimately D. ultimate
4. A. product B. produce C. production D. productive
5. A. royal B. loyal C. loyalty D. royalty
6. A. affective B. affect C. effect D. effective

Part B On Beauty

Beauty **as such** is certainly the most useless of all useful things. This may sound like a **paradox**, but is really an obvious, though much forgotten, truth. The proof is very easy. Take away the beauty from any useful thing whatever, and it keeps on being useful as it was before. Churches need not be **Romanesque** or **Gothic** or **Baroque** in order to harbor us and protect us against the sun, rain, and noise. They need only be a **shelter**. **As for** their form, it can be as simple as that of a **barn**. It is the same with furniture. Take away from it all proportion, grace, and **nobility** of line, and it will still be useful. The same could be said of cities: nothing whatever would happen to a community if its parks and gardens were not **trimmed** into beautiful patterns. As for pictures and statues, whose very nature is to beautify: if they were all to disappear from the world, houses would still go on sheltering, trains running, elevators **ascending**, and restaurant cooking meals.

There are and always have been men who have **dedicated their whole lives**

to this utterly useless thing. There is no better example than that of Vincent van Gogh, whose works have so **captivated** our times: sunflowers saturated with an almost **uncanny** glow of **dazzling** light; interiors flaming with colors. Son of a **well-to-do** family, Vincent van Gogh gave up a comfortable life in order to create useless beauty.

Beauty is essentially useless; precisely because it's useless and can never be used as means for anything else, beauty is loved **exclusively** for its own sake; consequently, the human **urge** after beauty, which we call creative action, is not a selfish urge, but essentially selfless.

The moment a man starts to beautify something, in that very instinct he has ceased to be selfish. He is giving without receiving. He is considering the thing which he is **molding** not as useful, but as lovable in itself and therefore worth beautifying.

It is not only the great artists who beautify that which they touch. All men have it in them to beautify anything somewhat; more or less according to their inborn capacity. The **coarse** person uses things, he has nothing to give; he only grabs and takes; the **humane personality** gives to everything that he does a touch of perfection, which is a joy to himself, and to all those who live with him. He **cares for** his own mind, for what he writes and says, for his home and his garden, for his friends, and for the land in which he lives.

The **cult** of the beautiful, when carried out in a healthy, **virile** way, is the most social of all training. It is a training for unselfishness.

| New Words

paradox *n.* 反论，悖论
Romanesque *n.* 罗马式建筑；罗马风
adj. 罗马式的；罗马风的
Gothic *n.* 哥特式 *adj.* 哥特式的
Baroque *n.* 巴洛克式 *adj.* 巴洛克式的
shelter *n.* 掩蔽处，掩体 *v.* 掩蔽，提供掩蔽
barn *n.* [农]谷仓；畜棚
nobility *n.* 高贵

trim *v.* 整理，修整
ascend *v.* 攀登；上升
captivate *v.* 迷住，迷惑
uncanny *adj.* 神秘的
dazzling *adj.* 耀眼的
well-to-do *adj.* 小康的，富裕的
exclusively *adv.* 排他地，专有地
urge *v.* 催促，力劝 *n.* 强烈欲望，迫切要求

mold *n.* 模子，铸型 *v.* 浇铸，塑造
coarse *adj.* 粗鄙的
humane *adj.* 仁爱的，高尚的

personality *n.* 个性，人格；人物
cult *n.* 狂热的崇拜；宗教信仰
virile *adj.* 精力充沛的；刚健的

Phrases

as such 本身
as for 至于

dedicate to 奉献于，献身于
care for 喜欢；在意

Exercises

I Discuss the following questions (pair work).

1. According to the text, can churches function to hold people without beauty and style?

2. Why is creative action not a selfish pursuit?

3. According to the text, is it only the great artists who beautify the world?

II Translate the following sentences into Chinese.

1. If they were all to disappear from the world, houses would still go on sheltering, trains running, elevators ascending, and restaurant cooking meals.

2. The moment a man starts to beautify something, in that very instinct he has ceased to be selfish.

3. He cares for his own mind, for what he writes and says, for his home and his garden, for his friends, and for the land in which he lives.

Space for Illustration

Use your imagination and creativity, and draw an illustration for Part A or B, after which you are supposed to explain in English why you draw it in the way you do.

插图作者：清华大学美术学院 美91班 鞠思雯 刘玥 娄翠芳 张欣 张笑醒

　　塞尚被称为"现代主义之父"，开立体主义之先河，但他的绘画又是富于生活情趣和装饰感的。塞尚曾是一个笨拙的、不适应学院主义教育的学生，然而这却促使他成为一个具有探索性的、个人风格卓著的画家。

　　本单元的两篇文章是一个整体，介绍这位画家的方方面面。Part A 讲述了塞尚的生平、作品，以及艺术风格的成长。而这种成长也可以被看作 19 世纪后半叶欧洲美术史演变的缩影。那是一个戏剧性的时代。

　　Part B 分析了塞尚的艺术风格。"塞尚想要在鲜活的色彩，坚实的形体，以及二维性的画面之间建立一种均衡。"Part B 第一段中的这句话很好地概括了塞尚的艺术风格，同时也影射了这种风格在美术史中的前因后果。塞尚"以色貌形"，以饱满、充盈的色彩来表现和突出形体的坚实感；以抽象化、几何化的笔触和形态来形成强有力的画面结构。同时，他以"扭曲的"的造型和空间来表达主观性的、动态的视角，并"发明"了三度空间和二度空间的结合，从而为美术向现代演变做好了准备（这尤其体现在他后期的风景画中）。

Unit 7 Cézanne
塞尚

Part A Biography of Cézanne

Cézanne was born in 1839 in the south of France. His banker father wanted him to study law, but the young Cézanne wanted something else.

At 15, he studied drawing at the local art **academy**, then at the proper time, entered law school. He eventually **convinced** his father to allow him to go to Paris to paint, where he attended **sessions** with a live model. He showed no particular **aptitude** for drawing up to this point.

His first stay in Paris was short. Disappointed in his own lack of **facility**, however, he returned to his hometown and worked in his father's bank for a year. But the bank was not his **cup of tea**, and he again returned to Paris to study in a small academy there. He eventually **made the acquaintance of** Monet, Renoir, Pissarro, and others. His early style was the complete opposite of the official, **academic** style—it was rough, **unrefined**, a **riot** of thick brushstrokes and color, with rather **passionate**, even somewhat **erotic**, themes. Compared with the **bland**, smooth brushstrokes, **lofty subject matter**, and muted color of the academic artists, his work was a rude shock, and perhaps meant to be so.

New ideas of painting were in the air. Courbet and Edouard Manet were painting with realism and **boldness** of subject matter and style, in a more contemporary manner. The young student friends were **soaking up** these new ideas, as well as studying the masters in the Louvre, the French art museum. They did not want to paint like the **academicians**—they wanted to paint outside, from life, not in their studios; they wanted clear, bright color, not the browns and grays of established painters. They wanted to paint with small, visible strokes, not the "**Victorian** smoothness". And, they wanted to paint modern life, not scenes of history or classical Greece. Pissarro particularly influenced Cézanne's way of thinking and working. He **urged Cézanne to** paint landscapes from nature, to discipline himself by studying the landscapes in front of him. Cézanne's **undisciplined** style became more **steadied** under Pissarro's influence;

he became much more focused with his energy. His color became more **subdued**, with earth colors, rather than the blacks, whites, and reds of his early work.

Even at this stage, however, his work remained somewhat different than Monet and Renoir. Their tiny strokes were rounded, soft; his were square, **blunt**, and more **structural**. While they were more interested in color and light, he was still concerned with form and structure; these differences put Cézanne in the **category** of post-impressionism, along with Gauguin, van Gogh and others, which means that as a group they were much influenced by impressionism, but their work moved forward from it to other artistic concerns. He remained friends with the impressionist group all his life, and continued to show his work with theirs in their independent exhibitions. They knew they were **forging** a new vision, and continued to create their new work, though it meant struggle and hardship for those without economic means.

Cézanne gradually forged his own unique vision. What he lacked in facility, he more than made up for in stubborn determination and hard work. He returned to Aix-en-Provence to his family **estate**, and even though he married and had a child, he continued to live and work in his family home. He painted every day—either outside on landscapes, or in his studio, on one of many **still lives** he had set up. He would work on paintings for many years—trying to reach the point of perfection, where each stroke, each color, each value, was absolutely **aligned with** all the other strokes, colors, and values.

New Words

academy *n.* 学院

convince *v.* 说服；使……确信

session *n.* 一场（一期）训练或授课

aptitude *n.* 天生的能力；天资

facility *n.* 熟练，敏捷；设备，工具

acquaintance *n.* 相识，熟人

academic *adj.* 学院的，学院派的

unrefined *adj.* 未精练的

riot *n.*（想象、感情等的）奔放；放纵

passionate *adj.* 充满热情的

erotic *adj.* 性欲的，色情的

bland *adj.* 温和的，柔和的

lofty *adj.* 崇高的

boldness *n.* 大胆，泼辣，粗豪

academician *n.* 学会会员；院士；学院派画家

Victorian *adj.* 维多利亚时代的，维多利亚式的

undisciplined *adj.* 无训练的，无修养的，任性的
steady *v.* （使）稳定，（使）稳固
subdued *adj.* 被抑制的；柔和的；减弱的
blunt *adj.* 钝的，生硬的

structural *adj.* 结构的，结构性的
category *n.* 种类，类别；[逻] 范畴
forge *v.* 稳步前进；铸造
estate *n.* 房产，不动产

Phrases

cup of tea 喜爱的人或事物
make the acquaintance of 结识
subject matter 主题
soak up 吸收

urge to 督促，激励
still life 静物
align with 与……结合、一致

Notes

Cézanne 塞尚（法国印象主义画家）
Monet 莫奈（法国印象主义画家）
Renoir 雷诺阿（法国印象主义画家）
Pissarro 毕沙罗（法国印象主义画家）
Courbet 库尔贝（法国画家）

Manet 马奈（法国画家）
Louvre 罗浮宫（法国国立美术博物馆）
post-impressionism 后期印象主义
Aix-en-Provence 埃克斯 – 昂 – 普罗旺斯（塞尚故乡）

Grammar

被动语态（The Passive Voice）

1. 含有情态动词的被动语态
形式：

> 情态动词 + be + 过去分词

例如：

主动语态：We can relate this kind of landscape and the feelings it evokes to the traditional oriental attitude of respect for cooperation with nature.

被动语态：This kind of landscape and the feelings it evokes **can be related** to the traditional oriental attitude of respect for cooperation with nature.

主动语态：When the work is compared to an impressionist painting, such as *Impression-Sunrise*, we can note two completely different effects.

被动语态：When the work is compared to an impressionist painting, such as *Impression-Sunrise*, two completely different effects can be noted.

2. 有直接宾语和间接宾语的句子的被动语态

有些及物动词可以有双宾语，一般可以分为直接宾语和间接宾语。在构成被动语态时，只将其中的一个宾语改为主语，另一个仍作宾语，称为保留宾语。这类动词有answer, ask, give, teach, show, tell, pay等。例如：

主动语态：This gives the characters an archaic quality.

被动语态：The characters **are given** an archaic quality.

被动语态：An archaic quality **is given** to the characters.

3. 动词词组的被动语态

英语中某些动词词组可以构成被动语态，如think of, take care of, take off, put on, make up等。在构成被动语态时，这些词组中的介词或副词都必须保留。例如：

主动语态：People still think of graphic designers as artists.

被动语态：Graphic designers **are still thought of** as artists.

主动语态：People put much stress on these formal elements.

被动语态：Much stress **was put on** these formal elements.

4. 过去进行时和过去完成时的被动语态

形式：

| was (were) + being + 过去分词 |
| had + been + 过去分词 |

主动语态：They **were forging** a new vision.

被动语态：A new vision **was being forged**.

主动语态：By the Later Han, Chinese people **had created** the basic script types.

被动语态：By the Later Han, the basic script types **had been created** by Chinese people.

Exercises

I **Discuss the following questions (pair work).**

1. How was drawing taught in Europe when Cézanne was young?
2. Can you describe Cézanne's early style?
3. Among the impressionists, who greatly influenced Cézanne?

II **Fill in the blanks with the words given below, changing the form when necessary.**

session	convince	lofty	facility	erotic
riot	subdue	forge	estate	category

1. During that special period, almost all artworks were of _____ subjects.
2. In this mural, there is a(n) _____ of figures: celestial beings, saints and ordinary people.
3. You need to _____ the yellow in the picture; it looks too bright.
4. The _____ of sculpture class elevated her shaping ability.
5. In this book, Edouard Manet was put in the _____ of realism.
6. My girlfriend _____ me that I should study product design.
7. These bronze wares were _____ with clay moulds.
8. It is a dream for those living in the city to have a(n) _____ in the country.
9. Sargent's paintings show great _____, but lack something durable and profound.
10. In art, nude figures should look lively, rather than _____.

III **Choose the best words to fill in the blanks, changing the form when necessary.**

1. structure, structural, construct

 a. In Cézanne's painting, each stroke plays a crucial role in the compositional

 _____.

b. The _____ design of architecture is more the concern of the civil engineers.

c. How can we _____ a building on such porous soil?

2. attitude, altitude, aptitude

a. A good teacher is one who can find his student's _____.

b. The comparison of these two works reveals the changes in artistic _____.

c. The rendering of _____ and distance is difficult in landscape painting.

3. academy, academic, academician

a. You should submit your _____ record when you apply for the university.

b. Most of great artists were not produced in the _____.

c. How can we convince those _____ that this young girl has great aptitude?

4. miss, mission, commission

a. I _____ my childhood friend.

b. The young artist felt so excited to get his first _____ in life.

c. It's really a _____ impossible to finish within one hour!

5. fine, refined, unrefined

a. The Central Academy of _____ Art is often called CAFA.

b. His works look _____, but they are strong, passionate and unrestrained.

c. In Qing Dynasty, Chinese calligraphy became more and more _____, but was gradually losing its vitality.

6. value (v., n.), valuable, evaluate

a. "Your thesis does not contain any _____ information!" The professor said angrily.

b. It's hard to _____ this cultural movement.

c. The art historians decided to _____ what they had previously taken for granted.

d. If you focus on the logical gradation of _____, you may lose your perception for hue or chroma.

IV Translate the following sentences into English.

1. 她力劝收藏者不要拍卖这件作品。（urge to）
2. 在塞尚的画中，结构本身就是主题。（subject matter）
3. 在巴黎的咖啡馆里，他结识了许多评论家。（make the acquaintance of）
4. 颜料与画布不是他的爱好，他喜欢用黏土来表达。（cup of tea）
5. 他试图从民间艺术中吸取营养。（soak up）
6. 赛尚的静物未必很写实，但却有着形体的坚实感。（still life）

V Cloze.

The _____1_____ of Cézanne does not lie only _____2_____ the perfection of single masterpieces; it is also in the quality of _____3_____ whole achievement. An exhibition of works spanning his forty years as a painter reveals a remarkable _____4_____ freedom. The lives of Gauguin and van Gogh have blinded the public to _____5_____ is noble and complete in Cézanne's less sensational, though anguished, career. Outliving these younger contemporaries, more fortunate in _____6_____ impulses and situations dangerous to art, he was able to mature more _____7_____ and to realize many more of his artistic ideas.

1. A. greatness B. great C. greation D. greatly
2. A. on B. in C. to D. of
3. A. he B. him C. his D. himself
4. A. inner B. in C. outer D. out
5. A. that B. what C. why D. when
6. A. overcome B. overcoming C. overcame D. to overcome
7. A. full B. fill C. fully D. filly

Part B　The Post-impressionism of Paul Cézanne

"I want to **make of** impressionism something solid and **durable**." (Cézanne) In his paintings Cézanne set himself an impossible task: establishing an equilibrium between the **vivacious** color and solid form and the two-dimensional picture plane. He sought to achieve illusionistic **solidity** and a strong compositional structure in two dimensions. His frustration with impressionism was **twofold**: impressionist painters did not create paintings that were compositionally strong, and they were not interested in endowing painted objects with three-dimensional solidity.

Cézanne's *Still Life with Basket of Apples* demonstrates his ability to render objects with solidity—note the white **napkin**, with its deep angular folds and **pockets** of shadow. The pieces of fruit have a physical presence that is in part the result of an unexpected richness of color, **exemplifying** Cézanne's **dictum** that "when color is at its richest, form is at its fullest." He modeled the fruit with pure, unmixed colors, **juxtaposing**, for example, yellow with green and red. He thereby created a richer color effect than that produced by the typical academic modeling.

If we analyze *Still Life with Basket of Apples* as an exercise in accurate drawing, it is a failure: neither the front nor the back edges of the table, for example, are continuous; and the **pastries** stacked on the plate seem tilted upward. In Cézanne's work these visual "inaccuracies" reveal the moving viewpoint of the artist relative to objects being painted. The difference in the edges of the table, for example, results because the table edge is seen from lower or higher, closer or farther viewpoints.

The structured pictorial surface Cézanne accomplished is best expressed in his later works, such as *Mont Sainte-Victoire*. Cézanne constructed his painting out of blocks of color and no one area or object is less strong than another. Cézanne urged painters to "see in nature the **cylinder**, the **sphere**, the **cone**," and this painting demonstrates his approach. Surface strength is also accomplished by intermingling blocks of limited color—in this case violet,

green, **ocher,** and blue: the violet of the atmospheric perspective reappears in the foreground, and the green of the middle ground is also found in the sky. When the work is compared to an impressionist painting, such as *Impression-Sunrise*, two completely different effects can be noted. Cézanne has sacrificed the **ravishing,** momentary subtlety of color that forms the foundation of Monet's accomplishment in his attempt to create a landscape that has an enduring strength and power.

Cézanne's painting had an important impact on developments in the twentieth century: Matisse called him the "father of us all".

New Words

durable *adj.* 耐用的，耐久的，持久的

vivacious *adj.* 活泼的，快活的

solidity *n.* 坚实感；可靠性

twofold *adj.* 由两部分组成的，有两部分的

napkin *n.* 餐巾，餐巾纸

pocket *n.* 口袋，钱袋；凹处

exemplify *v.* 是……的典型；举例证明

dictum *n.* 宣言；格言

juxtapose *v.* 把……并置

pastry *n.* 糕点；油酥糕点

cylinder *n.* 圆筒；圆柱

sphere *n.* 球（体）

cone *n.* 圆锥体

ocher *n.* 赭石；赭色

ravishing *adj.* 极其美丽的；迷人的

Phrase

make of 用……做成；使……发展成为

Notes

Still Life with Basket of Apples《有果篮的静物》（塞尚作品）

Mont Sainte-Victoire《圣维克多山》（塞尚作品）

middle ground 中景

Matisse 马蒂斯（法国画家）

Exercises

I **Discuss the following questions (pair work).**

1. In what ways was Cézanne disappointed with impressionism?
2. What did Cézanne use to represent the solidity of form besides academic modeling?
3. Why are the objects in Cézanne's paintings "inaccurate"?
4. How is Cézanne's landscape different from that of Monet?

II **Translate the following sentences into Chinese.**

1. In his paintings Cézanne set himself an impossible task: establishing an equilibrium between the vivacious color and solid form and the two-dimensional picture plane.
2. The pieces of fruit have a physical presence that is in part the result of an unexpected richness of color, exemplifying Cézanne's dictum that "when color is at its richest, form is at its fullest".
3. Cézanne has sacrificed the ravishing, momentary subtlety of color that forms the foundation of Monet's accomplishment in his attempt to create a landscape that has an enduring strength and power.

Space for Illustration

Use your imagination and creativity, and draw an illustration for Part A or B, after which you are supposed to explain in English why you draw it in the way you do.

插图作者：清华大学美术学院 美硕 213 班 焦万程

　　"夫书肇于自然。自然既立，阴阳生焉；阴阳既生，形势出矣。"（《九势》，蔡邕。）在这里，自然不是纯物理性的，而是一种浑然、无际、可感知的大的存在，认知主体（人）就在其中。自然化生出阴阳辩证，而阴阳又化生出艺术的"形式""形态"和"笔势"。这种文化机制和艺术机制使书法超越时代，以一种艺术形式维系着人与天地精神的交融往来。

　　书法包含三个要素：笔法、结体、章法。毫无疑问，笔法是书法的核心。行笔的顺与逆、提与按、疾与涩、取势与铺毫，无不渗透着阴阳辩证。在这种辩证互动之中，在力的转换（传动）之中，一种内生的、绵延不绝的生命性（力）得以生发和运行，而这又成为书法的美感和力量之所在。由此所产生的点画，则有着"肌肤之丽"（似健康的、气血调和的皮肤所焕发出的光彩）。这其实也就是卫夫人所说的"骨、肉、筋、血"（《笔阵图》）。

　　Part A 介绍了笔法的一些基本知识。点是诸多笔画中最为重要的一个，如刘熙载所说："侧（点）之一法，足统余法。"（《书概》）故而点法用了较多的篇幅。文章最后一段选取了林语堂先生翻译的卫夫人《笔阵图》中的段落，这是对于书法审美的生动描述。

　　Part B 阐述书法的哲学维度——阴阳辩证。

Unit 8 Chinese Calligraphy
中国书法

Part A The Brushwork of Chinese Calligraphy

The beauty of Chinese calligraphy does not **lie in symmetry** but in dynamic **asymmetry**. We do not **attach much importance to** printed characters, which, though they are neat and **readable**, are visually **lifeless**. By the way, the great **flexibility** of Chinese brush makes it possible to **invest** the individual strokes of a **character** with life and movement.

Knowledge of brushwork is a key to understanding Chinese calligraphy. Some basic brush-techniques are based on the strokes of Regular Script, such as dot, horizontal and **vertical**.

The dot is the most fundamental of the eight basic stroke types because the method by which dots are created is used to write many other strokes. A Horizontal Stroke, for example, both starts and ends with the brush movement of the dot, so does the beginning of a Vertical Stroke. The dot should be produced mainly by pressing down the brush and lifting it up. The dot can be formed in many different shapes. The most typical dot is **approximately semicircular**. To make such a dot, we should start from the upper left corner with the tip of the brush being **concealed**, press down, and then **launch** the brush using the **resilience** of the **bristles**. Finally, lift it off the paper to end up the stroke.

The Horizontal Stroke often determines the structure and **stability** of the entire character; thus it is important that it be written correctly. When writing a full horizontal line, follow this **procedure**: 1) Start from the upper left corner with the tip of the brush being concealed; press down at approximately a 45-degree angle. 2) Move the bristles rightward to form the main part of the stroke. 3) Lift the brush **slightly** and then press down. 4) Turn the bristles to the left, lifting them to end up the stroke.

The Vertical Stroke is called "Dropping-**Dew**", because the lower part is in the form of a dew-drop and has the appearance of dropping down **in relation to** the **upper** part. Another type of Vertical Stroke is called "**Suspended** Needle",

from its shape.

Generally, every stroke of a character is finished with three steps: first moving slightly to one direction, then turning to the opposite direction for the main part of the stroke, and finally turning again to end up the stroke. This is the so-called "three-fold method".

We have four terms to describe the quality of strokes: Bone, Flesh, **Sinew**, and Blood. Thus Lady Wei said, "In the writing of those who **are skillful in** giving strength to their strokes, the characters are '**bony**'; in the writing of those who are not thus skillful, the characters are 'fleshy'. Writing that has a great deal of bone and very little meat is called '**sinewy**'; and writing that is full of flesh and has weak bones is called 'piggy'. Powerful and sinewy writing is **divine**; witting that has neither power nor sinew is like an **invalid**."

▌New Words

brushwork *n.* 笔法，笔墨，用笔
symmetry *n.* 对称
asymmetry *n.* 不对称；倚侧
readable *adj.* 易读的
lifeless *adj.* 无生命的，无生气的
flexibility *n.* 柔韧性，灵活性
invest *v.* 赋予；使充满
character *n.* 性格；人物；汉字
vertical *adj.* 垂直的 *n.* 垂直线；竖画
approximately *adv.* 近似地，大约
semicircular *adj.* 半圆的
conceal *v.* 隐藏
launch *v.* 发射；（文中指）提笔

resilience *n.* 弹力；回弹
bristle *n.* 鬃毛；笔毫
stability *n.* 稳定（性），稳固
procedure *n.* 手续；步骤
slightly *adv.* 轻微地
dew *n.* 露水
upper *adj.* 上面的
suspend *v.* 挂；悬
sinew *n.* 筋，腱；肌肉
bony *adj.* 骨的，有骨力的
sinewy *adj.* 肌腱的；有力的
divine *adj.* 天赐的；极好的；神圣的
invalid *n.* 病人

▌Phrases

lie in 在于
attach importance to 重视

in relation to 相形于，相对于
be skillful in 善于，精于

Notes

Chinese brush 毛笔
Regular Script 楷书
dot 点
Horizontal Stroke 横
Vertical Stroke 竖

Dropping-Dew 垂露（对"竖"的称谓 / 比喻）
Suspended Needle 悬针（对"竖"的称谓 / 比喻）
three-fold method 三折法
Lady Wei 卫夫人（即卫铄，东晋女书法家）

Grammar

定语从句（The Attributive Clause）（I）

在复合句中担任定语成分的、修饰句中名词或代词的从句称为定语从句。被修饰的名词或代词称为先行词。按照和先行词之间的关系，定语从句可分为以下几类：

1. 用关系代词who，whom引导的定语从句，指人。

1）who在从句中作（逻辑上的）主语。例如：

Guo Xi, **who lived in the eleventh century**, relied on a private ritual.

In the writing of those **who are skillful in giving strength to their strokes**, the characters are "bony".

2）whom在从句中作（逻辑上的）宾语。例如：

Some of his works show the influence of Wu Changshuo, **whom he looked after in his old age**, even arranging his burial.

Below it is Picasso, **whom Rockwell admired greatly** but whose works, he admitted, were opposite to his own.

2. 用关系代词whose引导的定语从句既可以指人，也可以指物，在从句中作（逻辑上的）定语。例如：

There is no better example than that of Vincent van Gogh, **whose works have so captivated our times**.

Below it is Picasso, whom Rockwell admired greatly but **whose works, he admitted, were opposite to his own**.

3. 用关系代词which，that引导的定语从句，一般指物。关系代词在从句中作（逻辑上的）主语、宾语。例如：

Writing **that has a great deal of bone and very little meat** is called "sinewy".

European calligraphy is highly stylized, regular, and decorated with flourishes, **which in themselves are lacking in personal expression**.

4. 用关系副词when，where引导的定语从句，关系副词在从句中作（逻辑上的）状语。

1）when 表示时间，其先行词往往是表示时间的名词（如 time, day, hour, year 等）。例如：

Do you remember the time **when we visited the National Art Gallery**?

The figure, shown as a young man in his prime, is caught by the artist at the moment **when the arm stops its swing backward and prepares to sling forward to release the discus**.

2）where 表示地点，其先行词往往是表示地点的名词（如 place, room, house, street, area 等）。例如：

It is in the home **where these are most personally evident**.

Artistic use of line was a tradition in ancient China **where calligraphy, like painting, was looked on as a fine art**.

5. 用关系副词why引导的定语从句，关系副词在从句中作（逻辑上的）状语。表示原因，其先行词必然是reason。例如：

This is the reason **why this kind of fabric is chosen**.

Exercises

I **Discuss the following questions (pair work).**

1. According to the first paragraph, what kind of stroke is preferred in Chinese calligraphy?

2. The Vertical Stroke is called "Dropping-Dew" and "Suspended Needle". What do these metaphors imply?

3. What is the "divine" calligraphy according to Lady Wei?

II Fill in the blanks with the words given below, changing the form when necessary.

fundamental	resilience	lifeless	bony	character
brushwork	dew	vertical	slightly	sinewy

1. The techniques of calligraphy are collectively referred to as "_____".

2. He copied the manuscript _____ by _____ , which took him more than one week.

3. The Official Script（馆阁体）in Qing Dynasty, in pursuit of standardization, became rather _____ .

4. It's said that the celestial beings lived on drinking _____ .

5. The vertical stroke on the right should be _____ thicker than the one on the left.

6. Liu Gongquan's calligraphy was praised as being "_____", while Yan Zhenqing's work as being "_____".

7. The _____ stroke should be made like reining a horse, with a tension being felt in the downward movement of the bristles.

8. Making use of the flexibility and _____ of the brush, the calligrapher can let force generate in the writing process.

9. Chinese calligraphy has three _____ elements: stroke-techniques (brush-techniques), the structure of characters, and the composition（谋篇布局）.

III Choose the best words to fill in the blanks, changing the form when necessary.

1. calligraphy, calligrapher, calligraphic

 a. Brush, paper, ink, and ink stone are the basic tools of Chinese _____ and Chinese painting.

 b. Qi Baishi is known as a painter, but if we regard him as a _____, he is also worthy of the title.

 c. Pressing down the brush and bringing it up are basic _____ skills.

2. symmetry, asymmetry, symmetrical

 a. The Small Seal's Script in Qin Dynasty is rather _____.

 b. Movement and vitality are often created in _____.

 c. _____ adds to the stability of the composition.

3. read, reader, readability, misreading

 a. This book is intended for the _____ that are interested in fine art.

 b. He is one of the scholars who can _____ oracle bone inscriptions.

 c. The _____ of Han Clerical Script（汉隶）is higher than Qin Clerical.

 d. Due to various reasons, people have a lot of _____ about calligraphy.

4. flex, flexible, flexibility, flexor

 a. You need to _____ bicep to raise your forearm.

 b. When you are practicing calligraphy, you should keep your wrist and elbow suspended, which allows great _____ in manipulating them.

 c. The goat bristles, which are very _____, make a very good material for Chinese brush.

 d. Human muscles can be categorized as _____ and extensors.

5. proximity, approximate, approximately

 a. The historians can just give a(n) _____ time when the stele was set up.

 b. It took him _____ five years to find the whereabouts of that famous manuscript.

 c. When the objects are placed close to each other, this will certainly add to the sense of unity; this kind of visual device is called _____.

6. live (v.), lively, liveliness, life

 a. Modern industry led to the rise of cities, and the increase of urban population, which required lots of low-cost spaces for people to _____ in and work in.

 b. The ukiyo-e prints of the Edo period (江户时代) present the image of a _____ pre-industrial _____, which fascinated the Europeans.

c. The "calligraphic scripts" made by computer are lack of _____.

Ⅳ Translate the following sentences into English.

1. 闻一多不但是一位诗人，而且精于绘画和篆刻。（be skillful in）
2. 书法之美在于笔法和结体，也在于气韵。（lie in）
3. 秦始皇注重文字的统一，这导致了从大篆到小篆的演变。（attach importance to）
4. 这个字看起来不稳定，但它在与其他字的关系中获得了稳定。（in relation to）
5. 这个笔画以藏锋起笔，以露锋收尾。（end with）
6. 从东晋开始，书法被赋予了更多的文化内涵。（invest with）

Ⅴ Cloze.

The right way to hold the brush is: firmly pinch brush shaft（笔杆）by thumb, index finger and middle finger, with ring finger and little finger _____1_____ the hold from behind. Keep wrist and elbow _____2_____, and forearm parallel _____3_____ the surface of desk. Write with manipulating the wrist and the strength of the body.

Your palm should be _____4_____ and hollow, curved enough to hold a small egg. If you squeeze your fingers too tightly toward your palm, you lose _____5_____.

For maximum flexibility, all muscles directly _____6_____ in writing should be relaxed—this includes your fingers, wrists, arms, and shoulders.

1. A. reinforce B. reinforcing C. reinforced D. to reinforce
2. A. suspended B. suspected C. expended D. expected
3. A. to B. of C. in D. on
4. A. loose B. lose C. lost D. loses
5. A. flex B. flexible C. flexibility D. flexor
6. A. evolved B. involving C. involves D. involved

Part B The Yin and Yang of Chinese Calligraphy

The study of Chinese calligraphy is not only a study of Chinese writing. In many ways, it is also a study of Chinese philosophy and Chinese worldview. To the Chinese, the world consists of and operates on two great powers that are **opposing** in nature: yin, similar to a negative force in Western terms; and yang, **analogous** to a positive one. Yin and yang complement each other and come together to form a whole. These two concepts are represented in the Daoist symbol known as the Great Ultimate.

The Daoist philosophy of yin and yang has nurtured and fundamentally determined the character of calligraphy. The pure contrast of black writing on a white background is a perfect **manifestation**.

From classical calligraphy **treatises** to modern-day copy models, descriptions of the techniques of calligraphy are based on elaborations of **a full range of** contrasting concepts, including lift versus press, square versus round, curved versus straight, guest versus host, and **so forth**. In writing practice, the artist manipulates and elaborates on the balance between opposites. The **identification** of writing styles is often based on these concepts.

In writing practice, the contrast and unity of opposites in various dimensions create rhythm of movement. When a piece of writing has rhythm, it has an **innate** flowing vitality that **is of primary importance to** the artistic quality of a piece. Rhythmic vitality gives the piece life, spirit, **vigor**, and the power of expression. With it, a piece is alive; otherwise, it looks dead. The beauty of Chinese calligraphy is essentially the beauty of movement. Rhythm can be found in a single brush stroke, a character, or in an entire composition. When a piece is created with the vital forces of life and rhythm, the result is fresh in spirit and pleasing to the eye.

The Daoist principle of yin and yang represents a dynamic view of the world. Only when yin and yang are in perfect harmony, can the life force travel smoothly and **exert** its vigor.

The way of calligraphy and the way of nature, although differ in **scope,**

share similar principles. Calligraphy best illustrates Daoist philosophy when the brush embodies, expresses, and **magnifies** the power of the Dao. Thus, an adequate understanding of the concept of yin and yang and its manifestations in calligraphy is essential to your grasp of the core of the art.

New Words

opposing *adj.* 相反的，相对的

analogous *adj.* 相似的，类似的

manifestation *n.* 表现，显现；表现形式

treatise *n.* 论述；论文；专著

identification *n.* 辨认，识别；确认

innate *adj.* 内生的

vigor *n.* 活力，精力

exert *v.* 运用，施加

scope *n.* 范围，领域

magnify *v.* 放大，扩大

Phrases

a range of 一系列；一套

so forth 之类的；等等

be of importance to 对……很重要

Notes

Great Ultimate 太极图

copy model 字帖

Exercises

I **Discuss the following questions (pair work).**

1. What are the "counterparts" of yin and yang in Western culture?

2. What is the relationship between the philosophy of yin and yang and Chinese calligraphy?

3. What contrasting concepts in Chinese calligraphy reflect the philosophy of yin and yang?

Ⅱ **Translate the following sentences into Chinese.**

1. From classical calligraphy treatises to modern-day copy models, descriptions of the techniques of calligraphy are based on elaborations of a full range of contrasting concepts, including lift versus press, square versus round, curved versus straight, guest versus host, and so forth.

2. When a piece of writing has rhythm, it has an innate flowing vitality that is of primary importance to the artistic quality of a piece.

3. An adequate understanding of the concept of yin and yang and its manifestations in calligraphy is essential to your grasp of the core of the art.

Space for Illustration

Use your imagination and creativity, and draw an illustration for Part A or B, after which you are supposed to explain in English why you draw it in the way you do.

油画《我轻轻地敲门》（俞晓夫作品）

　　清末民初，面临所谓"三千年未有之大变局"，中国文化感受到前所未有的挑战与恐慌，中国画自然也在其中。以徐悲鸿、林风眠为代表的一些画家走向了学习西方、中西结合的道路。还有一些画家在持守中国绘画传统，并对外来的冲击做出了回应，这尤以"海上画派"的任伯年、赵之谦、吴昌硕、黄宾虹等人为代表。他们的画与中国传统绘画一脉相承，但新的时代又激发出一种大气、雄强与活跃。此外，自清代中期以来书法领域"碑学"的兴盛，又天然地为这种改变提供了笔墨上的准备。

　　回望这一段历史，中国文化在绘画领域又一次印证了其坚韧的生命力；而中国的画家们也以自己的求索和才华，向历史提交了一份令人满意的答卷。

　　Part A 的文章叙述清末民初中国传统绘画的状况和变化，涉及任伯年、吴昌硕、黄宾虹、赵之谦、齐白石等画家。

　　Part B 专门介绍吴昌硕的生平、轶事、画风，及其弟子王一亭和王个簃。

Unit 9

Traditional Chinese Painting in Modern China
近代中国的传统中国绘画

Part A The Inheritance and Revival of Traditional Chinese Painting

By the nineteenth century, the **literati** of China had become victims of the growing **paralysis** of Qing's culture, and there were few outstanding painters. After the middle of the nineteenth century there came a gradual change. The style of Ren Bonian, the most interesting of the Late Qing artists, **owed part of its vigor to** an **infusion** from popular art, part to the new **restless** spirit that was then **abroad** in the prosperous **coastal** cities.

In Shanghai, where Ren Bonian lived, the impact of European civilization was beginning to be felt. It showed itself in painting less in any change of style than in a new energy and boldness, which was perhaps the **unconscious** answer of the literati to the challenge of Western art. This new spirit **burst forth** in **a handful of** late followers of the Yangzhou School, such as Zhao Zhiqian, a distinguished scholar noted for his paintings of **vines** and flowers **amid** rocks, whose compositions and brush techniques were to influence the modern master Qi Baishi. Zhao's follower Wu Changshuo was a prolific painter chiefly of bamboo, flowers and rocks, which he combined with calligraphy in compositions of considerable power. The heavy, **emphatic** ink and strong color that these artists employed come as a **refreshing** contrast to the timid good manners of earlier generations.

Among the twentieth-century artists who may have been **provoked into** a **reassertion** of traditional styles were Huang Binhong, Qi Baishi and Zhang Daqian. Huang Binhong was one of the last of the Xin'an School landscape painters. He led the busy life between Shanghai and Peking, as painter, teacher, art historian and **connoisseur**, developing a style that became more and more daring and **expressionistic** as he approached old age. From a very different **milieu** came Qi Baishi, son of a small **tenant**-farmer in Hunan, who by talent and **sheer** determination became a dominating figure among painters in Peking,

expressing himself with great boldness and simplicity. In his sixties he painted some very original landscapes, but he **is best known for** his late paintings, chiefly of birds and flowers, crabs and shrimps, which he **reduces to** essentials while **miraculously** preserving their inner life.

A far more **versatile** and **sophisticated** figure is the painter, collector, and connoisseur Zhang Daqian. While in the landscapes of his later years he made bold experiments in ink-**splashing** that reflect the influence of abstract expressionism. He always remained a **traditionalist** at heart; in his dress and **bearing** he seemed like a **survival** from another age.

It might be thought that **westernization** in the first half of the twentieth century would have **dealt** traditional Chinese art the same **crippling** blow that had struck Japanese art in the nineteenth century. This did not happen, partly because of the **overpowering** strength of the tradition itself and the cultural self-confidence of the educated class; partly because "fine art" was in the **custody** of amateurs and was kept separate from their professional lives. Their work and milieu might change, but when they took up the brush, it was still to express themselves in the language of Dong Qichang and Wang Hui. Such was their belief in the **validity** of the tradition, moreover, that they could take what they wanted from Western art without **surrendering** to it.

New Words

literati *n.* 文人

paralysis *n.* 瘫痪；麻痹，僵化

infusion *n.* 灌输

restless *adj.* 不平静的，不安宁的

abroad *adj.* 到处的，广泛的 *adv.* 到国外，在海外

coastal *adj.* 海岸的，沿海的

unconscious *adj.* 无意识的

vine *n.* 蔓生植物；藤，蔓

amid *prep.* 在……中

emphatic *adj.* 用力的；显著的；断然的

refreshing *adj.* 提神的；使人喜欢的

reassertion *n.* 再主张

connoisseur *n.*（艺术品的）鉴赏家，鉴定家

expressionistic *adj.* 有表现派作风的

milieu *n.* 氛围，环境

tenant *n.* 承租人；佃农

sheer *adj.* 全然的；纯粹的；绝对的

miraculously *adv.* 奇迹般地

versatile *adj.* 多才多艺的；博学多才的

sophisticated *adj.* 复杂的；老于世故的

splash *v.* （使）溅起；泼（水）

traditionalist *n.* 传统主义者

bearing *n.* 举止，做派

survival *n.* 幸存者；遗民

westernization *n.* 西方化，欧美化

deal *v.* 给予

cripple *n.* 跛子 *v.* 削弱

overpowering *adj.* 压倒性的

custody *n.* 保管；掌控

validity *n.* 正确性

surrender *v.* 投降；自首

Phrases

owe to 把……归功于

burst forth 喷出；迸发

a handful of 一把，几个

provoke... into... 激发，激起……做……

be known for 因……而著名

reduce to 使……降低到；使……简化为

Notes

Ren Bonian 任伯年

Yangzhou School 扬州画派

Zhao Zhiqian 赵之谦

Wu Changshuo 吴昌硕

Zhang Daqian 张大千

Xin'an School 新安画派

ink-splashing 泼墨

Abstract Expressionism 抽象表现主义

Dong Qichang 董其昌

Wang Hui 王翚（清代画家）

Grammar

动词不定式（The Infinitive）（Ⅱ）

1. 不定式短语在句子结构中充当的成分（续）：

1）作宾语补足语。例如：

His banker father wanted him **to study law**.

Looking at the stars always makes me **dream**.

We need to incorporate tools in our design process that help us **to solve their problems in a successful business way**.

2）作主语补足语。例如：

Graphic designers are asked **to perform** the difficult task of being creative every

single day.

Although his best period was said **to be** between 1905 and 1915, his painting was always fresh and vigorous, raising the Shanghai School to a new level of achievement.

2. 动词不定式的被动式和完成式：

1）动词不定式的被动式

如果动词不定式逻辑上的主语是不定式所表示的动作的承受者时，一般要用被动式：

to be + 过去分词

例如：

Everything was stored in the memory, **to be released** later during an act of creativity.

In Shanghai, where Ren Bonian lived, the impact of European civilization was beginning **to be felt**.

2）动词不定式的完成式

动词不定式所表示的动作发生在谓语动词所表示的动作之前时，往往用完成式：

to have + 过去分词

例如：

Unlike Rockwell, all four artists produced numerous formal self-portraits—Rembrandt is known **to have done** more than 90.

3）被动式的完成式：

to have been + 过去分词

例如：

Those people were jestingly said **to have been born** in a pre-scientific age.

3. 动词不定式的复合结构：

1）带连接代词或连接副词的不定式的复合结构。例如：

What to do next is the present problem.（主语）

Renoir said that he was just beginning to learn **how to paint**.（宾语）

When just starting out, a student may not know **where to begin**.（宾语）

People with style seem to know **when to stop** just short of excess.（宾语）

2）"for... to..."复合结构：for 后面的名词或代词是不定式的"逻辑上的主

语"。例如：

Art is simply a path **for artists to vent their yearning**.（定语）

It is very important **for us to understand** the internal logic of language.（主语）

注意：

作主语补语的不定式只可能在被动语态的句子中出现，如果将其还原为主动语态，该不定式短语就成了宾语补足语。

动词不定式的被动式、完成式、被动式的完成式、复合结构在属性上仍是动词不定式。因此，它们在句子中的功能等同于一个普通的动词不定式的功能。

Exercises

I **Discuss the following questions (pair work).**

1. According to the text, what added to the vigor of Ren Bonian's art?

2. What are the subject matters of Wu Changshuo?

3. What kind of paintings is Qi Baishi best known for?

II **Fill in the blanks with the words given below, changing the form when necessary.**

abroad	coastal	surrender	vine	paralysis
survival	restless	connoisseur	reassertion	refreshing

1. The galloping horses painted by Xu Beihong made a(n) _____ change to the traditional way of painting animals.

2. The treasures of Dunhuang kept being smuggled _____ at the end of Qing Dynasty.

3. Our history saw the _____ of Confucianism time and again.

4. It's said that Zheng He's fleet reached the African _____ kingdoms.

5. In his prose and poetry, Gong Zizhen (龚自珍) harshly criticized the _____ of Qing's politics and culture.

6. Xu Wei (徐渭) was admired for the _____ that he painted.

7. The used-to-be official of Qing Dynasty became a famous _____ in the Republic Time.

8. Those _____ of Ming Dynasty would rather die or become monks than _____ to the Manchurians.

9. A(n) _____ atmosphere was abroad in the South of China before the Wuchang Uprising (武昌起义).

Ⅲ **Choose the best words to fill in the blanks, changing the form when necessary.**

1. conscious, unconscious, consciousness, subconsciousness

 a. What surrealism focuses on is man's _____.

 b. Stream of _____ is a device that modernist writers would like to use.

 c. They were _____ of the change, yet they were holding to their own values.

 d. We call the Crystal Palace a modern building, but that kind of modernity was very _____.

2. emphasis, emphasize, emphatic

 a. Mary Cassatt's _____ shifted from 3D form to line and pattern.

 b. Rodin's sculpture _____ the physical features of individual.

 c. His heavy, _____ stroke are based on his study of seal's script and clerical script.

3. valid, invalid, validity

 a. The accessible design is specially done for the aged, the _____ and children.

 b. After World War I, the machinery aesthetic was gradually accepted by the public and obtained its _____.

 c. Man's aesthetic keeps changing, and no taste is eternally _____.

4. express, expression, expressionism, expressionistic

 a. His style evolved formally towards _____, without precise forms but with vivid colors.

 b. Zhang Daqian painted a series of striking _____ works in

which ink and strong mineral colors merge with, repel, or fight against one another.

c. The cultural movement swept the country as an _____ of the nation's self-awareness.

d. It's no good to spend all your time copying; you should use your brush to _____ your own feelings.

5. literati, literate, literature, transliteration

a. The word "摩登" is the _____ of "modern".

b. Wang Wei is recognized as the originator of _____ painting.

c. How do you think about "the web _____"?

d. After 1949, the _____ population mounted up steadily.

6. miracle, miraculous, miraculously

a. Those murals were _____ preserved well.

b. It is a _____ to finish such a great project in such a short time.

c. Art is not to seek for something _____, but something true and beautiful.

Ⅳ Translate the following sentences into English.

1. "野火烧不尽，春风吹又生。"（burst forth）
2. 俞晓夫先生是在以这幅油画向几位海派画家致敬。（a handful of）
3. 日本的入侵使他们奋起为抗战进行创作。（provoke... into... ）
4. 伦勃朗因画自画像而著名，据说他画过 90 多幅。（be known for）
5. 工业化使得工人成为机器的附庸。（reduce to）
6. 在某种程度上，艺术的繁荣归因于城市化和文化消费。（owe to）

Ⅴ Cloze.

In 1864, Shanghai was _____1_____ its way to _____2_____ the richest city in China not only in material wealth but also in private art collections and enthusiastic patrons. Literary and artistic societies flourished as the _____3_____ rich and the lower gentry surrounded themselves with the culture of the literati and the official class. A _____4_____ school of painting, variously called Hai Pai, grew

up on foundations laid early in the nineteenth century. _____5_____ in Yangzhou a century earlier, artists strove both to satisfy and to educate their patrons, who had no taste for the _____6_____ of the Four Wangs. They wanted pictures that were enjoyable and easy to understand.

1. A. in B. for C. on D. by
2. A. becoming B. become C. became D. becomes
3. A. new B. newly C. news D. renew
4. A. vigerous B. vigorously C. vigor D. vigorous
5. A. For B. As C. But D. While
6. A. academia B. academician C. academicism D. academy

Part B Wu Changshuo and His Students

"Wu in the South, and Qi in the North" —the **parallel** is apt **up to a point**, for both Wu Changshuo and Qi Baishi played dominant roles in their own art worlds.

Wu Changshuo had begun to learn to paint as a **pastime** in 1877, from a painter who had also taught Ren Bonian. But like so many gentlemen after the 1911 Revolution, when the Confucian **bureaucracy** was **virtually** destroyed, he came to live by his brush as a calligrapher (chiefly as a master of the "stone drum" seal script of the early Zhou Dynasty), as a painter, and as a **carver** of seals, an art in which he already had a great reputation. When the Xiling Seal Engraving Society was **revived** in Hangzhou in 1903, he was the natural person to be elected as its first president.

Wu Changshuo was greatly admired in Japan. During the chaotic weeks of Chiang Kai-shek's takeover of Shanghai in 1927, Wu **took refuge** with his pupil Wang Geyi in Hangzhou. One day they went together to the Xiling Hill, home of the famous society he had helped to found, where they were astonished to see people **kowtowing** and burning incense before a bronze image. This was no Buddha but a bust of Wu Changshuo himself, **fashioned** by the prominent academic Japanese **sculptor** Asakura Fumio.

Wu Changshuo had none of Ren Bonian's natural facility in painting, but he was a powerful artist who used the strong color and forms typical of the Shanghai School to structure compositions based on the calligraphic brushstrokes. His earlier work is richly colorful, but as he grew older his brushwork became harder and drier. Although his best period was said to be between 1905 and 1915, his painting was always fresh and **vigorous**, raising the Shanghai School to a new level of achievement.

Wu Changshuo's influence was great and his pupils many. Among the best of Wu's students was Wang Yiting, who began life as an apprentice in a picture **mounting** shop and became a very successful merchant and a generous supporter of artists in Shanghai. As a painter, he was thoroughly **eclectic**. Some of his works show the influence of Ren Bonian; others of Wu Changshuo, whom he looked after in his old age, even arranging his **burial**.

Wang Geyi became Wu Changshuo's pupil only three years before Wu's death. He remained with the family for seven years, acquiring so intimate a **familiarity** with Wu's style and his collection of antiques, paintings, and calligraphy that it was said that the **mantle** of the master had fallen on his shoulders. As a highly accomplished artist, he had a long career teaching in Shanghai.

New Words

parallel *n.* 平行线；类比

pastime *n.* 消遣，娱乐

bureaucracy *n.* 官僚机构

virtually *adv.* 事实上，实质上

carver *n.* 雕刻匠，雕工

revive *v.* （使）苏醒，（使）复兴，（使）复活

kowtow *v.* 磕头，叩头

fashion *v.* 造，塑造

sculptor *n.* 雕塑家

vigorous *adj.* 精力旺盛的；有力的，健壮的

mount *v.* 装裱，裱（画）

eclectic *adj.* 折中的；多元的

burial *n.* 下葬；葬礼

familiarity *n.* 熟悉；通晓

mantle *n.* （某一职业或要职的）责任；衣钵

Phrases

up to a point 在一定程度上

take refuge 避难

Notes

1911 Revolution 辛亥革命
"stone drum" seal script 石鼓文
Xiling Seal Engraving Society 西泠印社
Chiang Kai-shek 蒋介石
Wang Geyi 王个簃

Xiling Hill 西泠山
Asakura Fumio 朝仓文夫（日本雕塑家）
Shanghai School 海上画派（上海画派）
Wang Yiting 王一亭（画家、实业家）

Exercises

I **Discuss the following questions (pair work).**

1. Why was Wu Changshuo elected as the first president of Xiling Seal Engraving Society when it was revived in Hangzhou in 1903?

2. Who made the bust of Wu Changshuo on the Xiling Hill?

3. What was Wang Yiting's other identities besides being a painter?

II **Translate the following sentences into Chinese.**

1. "Wu in the South, and Qi in the North"—the parallel is apt up to a point, for both Wu Changshuo and Qi Baishi played dominant roles in their own art worlds.

2. One day they went together to the Xiling Hill, home of the famous society he had helped to found, where they were astonished to see people kowtowing and burning incense before a bronze image.

3. Some of his works show the influence of Ren Bonian; others of Wu Changshuo, whom he looked after in his old age, even arranging his burial.

Space for Illustration

Use your imagination and creativity, and draw an illustration for Part A or B, after which you are supposed to explain in English why you draw it in the way you do.

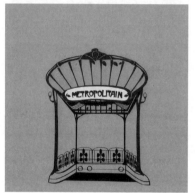

插图作者：清华大学美术学院 美26班 于梦淼 李鑫

　　工业革命（或：工业化）是设计的引擎，它推动了设计史的前行，左右了现代设计的形态，并造就了新的工业美学。理解工业革命是研究现代设计史的一把钥匙。

　　19世纪后半叶至第二次世界大战之前是设计史最具戏剧性的、最为精彩的阶段。这体现为数次大的设计运动和事件，包括1851年伦敦世博会、工艺美术运动、新艺术运动、现代主义运动。它们折射出突如其来的工业化和人、文化、时代之间的矛盾冲突以及这些矛盾冲突的解决和妥协。设计史就是在这个"提出问题—解决问题"的过程中得以生成的。

　　Part A 介绍工艺美术运动和新艺术运动。

　　Part B 以社会改革为切入点，概述了现代主义运动的前因后果。

10 Design Movements
设计运动

Part A The Great Exhibition, Arts and Crafts Movement, and Art Nouveau

The Great Exhibition 1851

The Great Exhibition was held in 1851 in the famous Crystal Palace in Hyde Park, London. One of its key **instigators**, Queen Victoria's husband, Prince Albert, wanted the **manufacturers** to use good design in their products. Many manufacturers spent a lot of efforts, for the first time, to use good design to **show off** their products.

The Great Exhibition became a **catalyst** for Industrial Design and was the start of the Arts and **Crafts** movement.

Arts and Crafts movement

During the early part of the Industrial Revolution, it was natural for manufacturers to use the **ever-increasing** technological advances to produce more, for greater **profit**. The products looked like they did because that's how they were made. The role of good artistic design was never felt to be important, as it cost time and money and manufacturers had little **competition** throughout the world. On the other hand, the decoration was often over **elaborate** with mixed styles from **previous** ages. What's more, the **mass produced** products lacked vitality and creativity compared with handcrafts, and **mass production** itself was an **alienation** of humanity, as was observed by some intellectuals and artists.

A group of artists **reacted against** these poorly designed products and **started up** the Arts and Crafts movement. They wanted to create a style that reflected the old ideals of **craftsmanship**.

In 1861, William Morris started up a design company to produce **handcrafted** furniture, **metalwork**, **jewelry**, **textiles** and his famous styles of **wallpaper**. His designs **recaptured** the beauty and quality of **medieval**

craftsmanship. This movement failed, however, because it was looking backwards and had no way of **transforming** itself into modern styles. It **was not practical, not suitable for** mass production and was only available to the wealthy.

The Arts and Crafts movement was mainly a British movement. Other countries, especially European countries and USA used its ideas and developed them into their own style called "Art Nouveau".

Art Nouveau 1890—1910

The name "Art Nouveau" was taken from the name of the shop (La Maison d' Art Nouveau) opened by the art **dealer** Samuel Bing in Paris in 1895.

Art Nouveau was a decorative style **applied to** the surface of products ranging from buildings to tea pots, posters and wallpapers. It **is characterized by** its **curving** lines and organic forms. The Art Nouveau designers were heavily influenced by the Arts and Crafts movement but used their flowing lines to show the **extraordinary** energy of this period. Two of the most famous products of this time were the lamps made by Louis Tiffany in America and the Paris **Metro** Stations by Hector Guimard.

By the time of the First World War, the Art Nouveau style had **faded** from **popularity**. Designers had come to understand materials and processes and now realized that there was much more to the mass-produced products than just surface decoration.

▌New Words

instigator *n.* 煽动者

manufacturer *n.* 制造商

catalyst *n.* 催化剂

craft *n.* 工艺，手艺

ever-increasing *adj.* 不断增长的，不断提高的

profit *n.* 利润；益处，得益

competition *n.* 竞争，竞赛

elaborate *adj.* 精心制作的；详细阐述的

previous *adj.* 在前的，早先的

mass produce *v.* 大规模生产，规模化生产

mass production *n.* 大规模生产，规模化生产

alienation *n.* 异化

craftsmanship *n.* 技能，技术

handcrafted *adj.* 手工的，手工艺的

metalwork *n.* 金属工艺

jewelry *n.* 首饰

textile *n.* 纺织品

wallpaper *n.* 壁纸，墙纸

recapture *v.* 拿回，夺回，重获

medieval *adj.* 中世纪的

transform *v.* 转换，改变；改造；使……
变形

practical *adj.* 实际的；实践的；实用的

dealer *n.* 经销商，商人

curving *adj.* 弯曲的

extraordinary *adj.* 特别的，非凡的

metro *n.* 地下铁道

fade *v.* 褪色；枯萎，凋谢

popularity *n.* 普及，流行

Phrases

show off 炫耀，卖弄；使显眼

react against 反抗

start up 发动，开动

be suitable for 适合于

apply to 将……应用于

be characterized by ……的特点在于，
……的特点是

Notes

Great Exhibition 1851年伦敦世博会

Crystal Palace 水晶宫

Hyde Park 海德公园

Queen Victoria 维多利亚女王

Prince Albert 阿尔伯特亲王

Arts and Crafts movement 工艺美术运动

William Morris 威廉·莫里斯

Art Nouveau 新艺术运动

La Maison d' Art Nouveau 新艺术之家

Samuel Bing 塞缪尔·平（法国画商、设
计师）

Louis Tiffany 路易斯·蒂凡尼

Hector Guimard 何克特·吉玛德（法国设
计师）

Grammar

分词（The Participle）（Ⅰ）

作为动词非谓语形式，分词的作用相当于形容词或副词，在句子结构中充
当定语、表语或状语等。它仍保留着动词的某些特征，如可以有自己的宾语、
状语等。分词连同其（逻辑上的）宾语、状语等一起构成分词短语。

1. 形式：

动词原形＋ing，及特殊形式
动词原形＋ed，及特殊形式

2. 现在分词与过去分词的区别：

两者的区别主要表现在语态和时间关系上。现在分词表示主动的动作，过去分词表示被动的动作。其次，现在分词表示进行状态的动作，而过去分词表示完成状态的动作。例如：

interesting light effect　　有趣的光影效果

interested audience　　感兴趣的观众

an **aging** actress　　正在变老的女演员

an **aged** actress　　已经变老的女演员

3. 分词及分词短语在句子结构中充当的成分：

1）作定语

分词作定语时，相当于一个形容词，一般放在所修饰词的前面，但分词短语作定语时，一般放在所修饰词的后面，作后置定语。例如：

前置定语：

a **moving** dot

Shouldn't the **shining** dots of the sky be as accessible as the black dots on the map of France?

They can form empty or **filled** shapes.

It was often over elaborate with **mixed** styles from previous ages.

When the war came, it gave Brandt new kinds of contrast, new kinds of **jarring** detail: **living** people lying in crypts meant for the dead.

后置定语：

In five and a half months over six million people visited the exhibition **held in the famous Crystal Palace** in Hyde Park, London.

Complementary colors **placed next to one another** will make one another appear brighter.

The name "Art Nouveau" was taken from the name of the shop **opened by the art dealer Samuel Bing** in Paris in 1895.

Art Nouveau was a decorative style **applied to the surface of products ranging**

from buildings to tea pots, posters and wallpapers.

2）作表语

分词作表语时，表示主语的特征或状态，不表示主语的动作（不是进行时态）。例如：

Lines can be straight, **curved**, or organic.

The extreme social contrasts during those years before the war were, visually, very **inspiring** for me.

The things the lens saw were so **distorted** that they were abstractions even before Brandt printed them.

3）作状语

分词作状语时，修饰谓语动词所表示的动作，其逻辑上的主语就是句子的主语。分词和句子主语之间的关系决定使用现在分词还是过去分词。

a. 时间状语

Mixed together, they can form neutral colors.

b. 原因状语

Deciding that there was little future under the regime in Hungary, he left home at 18 and found a job as a darkroom apprentice with a Berlin picture agency.

c. 方式状语

Using the richness of Capa, Gerda sold each of his photos for 150 francs and more.

Exercises

I **Discuss the following questions (pair work).**

1. Why wasn't good artistic design felt to be important during the early part of the Industrial Revolution?

2. Why did the Arts and Crafts movement turn out to be a failure?

3. What are the most famous products of Art Nouveau?

4. When did the Art Nouveau style lose its popularity?

II Fill in the blanks with the words given below, changing the form when necessary.

manufacturer	catalyst	alienation	fade	metalwork
popularity	dealer	wallpaper	elaborate	process

1. William Morris designed the _____ for his "Red House", which turned out to be a major product in his design company.
2. The relationship between the _____, the _____, and the consumer is the essential of economics.
3. A good designer has to take the producing _____ into consideration.
4. If the design is too _____, it often means the increase of cost.
5. I own a(n) _____ produced in the Art Nouveau period, which is a leaf-like ash tray.
6. The _____ of an art form may let us ignore its artistic value, such as the posters and illustrations in the Art Nouveau period.
7. The Second World War was a(n) _____ for the growth of military design.
8. Labor-division can raise the efficiency of labor, but it also leads to the _____ of humanity.
9. Colors _____ as they recede into the depth of space.

III Choose the best words to fill in the blanks, changing the form when necessary.

1. craft, craftsman, craftsmanship, handicraft
 a. Objects were made through _____ before the Industrial Revolution.
 b. The Arts and _____ movement was in a way a reaction against industrialization.
 c. In the 19th century, with the booming of industrialization, scores of _____ lost their jobs, and came down to the world.
 d. The chair was admired for its _____ and design.
2. media, meditate, medieval
 a. Hamlet _____ about the question of "To be, or not to be".

 b. To communicate a message through certain _____ is the essence of visual communication design.

 c. The pre-Raphaelite painters wanted to go back to the _____ Age.

3. compete, competition, competitive

 a. To _____ with other European countries, Germany quickened its pace of industrialization.

 b. There is a _____ situation between the two art academies.

 c. Free _____ contributes to the improvement of design.

4. history, historic, historical, prehistoric

 a. There is no denying that walking in outer space is quite _____.

 b. Watching _____ movies is his cup of tea.

 c. He intended to unveil the _____ civilization of this area.

 d. _____ is never linear, but intricate and complex.

5. modern, modernist, modernism

 a. The world started to be _____ after 1851.

 b. _____ design is based on industrial aesthetics or mechanical aesthetics.

 c. When we talk about _____, we can't avoid mentioning Frank Lloyd Wright and Mies van der Rohe.

6. produce, product, productive, mass production

 a. Inspired by the movements of leopard, he designed the new _____.

 b. The times _____ the Nazis, a political organization which advocated nationalism, centralization and monocracy.

 c. Mondrian was a _____ painter; people can see his tri-colored compositions everywhere in the world.

 d. _____ requires two things: systemization and standardization.

Ⅳ Translate the following sentences into English.

1. 有人说埃菲尔铁塔的建造是为了向世界炫耀法国的钢铁工业。(show off)

2. 约翰·拉斯金写了许多书，反对工业化对人的异化。（react against）

3. 他们着手创立一所设计学校，培养新型的设计人才。（start up）

4. 新艺术运动的特征在于自然主义和东方情调。（be characterized by）

5. 有机形往往不适合于规模化生产。（be suitable for）

6. 福特主义（Fordism）被应用于几乎所有的工业生产之中。（apply to）

Ⅴ **Cloze.**

The design of products has come a very long way and the role of the industrial designer is now ____1____ valued. The ____2____ components of many products are very similar if not the same. The mobile phone uses a mass produced chip available to any ____3____. There are not that many different types of batteries. It is the designer's task to package these internal components into a unique ____4____. To do this they have to know all about the ____5____ processes of production, the artistic values of color, shape and form, the functionality of the product (ergonomics) and ____6____ of the user (marketing). This has been going on for the last one hundred and fifty years.

1. A. high B. hi C. hilly D. highly

2. A. international B. internal C. external D. internet

3. A. manufacture B. manufacturer C. manufactured D. manual

4. A. producer B. production C. produce D. product

5. A. technical B. technique C. technology D. technically

6. A. politics B. profile C. policy D. process

Part B　The Bauhaus

The Bauhaus was founded in 1919 in the city of Weimar by German architect Walter Gropius. He developed a **curriculum** that would turn out designers capable of creating useful and beautiful objects appropriate to the new system of living.

The Bauhaus combined elements of both fine arts and design education. The curriculum **commenced with** a **preliminary** course that **immersed** the

students, who came from a diverse range of social and educational backgrounds, in the study of materials, color theory, and formal relationships **in preparation for** more specialized studies. This preliminary course was often taught by visual artists, including Paul Klee, Wassily Kandinsky, and Josef Albers, and so on. Then, students entered specialized workshops, which included metalworking, **cabinetmaking**, weaving, pottery, typography, and wall painting. Gropius established the goals of the Bauhaus in 1923, stressing the importance of designing for mass production. It was at this time that the school adopted the slogan "Art into Industry".

In 1925, the Bauhaus moved from Weimar to Dessau, where Gropius designed a new building to house the school. This building contained many features that later became **hallmarks** of modernist architecture, including **steel-frame construction**, a **glass curtain wall**, and an asymmetrical, **pinwheel** plan, throughout which Gropius distributed studio, classroom, and **administrative** space for maximum efficiency and spatial logic.

The cabinetmaking workshop was one of the most popular at the Bauhaus. Under the direction of Marcel Breuer from 1924 to 1928, this studio **reconceived** the very essence of furniture, often seeking to **dematerialize** conventional forms such as chairs to their minimal existence. Breuer **theorized** that eventually chairs would become **obsolete**, replaced by supportive columns or air. Inspired by the steel tubes of his bicycle, he experimented with metal furniture, ultimately creating lightweight, **mass-producible** metal chairs.

The textile workshop created abstract textiles suitable for use in Bauhaus environments. Students studied color theory and design as well as the technical aspects of weaving. Fabrics from the weaving workshop were **commercially** successful, providing vital and much needed funds to the Bauhaus.

During the **turbulent** and often dangerous years of World War II, many of the key figures of the Bauhaus **emigrated** to the United States, where their work and their **teaching philosophies** influenced generations of young architects and designers. Marcel Breuer and Joseph Albers taught at Yale, Walter Gropius went to Harvard, and Moholy-Nagy established the New Bauhaus in Chicago in 1937.

New Words

curriculum *n.* 课程，课程设置

commence *v.* 开始，着手

preliminary *adj.* 预备的，初步的

immerse *v.* 沉浸，使陷入

cabinetmaking *n.* 家具制作

hallmark *n.* 特点，标志

pinwheel *n.* 轮转焰火；纸风车

administrative *adj.* 管理的，行政的

reconceive *v.* 重构；重新认识

dematerialize *v.* 消解；（使）非物质化

theorize *v.* 建立理论

obsolete *adj.* 荒废的；陈旧的

mass-producible *adj.* 可规模化生产的

commercially *adv.* 在商业上

turbulent *adj.* 狂暴的，激荡的

emigrate *v.*（使）移民

Phrases

commence with 以……开始

in preparation for 为……准备

steel-frame construction 钢架结构

glass curtain wall 玻璃幕墙

teaching philosophy 教学理念

Notes

Bauhaus 包豪斯

Weimar 魏玛（德国城市）

Walter Gropius 瓦尔特·格罗皮乌斯

Paul Klee 保罗·克利

Wassily Kandinsky 瓦西里·康定斯基

Josef Albers 约瑟夫·阿尔伯斯

Dessau 德骚（德国城市）

Marcel Breuer 马塞尔·布劳耶

Yale 耶鲁大学

Harvard 哈佛大学

Moholy-Nagy 莫霍利·纳吉

Chicago 芝加哥

Exercises

I **Discuss the following questions (pair work).**

1. What were taught in the preliminary course of the Bauhaus?

2. What are modernist features of the Bauhaus building in Dessau? (or: What made the building modern?)

3. Who was the director of the cabinetmaking workshop of the Bauhaus?

II Translate the following sentences into Chinese.

1. Then, students entered specialized workshops, which included metalworking, cabinetmaking, weaving, pottery, typography, and wall painting.

2. Under the direction of Marcel Breuer from 1924 to 1928, this studio reconceived the very essence of furniture, often seeking to dematerialize conventional forms such as chairs to their minimal existence.

3. Fabrics from the weaving workshop were commercially successful, providing vital and much needed funds to the Bauhaus.

Space for Illustration

Use your imagination and creativity, and draw an illustration for Part A or B, after which you are supposed to explain in English why you draw it in the way you do.

插图作者：清华大学美术学院 美88班 何绍同

　　19世纪的美国还远远不是我们今天所看到的美国，与欧洲相比，社会风尚十分保守。一位年轻女性不顾一切地投身艺术，这对于当时的美国人来讲几乎是不可想象的。然而，这位女性冲破重重阻碍，行至她所向往的艺术的彼岸。她就是玛丽·卡萨特。

　　卡萨特是一位人物画家，她笔下的女性形象，一反以往的男性视角下的人物塑造，而是她们本然的样子，是她们自己。这使得她的作品在同时代的女性肖像画中显得卓尔不群。

　　Part A 是一篇饶有趣味的文章，语言幽默，它记述了玛丽·卡萨特说服父母、求学巴黎的故事。

　　Part B 概述了玛丽·卡萨特的生平、作品、艺术风格等。

Unit 11 Mary Cassatt
玛丽·卡萨特

Part A **Nice Girls Don't Become Artists**

Some things never change. For generations parents have been **dismayed**, even **downright hostile**, when their children have expressed an interest in **pursuing** careers as artists. "Why don't you choose something that's **gonna** pay a **decent** wage?" "Get a real job." "Art may be okay as a hobby, but you'll never earn a living at it." "You're good, but you're not that good." Sound familiar? How about, "Nice girls don't go running off to Paris to study art. You should find a good man, get married, **settle down**, raise some kids..." Those words, or something to that effect, were **no doubt** ringing in the ears of an attractive young Pennsylvania girl shortly after she announced to her **horrified** parents that four years of study at the Academy of Fine Arts in Philadelphia were not enough, and she wanted to go to Paris and study the old masters.

Mary Cassatt's parents **weren't overly afraid of** her choosing art over marriage but her running off to Paris was downright **scandalous**. It wasn't that they couldn't afford it. They could. It was the thought of their daughter alone, in a **faraway** country, in a city widely known for its **immoral** character, and **fraternizing** with some of the most **notoriously** immoral types on earth—artists. Mary **got her way though**, but not without some rather **stiff concessions**. Her mother went with her, to make sure she was properly "**established**", in a good home, **enrolled** in a **reputable** school, and didn't mix with the wrong kind. She began her studies in the workshop of an **upstanding** academic painter and **apparently** satisfied her mother that she would be quite all right living alone, attending classes in the morning, copying the old masters in the Louvre in the afternoon. **At any rate**, although not without some **maternal reluctance**, her mother eventually returned to this country.

Whereupon Mary immediately abandoned the structured environment of the academic workshop **in favor of** independent study at the Ecole des Beaux Arts, and especially the works of seventeenth century old masters such as Frans

Hals, Rubens, and Velasquez, all of which is quite obvious in her early works such as *The **Mandolin** Player* of 1868 and the *Musical Party* of 1874. And just as her parents had feared, she fell in with the wrong crowd—the impressionists. Edgar Degas was especially fond of her work. She considered him her **mentor**. In the early 1880s, perhaps to keep her in line, Mary's parents sent her younger sister to live in Paris with her. Later, Mary was strongly influenced by Japanese **woodcuts**. In 1890, she had her first one-woman show in Paris, which was well received by the French. She was **awarded** their Legion d'honneur in 1904, but it wasn't until 1912 before she received any **recognition** in this country. It was then that she received a Gold Medal of Honor from her **alma mater**, now known as the Pennsylvania Academy of Art, proving **once and for all** that nice girls do study art and come to paint some very nice pictures.

New Words

dismay *v.* 使沮丧，使惊慌 *n.* 沮丧，惊慌
downright *adv.* 全然，完全，彻底
hostile *adj.* 敌对的，敌意的
pursue *v.* 追赶，追踪，追求
gonna(=going to) <美> 将要
decent *adj.* 像样的
horrify *v.* 使恐怖，使惊骇
scandalous *adj.* 丢脸的；丑闻般的
faraway *adj.* 遥远的
immoral *adj.* 不道德的，放荡的
fraternize *v.* 结有深交
notoriously *adj.* 声名狼藉地
though *adv.* 虽然，可是
stiff *adj.* 拘谨的；呆板的；艰难的

concession *n.* 让步
establish *v.* 建立，设立；安置，使定居
enroll *v.* （使）入伍（入会、入学等）
reputable *adj.* 声誉好的
upstanding *adj.* 直立的；正直的，诚实的
apparently *adv.* 显然地，表面上地
maternal *adj.* 母亲的，似母亲的，母性的
reluctance *n.* 勉强
whereupon *adv.* 于是，因此，就此
mandolin *n.* [音]曼陀林（一种乐器）
mentor *n.* [希神]门特（良师益友）；导师
woodcut *n.* 木刻，木版画
award *v.* 授予
recognition *n.* 承认，认可，公认

Phrases

settle down 定居，安顿下来；平静下来
no doubt 无疑地

be afraid of 害怕，担忧
get one's way 随心所欲，独行其是

at any rate 无论如何，至少 alma mater 母校

in favor of 赞同；有利于；出于对……的 once and for all 一次了结地，一劳永逸地
偏爱

Notes

Mary Cassatt 玛丽·卡萨特（美国女画家） *The Mandolin Player*《曼陀林弹奏者》（卡

Frans Hals 弗朗斯·哈尔斯（荷兰画家） 萨特作品）

Rubens 鲁本斯（荷兰画家） Edgar Degas 埃德加·德加（法国画家）

Velasquez 委拉斯凯兹（西班牙画家） Legion d'honneur 法国荣誉勋级

Grammar

动名词（The Gerund）（Ⅱ）

1. 动名词的复合结构

动名词前加一个物主代词或名词所有格，与动名词一起构成动名词的复合结构。这一物主代词或名词所有格是动名词的逻辑主语。例如：

Mary's parents weren't overly afraid of **her choosing** art over marriage.

Her running off to Paris was downright scandalous.

The principal motif of her mature and perhaps most familiar period is **mothers caring for small children**.

Photography influenced painting, with its snapshot effects of **figures accidentally being cut off** at the edges, etc.

2. 动名词的完成式

1）形式：

肯定式	having + 过去分词
否定式	not + having + 过去分词

2）动名词的完成式表示动作发生在谓语动词的动作之前。例如：

Having established this 3D idea allows you to visualize and construct the finer details in perspective more accurately.

3. 动名词的被动式和动名词完成式的被动式

1）形式：

动名词的被动式	being + 过去分词
完成式的被动式	having + been + 过去分词

2）动名词的被动式表示动作的被动，完成式的被动式表示动作的被动及发生在谓语动词的动作之前。例如：

Photography influenced painting, with its snapshot effects of figures accidentally **being cut off** at the edges, etc.

This meant **being attuned to** their original and deepest artistic intentions.

After **having been told** for years that everyone just likes to do things in their own way, he is unlikely to head straight for the conclusion that a great artist is someone whose work is better than the others'.

Exercises

I **Discuss the following questions (pair work).**

1. When you showed an interest in pursuing careers as an artist, did your parents look dismayed or hostile?
2. Why were Cassatt's parents so hostile to her idea of going to Paris?
3. Which art styles had greatly influenced Cassatt in her art career?

II **Fill in the blanks with the words given below, changing the form when necessary.**

recognition	concession	pursue	stiff	enroll
mentor	mandolin	woodcut	award (*v.*)	decent

1. Japanese _____ has a unique flavor.
2. He _____ the golden prize in the National Art Exhibition for twice.
3. Having been living like a tramp for such a long time, he can't get used to the "_____" way of dressing.

4. The boy in the painting stands _____, staring forward, suppressing all playful thoughts.

5. Without telling anyone, he _____ in the volunteer team which was setting off to Southwest China.

6. He is lucky enough to meet many great _____ in his career as an artist.

7. In the figure drawing class, the students _____ anatomical accuracy.

8. A(n) _____ is a musical instrument that looks like a small guitar.

9. Modernist design was somehow a perfect _____ between cost, efficiency and aesthetic.

10. Mr. Wu Guanzhong finally got the _____ he deserves.

Ⅲ Choose the best words to fill in the blanks, changing the form when necessary.

1. hostile, hostel, hospitable

 a. When you are traveling in America, living in a _____ is the cheapest way of accommodation.

 b. The local people were _____ to the new-comers, who did not respect their culture.

 c. A _____ person should never keep guests out of his door.

2. scan, scanner, scandal, scandalous

 a. Do you prefer to _____ your works or to photograph them?

 b. The famous artist has been involved in the _____ of selling fake paintings.

 c. Manet's *Olympia*, painted in the same year as *Le Déjeuner sur l'Herbe*, was _____ to the French viewing public.

 d. Is the _____ good enough to replicate the tone of these pictures?

3. maternal, fraternize, fraternity

 a. Mary Cassatt rendered _____ love from her unique perspective.

b. In those days, it's ordinary for the soldiers to _____ with each other.

c. The modern idea _____ actually originated from Christianity.

4. moral, immoral, mortal, immortal

a. All things that live are _____.

b. In Greek mythology, the heroes were a class of mortals, although they were often the children of the _____ gods.

c. It's _____ to steal other designers' ideas.

d. In Chinese culture, a man's calligraphy is a clue to his temperament, his _____ worth, and his learning.

5. award, reward, forward

a. We are looking _____ to the coming of a new era.

b. Although the job almost wore him out, he was very well _____.

c. He won the National _____ for automobile design.

6. appearance, apparent, apparently

a. You cannot judge a person by his _____.

b. The grand scale of the building is _____ in an aerial view.

c. Without the knowledge in anatomy, you can only render the human figure _____.

IV Translate the following sentences into English.

1. 漂泊多年以后，他在那个城市安顿下来。(settle down)

2. 卡萨特无疑受到过哈尔斯、德加和日本木版画的影响。(no doubt)

3. 学生们总是害怕选错专业。(be afraid of)

4. 无论如何，在 19 世纪，美国仍是欧洲文化的学习者。(at any rate)

5. 她放弃了历史和神话的主题，（因为）更喜欢（画）居家场景。(in favor of)

6. 这本书使他一劳永逸地（一举）解决了造型问题。(once and for all)

V Cloze.

Paris was the art capital of the 19th century. The city's art schools, ____1____,

and exhibition spaces, along with the popular _____2_____ that the arts were an integral part of everyday life, attracted painters, _____3_____, and architects from around the world. The American painter May Alcott observed that Paris "is apt to strike a new-comer as being but one vast _____4_____". Her compatriot Cecilia Beaux exclaimed, "Everything is there."

Mary Cassatt was completely _____5_____ ease in Paris. French-speaking, independent, fiercely _____6_____ to her work, and committed to making a living as an artist despite her wealth, she was the only American member of the French impressionist group, exhibiting with them four times between 1879 and 1886. She made the home her most _____7_____ subject, applying her modern painting technique to traditional domestic themes.

1. A. museams B. museums C. musuems D. musiums
2. A. attitude B. altitude C. aptitude D. attune
3. A. sculptures B. sculptors C. skulptors D. sculpters
4. A. studying B. studios C. study D. studio
5. A. for B. in C. on D. at
6. A. devoted B. devoting C. devotee D. devote
7. A. frequently B. frequent C. frequency D. free quent

Part B Mary Cassatt

Cassatt was the daughter of a banker and lived in Europe for five years as a young girl. She was tutored **privately** in art in Philadelphia and attended the Pennsylvania Academy of the Fine Arts in 1861—1865, but she preferred a less academic approach and in 1866 travelled to Europe to study with such European painters as Jean-Léon Gérôme and Thomas Couture. Her first major show was at the Paris Salon of 1872; four more **annual** Salon exhibitions followed.

In 1874 Cassatt chose Paris as her permanent **residence** and established her studio there. She shared with the impressionists an interest in using bright colors inspired by the **out-of-doors**. Edgar Degas became her friend; his style and that

of Gustave Courbet inspired her own. Degas was known to admire her drawing especially, and **at his request** she exhibited with the impressionists in 1879 and joined them in shows in 1880, 1881 and 1886. Like Degas, Cassatt showed great **mastery** of drawing, and both artists preferred **unposed** asymmetrical compositions. Cassatt also was **innovative** and **inventive** in **exploiting** the medium of **pastels**.

Initially, Cassatt painted mostly figures of friends or relatives and their children in the impressionist style. After the great exhibition of Japanese prints held in Paris in 1890, she brought out her series of 10 colored prints— e.g., *Woman Bathing* and *The Coiffure*—in which the influence of the Japanese masters Utamaro and Toyokuni is apparent. In these **etchings**, she brought her **printmaking** technique to perfection. Her emphasis shifted from form to line and pattern. The principal **motif** of her mature and perhaps most familiar period is mothers caring for small children—e.g., *The Bath* (1892) and *Mother and Child* (1899). In 1894 she purchased a **château** in Le Mesnil-Théribus and **thereafter** **split** her time between her country home and Paris. Soon after 1900 her eyesight began to fail, and by 1914 she had ceased working.

Cassatt urged her wealthy American friends and relatives to buy impressionist paintings, and in this way, more than through her own works, she exerted a lasting influence on American taste. She was largely responsible for selecting the works that make up the H.O. Havemeyer Collection in the Metropolitan Museum of Art, New York City.

New Words

privately *adv.* 私下地

annual *adj.* 一年一次的，每年的

residence *n.* 居住，住处

out-of-doors *n.* 户外画家（主要指巴比松画派）

request *n.* 请求，要求；邀请

mastery *n.* 掌握，精通

unposed *adj.* 没有摆姿势的

innovative *adj.* 创新的

inventive *adj.* 善于创造的，发明的

exploit *v.* 开拓；开发，开采

pastel *n.* 彩色粉笔

etching *n.* 蚀刻版画，铜版画

printmaking *n.* 版画复制（术），版画创作

motif *n.* 主题，主旨；动机

château *n.* （法语）古堡

thereafter *adv.* 其后，从那时以后

split *v.* 劈开，（使）裂开；分裂，分离

Phrase

at one's request 依照某人的请求

Notes

Jean-Léon Gérôme 让·莱昂·杰罗姆（法国画家）

Thomas Couture 托马斯·古都尔（法国画家）

Gustave Courbet 古斯塔夫·库尔贝（法国画家）

Woman Bathing《浴女》（卡萨特作品）

The Coiffure《束发》（卡萨特作品）

Utamaro 喜多川歌麿（日本浮世绘画家）

Toyokuni 歌川豊国（日本浮世绘画家）

The Bath《洗浴》（卡萨特作品）

Mother and Child《母与子》（卡萨特作品）

Le Mesnil-Théribus 勒梅斯尼泰里比（法国地名）

Metropolitan Museum of Art 大都会博物馆（美国）

Exercises

I Discuss the following questions (pair work).

1. Where did Cassatt study before travelling to Europe?

2. What are the similarities between Cassatt and Degas in art?

3. How did Cassatt's emphasis shift from form to line and pattern?

4. In what way did Cassatt influence American taste?

II Translate the following sentences into Chinese.

1. Like Degas, Cassatt showed great mastery of drawing, and both artists preferred unposed asymmetrical compositions.

2. In these etchings, combining aquatint, drypoint, and soft ground, she brought her printmaking technique to perfection.

3. In this way, more than through her own works, she exerted a lasting influence on American taste.

Space for Illustration

Use your imagination and creativity, and draw an illustration for Part A or B, after which you are supposed to explain in English why you draw it in the way you do.

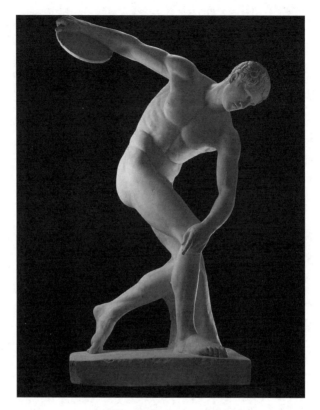

雕塑《掷铁饼者》（米隆作品）

　　西方文化有三个源流：古希腊文化、古罗马文化和以色列文化。西方的艺术和科学源于古希腊文化，立法和政治源于古罗马文化，宗教信仰源于以色列文化。时至文艺复兴，基于人文精神和理性的古希腊艺术得以再发现和再创造，从而开启了自文艺复兴之后西方艺术的辉煌，虽然基于宗教信仰的艺术与之交错并行，但前者的唤醒、发展、延伸仍然是近现代艺术的主脉。因此，要真正理解西方艺术，我们有必要回溯和探寻希腊文化和艺术的本质。

　　Part A 是对于希腊文化艺术的总体性介绍，涉及人文主义、理性主义、自然主义、理想主义等重要概念。同时，文章以清晰简洁的语言叙述了这些取向之间的相互关系。

　　Part B 介绍了古希腊雕塑《掷铁饼者》《拉奥孔》和《米洛的维纳斯》。

Unit 12 Greek Art
古希腊艺术

Part A Greek Culture in General

To this day, Greece's influence can be felt in science, mathematics, law, politics, and art. Unlike some other cultures which flourished, died, and left barely an **imprint** on the pages of history, that of Greece has **asserted** itself time and again over the 3,000 years since its birth. During the 15th century, there was the **revival** of Greek art and culture called the Renaissance, and, **on the eve of** the French Revolution of 1789, artists of the neo-classical period again turned to the style and subjects of ancient Greece.

The most important concerns of the ancient Greeks were mankind, reason, and nature, and these concerns **formulated** their attitude toward life. The Greeks considered human beings to be the center of the universe—the "measure of all things". This concept is called humanism. The value put on the individual led to the development of **democracy** as a system of government among independent **city-states** throughout Greece. It was also the responsibility of the individual to reach his or her full potential. Much **emphasis was placed on** the notion of a "sound body"; physical **fitness** was of **utmost** importance. The Greeks also recognized the power of the **intellect**. Their love of reason and admiration for **intellectual** pursuits led to the development of **rationalism**, a philosophy in which knowledge is assumed to come from reason alone, without input from the senses. **Perfection** for the Greeks was the achievement of a sound mind in a sound body. This is not to say that Greeks were wholly without emotion—on the contrary, they were **vital** and passionate—but the Greeks sought a balance between mind and body, emotion and intellect.

The Greeks had a profound love and respect for nature and **viewed human beings as** a reflection of its perfect order. In art, this concern **manifested** itself in naturalism, based on a keen observation of nature. But the Greeks were also lovers of beauty. Thus although they based their representation of the human body on observation, they could not resist perfecting it. The representation of

forms according to an **accepted** notion of beauty or perfection is called **idealism**, and in the realm of art idealism ruled the Greek mind.

Ancient Greece has given us such names as Homer and Hesiod in the art of poetry; Aristotle, Socrates, and Plato **in the field of** philosophy; and Archimedes and Euclid in the realms of science. Even more astonishing is the fact that Greece gave us these figures and achieved its **accomplishments** during a very short period of its history. Although Greek culture **spans** almost 1,000 years, her "Golden Age", or period of greatest achievement, lasted no more than eighty years.

As with many civilizations, the development of Greece occurred over a **cycle** of birth, **maturation**, perfection, and **decline**. These points in the cycle **correspond to** the four periods of Greek art: Geometric, **Archaic**, Classical, and **Hellenistic**.

▌New Words

imprint *n.* 盖印；痕迹；特征
assert *v.* 断言，声称
revival *n.* 苏醒；复兴，复活
formulate *v.* 用公式表示；明确地表达
democracy *n.* 民主政治，民主主义
city-state *n.* （古希腊的）城邦
fitness *n.* 适当；健康
utmost *adj.* 极度的；最远的
intellect *n.* 智力，才智
intellectual *adj.* 智力的，有智力的 *n.* 知识分子
rationalism *n.* 理性主义，唯理论

perfection *n.* 尽善尽美，完美
vital *adj.* 生命的，生机的
manifest *v.* 表明，证明
accepted *adj.* 一般承认的，公认的
idealism *n.* 理想主义
accomplishment *n.* 成就，完成
span *v.* 横越
cycle *n.* 周期，循环
maturation *n.* 成熟
decline *n.* 下倾，下降；下垂
archaic *adj.* 古老的，古代的，陈旧的
Hellenistic *adj.* 希腊风格的，希腊文化的

▌Phrases

on the eve of 在……的前夕
place emphasis on 注重，强调
view... as... 把……看作……，认为……是……

in the field of 在……方面，在……领域
as with 如同，和……一样
correspond to 相应，符合

Notes

"measure of all things" 万物的尺度	**Euclid** 欧几里得（古希腊数学家）
Homer 荷马（古希腊诗人）	**Geometric** 指"几何时期"
Hesiod 赫西奥德（古希腊诗人）	**Archaic** 指"古风时期"
Aristotle 亚里士多德（古希腊哲学家）	**Classical** 指"古典时期"
Socrates 苏格拉底（古希腊哲学家）	**Hellenistic** 指"希腊化时期"
Archimedes 阿基米德（古希腊数学家）	

Grammar

分词（The Participle）（Ⅱ）

1. 分词及分词短语在句子结构中充当的成分（续）

分词及分词短语除了充当定语、表语或状语外，还可以作补足语。

1）作宾语补足语

Smith saw the thief **picking the wallet out of the old man's pocket**.

2）作主语补足语

He was found still **clutching his camera**.

2. 现在分词的完成式

1）形式：

肯定式	having + 过去分词
否定式	not + having + 过去分词

2）用法：

现在分词的完成式主要用作状语，表示状语的动作发生在谓语动词的动作之前。例如：

Having seen the lacquer ware before, he identified it right away.

Not having had the experience, she felt lost when playing the game.

3. 现在分词的被动式与现在分词完成式的被动式

1）形式：

现在分词的被动式	being + 过去分词
完成式的被动式	having + been + 过去分词

2）用法：

现在分词的被动式表示动作的被动，与谓语动词的动作同时发生，在句子结构中充当定语或状语。例如：

The meeting **being held** is about the Olympic Games.

完成式的被动式表示动作的被动，发生在谓语动词的动作之前。例如：

Having been covered under the ground for so many years, the ware still catches the audience's eyes with its refinement.

Exercises

I Discuss the following questions (pair work).

1. What are the two significant revivals of Greek culture in Western art history?

2. What is rationalism according to the text? Does it show that Greeks were without emotion?

3. What do you know about Homer, Hesiod, Aristotle, Socrates, Plato, Archimedes and Euclid?

II Fill in the blanks with the words given below, changing the form when necessary.

assert	manifest	utmost	span	decline
cycle	flourish	vital	accepted	city-state

1. They were so surprised to find the relics of a(n) _____ in the depth of desert.

2. We can _____ that art is one of the most basic human activities.

3. Painting _____ in Italy in the fifteenth century.

4. That period saw the _____ of Roman Empire.

5. As to beauty, there are _____ comments, but no absolute criteria.

6. Greek sculpture attained the _____ perfection of human body.

7. Greco-Persian Wars _____ half a century.

8. The handicrafts from that era are _____ and unique.

9. Every great culture may have experienced a(n) _____ of flourish, decline and revival.

10. Idealism _____ itself in the art of neo-classicalism in the 19th century.

III **Choose the best words to fill in the blanks, changing the form when necessary.**

1. vive, revive, revival

 a. We are so familiar with the Renaissance, but few people know about the Gothic _____.

 b. He returned to the blackboard, took a piece of chalk, and wrote in large letters, "_____ LA FRANCE." (*The Last Lesson*)

 c. Inscriptions of Northern Dynasties (北朝碑刻) was _____ in the second half of Qing Dynasty.

2. demo, democracy, democratic

 a. _____ is the abbreviation of "demonstration".

 b. All these show the elevation of people's _____ consciousness.

 c. Ancient Athens was the cradle of _____.

3. intellect, intellectual (*adj.*), intellectual (*n.*)

 a. Mo Zi (墨子) is said to be a man of considerable _____.

 b. That was a salon for _____, artists and celebrities.

 c. Translation is somehow an _____ challenge.

4. ration (*v.*), rational, rationalism

 a. The _____ utilization of space is a good point in his design.

 b. They had to _____ petrol during the war.

 c. German design always manifests a kind of _____.

5. ideal (*n.*), idealist, idealize

 a. Instead of _____ the figures, Rodin always revealed their misery and inner doubt.

 b. An _____ tends to feel disillusioned and frustrated in reality.

 c. Venus was the goddess who best expressed the _____ of woman.

6. perfect (*v.*), perfect (*adj.*), perfection

 a. He would not stop until he reaches the point of _____.

 b. In da Vinci's *Last Supper*, the figure of Jesus makes a _____ isosceles triangle.

 c. He _____ his printmaking techniques in creating these etchings.

Ⅳ Translate the following sentences into English.

1. 抗战前夕，他们将故宫珍藏的历代文物搬运到中国西南地区。(on the eve of)

2. 在任校长期间，他着眼于中国的教育独立。(place emphasis on)

3. 其他人看起来是平静安宁的景象，凡·高却用波浪般的形态去表现。(view as)

4. 在建筑领域，国际风格已被广泛采用。(in the field of)

5. 如同古希腊哲学一样，轴心时代的中国哲学也被认为是永恒的和不可替代的。(as with)

6. 古希腊神话中，每一位神祇都对应着一种品德。(correspond to)

Ⅴ Cloze.

 The Three Goddesses, a figural group, is typical ____1____ the Phidian style (菲迪亚斯风格). The bodies of the goddesses are weighty and substantial. Their positions are ____2____ and their gestures fluid, despite the fact ____3____ limbs and heads are broken ____4____. The draperies hang over the bodies in realistic fashion, and there is a marvelous contrast of textures between the heavier garments that wrap around the legs and the more diaphanous (薄如蝉翼的)

fabric _____5_____ the upper torsos. The thinner drapery clings to the body as if it _____6_____ wet, revealing the shapely figures of the goddesses. The intricate play of the linear folds renders a tactile quality not _____7_____ in art before its time.

1. A. of B. with C. in D. at
2. A. nature B. naturalism C. naturalistic D. nurture
3. A. that B. which C. when D. where
4. A. apart B. in C. out D. off
5. A. covers B. covering C. covered D. cover
6. A. are B. were C. is D. has been
7. A. saw B. see C. seeing D. seen

Part B Masterpieces of Greek Sculpture

Discus Thrower

The most significant development in Classical art was the introduction of implied movement in figure sculpture. This went hand in hand with the artist's keener observation of nature. One of the most widely copied works of this period is the *Discus Thrower* by Myron. Like most Greek **monumental** sculpture, it survives only in Roman copy. The **life-size** statue depicts an event from the Olympic games—the **discus** throw. The figure, shown as a young man in his **prime**, is caught by the artist at the moment when the arm stops its swing backward and prepares to sling forward to release the discus. His **torso** intersects the arc shape of his extended arms, resembling an arrow pulled **taut** on a bow. It is an image of **pent-up** energy that the artist will not allow to escape. As in most of Greek Classical art, there is a balance between motion and stability, between emotion and restraint.

Laocoon

The *Laocoon* **group** depicts the **gruesome** death of the Trojan priest

Laocoon and his two sons, who were **strangled** by sea serpents.

Laocoon is portrayed as a **burly** man, whose **knotty** musculature and swirling hair and beard **bespeak** his unbearable **plight**. He **writhes** in anguish, vainly attempting to detach the serpents from his neck and limbs.

The snakes bind the figures not only physically, but compositionally as well. They pull together the priest and his sons, who otherwise **thrust** away from the center of the **pyramidal** composition. It is the artist's way of controlling the potentially run-away action. But it is not a balance of movement and restraint or of tension and relaxation that is sought. Rather, the alternating thrusts and constraints heighten the tension and illustrate the mortals' **futile** attempts to battle the gods.

Venus de Milo

In Hellenistic art, one of the most splendid examples of the simplicity and idealism of the Classical period, and indeed one of the most famous sculptures in the history of art, is the *Venus de Milo*. The S-curve and the subtly modeled body **are reminiscent of** the work of Praxiteles. The harsh realism and passionate emotion of the Hellenistic artist could not be farther in spirit from this **serene** and highly idealized form.

New Words

monumental *adj.* 纪念碑的，纪念物的
life-size *adj.* 与实物大小一样的
discus *n.* 铁饼
prime *n.* 最初；青春；精华
torso *n.* 躯干
taut *adj.* （绳子）拉紧的；紧张的
pent-up *adj.* 被压抑的
group *n.* 群像
gruesome *adj.* 可怕的；可憎的
strangle *v.* 扼死，勒死

burly *adj.* 魁伟的，结实的
knotty *adj.* （木材等）多结的，多节的
bespeak *v.* 证明
plight *n.* 情况，状态；困境
writhe *v.* 翻腾
thrust *v.* 力推，冲
pyramidal *adj.* 金字塔形的，锥体的
futile *adj.* 无用的，无效果的
serene *adj.* 平静的

Phrase

be reminiscent of 让人回忆起

Notes

Discus Thrower《掷铁饼者》

Classical art 这里指希腊古典时期的艺术

Myron 米隆（古希腊雕塑家）

Laocoon《拉奥孔》

Trojan 特洛伊

Venus de Milo《米洛的维纳斯》

Praxiteles 普拉克西特利斯（古希腊雕塑家）

Exercises

I **Discuss the following questions (pair work).**

1. What is the dialectic contained in the *Discus Thrower*?

2. What is the compositional function of snakes in *Laocoon*?

3. What is the charm of *Venus de Milo* according to the text?

II **Translate the following sentences into Chinese.**

1. The figure, shown as a young man in his prime, is caught by the artist at the moment when the arm stops its swing backward and prepares to sling forward to release the discus.

2. The alternating thrusts and constraints heighten the tension and illustrate the mortals' futile attempts to battle the gods.

3. The harsh realism and passionate emotion of the Hellenistic artist could not be farther in spirit from this serene and highly idealized form.

Space for Illustration

Use your imagination and creativity, and draw an illustration for Part A or B, after which you are supposed to explain in English why you draw it in the way you do.

插图作者：清华大学美术学院 美98班 赵自然

在雕塑的历史上，罗丹是一位划时代的人物，他使得雕塑独立于传统的纪念和装饰功能，从而成为一种独立的、自我表达的艺术。在风格上，他摆脱了古希腊雕塑的理想主义，成为一位自然主义者。他的雕塑在用形体说话，强调个体、特征、运动。说到他的自然主义，群雕《加莱义民》或许是最具典型性的。

Part A 论说罗丹的美学，并介绍《加莱义民》。罗丹是一位跨越世纪的大师，他的风格在 19 世纪末期也有所变化。最能说明这种变化的无疑是著名的《巴尔扎克像》，该作品已经颇具现代性。

Part B 介绍了《巴尔扎克像》《思想者》和《美惠三女神的舞蹈》等作品。

Auguste Rodin
奥古斯特·罗丹

Part A The Aesthetic of Rodin

Rodin was a **naturalist**, less **concerned with** monumental expression than with character and emotion. **Departing** with centuries of tradition, he **turned away from** the idealism of the Greeks, and the decorative beauty of the Baroque and neo-Baroque movements. His sculpture emphasized the individual and the **concreteness** of **flesh**, and suggested emotion through detailed, **textured** surfaces, and the interplay of light and shadow. To a greater degree than his **contemporaries**, Rodin believed that an individual's character was revealed by his physical **features**.

Rodin's talent for surface **modeling** allowed him to let every part of the body speak for the whole. The male's passion in *The Kiss* is suggested by the **grip** of his **toes** on the rock, the **rigidness** of his back, and the **differentiation** of his hands. **Speaking of** *The Thinker*, Rodin illuminated his aesthetic: "What makes my Thinker think is not only his brain, his **knitted** brow, his **distended nostrils** and compressed lips, but also every muscle of his arms, back, and legs, his **clenched** fist and gripping toes."

Sculptural **fragments** to Rodin were **autonomous** works, and he considered them the essence of his artistic statement. His fragments—perhaps lacking arms, legs, or a head—took sculpture further from its traditional role of portraying **likenesses**, and into a realm where forms existed for their own sake. **Notable** examples are *The Walking Man* and *Meditation without Arms*.

The Burghers of Calais

Instead of focussing on the first of the citizens who had volunteered, Eustache de Saint-Pierre, Rodin decided to portray six individuals. Instead of idealizing the dignity of their heroic sacrifice, he revealed their **misery** and inner doubt and showed them in rough **sack**-like clothes. Instead of **setting**

up a traditional pyramidal composition, he placed the six men on the same level, each of them occupied by his own personal conflict: Pierre de Wissant, who, on his slow **procession** towards death, turns round and lifts his right arm back, just like setting free a bird (Rilke); Jean d'Aire, on the other side of the **monument**, is standing **upright** with clenched hands but **stoically** reflecting his fate.

To reach a **maximum** of individuality, Rodin studied each of the six personalities separately in different poses, dressed and undressed. **Being convinced of** his artistic conception, Rodin refused to serve given expectations. The second **maquette** of the Calais Monument was presented in July/August 1885, with a very low **pedestal**, showing six separate **freestanding** figures at one-third height. This time, the composition met **critique**, but Rodin insisted it had not been presented to negotiate a completely new design.

New Words

naturalist *n.* 自然主义者

depart *v.* 离开，起程；不按照

concreteness *n.* 具体

flesh *n.* 肉，肉体，人体

textured *adj.* 质地粗糙的；手摸时有感觉的

contemporary *n.* 同时代的人

feature *n.* 特征，特色；容貌

model *v.* 塑造，造型

grip *v.* 紧握，紧夹

toe *n.* 趾，脚趾，足尖

rigidness *n.* 坚硬，劲直

differentiation *n.* 区别

knit *v.* 编织，密接；皱（眉）

distend *v.* （使）扩大，（使）扩张

nostril *n.* 鼻孔

clench *v.* 紧握，（拳头）牢牢地抓住

fragment *n.* 碎片；断片，片段

autonomous *adj.* 自发性的

likeness *n.* 相像；相似物

notable *adj.* 值得注意的，显著的，著名的

meditation *n.* 沉思，冥想

misery *n.* 痛苦，悲惨，不幸

sack *n.* 麻布袋

procession *n.* 队伍；列队行进

monument *n.* 纪念碑

upright *adj.* 垂直的，竖式的；正直的

stoically *adv.* 坚忍地，不以苦乐为意地

maximum *n.* 最大量，最大限度，极大

maquette *n.* 初步设计的模型（或草图）

pedestal *n.* 基架，底座；基础

freestanding *adj.* 独立式的，不需依靠支撑物的

critique *n.* 批评

▌Phrases

concern with 关心

turn away from 背离

speak of 谈及，说到

instead of 代替，而不是

focus on 集中于

set up 设立，竖立，架起

be convinced of 确信，认识到

▌Notes

Rodin 罗丹（法国雕塑家）

Baroque and neo-Baroque movements
巴洛克和新巴洛克运动

The Kiss 《吻》（罗丹作品）

The Thinker 《思想者》（罗丹作品）

The Walking Man 《行走的人》（罗丹作品）

Meditation without Arms 《无臂的冥想》（罗
丹作品）

The Burghers of Calais 《加莱义民》（罗
丹作品）

Eustache de Saint-Pierre 《加莱义民》中
人物

Pierre de Wissant 《加莱义民》中人物

Rilke 里尔克（奥地利诗人）

Grammar

同位语和同位语从句
（The Appositive and Appositive Clause）

1. 同位语

在名词（或代词）后面有时可跟另一个名词或起名词作用的成分，进一步说明该名词（或代词）所指的人或物，这称作同位语。同位语可以由名词、代词或从句等来表示。例如：

During this time Rodin created one of his most powerful figures, *Saint John the Baptist*.（名词作同位语）

Instead of focussing on the first of the citizens who had volunteered, **Eustache de Saint-Pierre**, Rodin decided to portray six individuals.（名词作同位语）

They **two** will go to study in France.（数词作同位语）

We **both** love paper-cutting. （代词作同位语）

2. 同位语从句

作同位语的从句称为同位语从句。同位语从句由连词that引导，常放在fact, news, idea, truth, hope, problem, discovery, information等名词的后面，说明该名词的具体内容。例如：

I saw immediately that it would be ridiculous to proceed with the idea **that I was the artist and the inmates were not**.

He is not concerned with the fact **that this poem is Persian**; he is interested in the vague and suggestive meanings.

The title leaves room for the interpretation **that Rodin, at times, perceived womanhood as a diabolic invention**.

During this period, the theory **that a reader could see qualities of the man behind the brush** arose.

3. 特定语句引出的同位语

有时可以用下列词语引出同位语，说明其前面的名词：namely, or rather, that is to say, in other words, that is, i.e., for example等。例如：

Eventually, artists will see these relationships separately from the objects they make up, in other words, **their abstract identity**.

Our concern is the interaction of color, that is, **seeing what happens between colors.**

Mixing a color common to others, i.e., **adding a certain color to most other colors**...

Exercises

1 Discuss the following questions (pair work).

1. What can be the key words for Rodin's aesthetic?

2. Besides the examples listed in the third paragraph, do you know any other fragments made by Rodin?

3. What kind of composition does *The Burghers of Calais* take?

Ⅱ Fill in the blanks with the words given below, changing the form when necessary.

toe	flesh	contemporary	pedestal	sack
misery	feature	meditation	fragment	autonomous

1. _____ can make or break an artist.

2. Being different from Ancient Greek sculptors, Rodin favored the physical _____ of individual.

3. Rodin made a head of a woman who is deep in _____, which was entitled *Thought*.

4. The quick sketches of this artist are also regarded as _____ works.

5. The statue of Buddha is so large that a _____ of it can hold five people.

6. Zola (左拉) was a(n) _____ of Rodin.

7. They put the monument of Confucius on a high _____.

8. Unfortunately, what were left was only the _____ of the temple.

9. Anatomically, human _____ can be compared to a(n) _____ containing some potatoes.

Ⅲ Choose the best words to fill in the blanks, changing the form when necessary.

1. monument, moment, monumental
 a. The pyramidal composition is used in this _____.
 b. Rodin decided to show the _____ when all six burghers taking their first steps toward the camp of Edward Ⅲ.
 c. Most of the ancient sculptures are either ornamental or _____.

2. pose, propose, proposition
 a. What kind of _____ is raised in your thesis?
 b. The architect _____ to build a new city and retain the old one.
 c. The _____ of the sculpture violated the Classical aesthetics.

3. ideal, idealized, unidealized, idealism
 a. In his novel, rural life was _____.

b. In *Venus de Milo*, we see both the _____ of Classical Period and the passion of Hellenistic Period.

c. Rodin made an _____ Saint John the Baptist (圣施洗约翰).

d. The power of overcoming difficulties comes from great _____.

4. aesthetic (*n.*), aestheticism, aesthetics

a. "Art for Art's Sake" is Oscar Wilde's _____ manifesto.

b. This small fragment can also show the _____ of Rodin.

c. Here, we normally call _____ as Art in General (艺术概论).

5. nature, natural, naturalist, naturalism

a. In many places, the _____ environment is exposed to damage of industrialization.

b. Anything against _____ will turn out to be pretentious and unsatisfying.

c. Zola is a _____, but his _____ is not quite the same as that of Rodin.

6. individual, individualism, individuality

a. In the group sculpture, each _____ echoes with the others.

b. _____ and originality enabled this design work to survive the vast sea of information.

c. _____ is a main thread of modern culture.

Ⅳ Translate the following sentences into English.

1. 为了成功塑造，罗丹试做了很多头、手、躯干等。(for the sake of)

2. 这件独立式作品衍生于《地狱之门》，而不是《加莱义民》。(instead of)

3. 他在这本书中谈及罗丹对于米开朗琪罗的崇敬。(speak of)

4. 与古希腊雕塑家不同，罗丹更关心特征和个性。(concern with)

5. 尽管他背离了传统，但他并没有背离美。(turn away from)

6. 他集中展现了这个流浪汉的眼睛和眉毛。(focus on)

Ⅴ Cloze.

In 1875, as the major ____1____ projects in Brussels were nearing

_____2_____, the marble bust of *The Man with a Broken Nose,* executed from the 1864 mask but completed and re-worked, was exhibited at the Salon in Paris. It was the first time one of Rodin's _____3_____ was accepted by the Salon, and this _____4_____ encouraged him. Furthermore, his financial worries were alleviated by the _____5_____ of his decorative busts. This peaceful atmosphere _____6_____ Rodin to devote his artistic efforts to a male nude, *The Age of Bronze,* during the last two years of his stay in Brussels. He worked on it for eighteen months, with an interruption in February and March of 1876 to travel to Italy _____7_____ he discovered the works of Michelangelo in Florence, in a _____8_____ of enthusiasm.

1. A. decorate B. decorative C. decoration D. decorates
2. A. completion B. complete C. complatie D. complation
3. A. work B. working C. worked D. works
4. A. great B. greatly C. greatness D. greater
5. A. success B. succeed C. successful D. successive
6. A. enable B. able C. ability D. enabled
7. A. when B. why C. where D. whom
8. A. burst B. bust C. beast D. boast

Part B Other Works of Rodin

The Thinker: muscle and mind...

The Thinker is perhaps the most famous in Rodin's works. Though an independent work **in its own right,** it **was originally intended to** occupy the summit of the *Gates* and to represent Dante meditating on his creation. But in Rodin's mind, the meaning of *The Thinker* developed from a representation of Dante into a more general image of man meditating: of the human who, in a **convulsive** effort to **rise above** animal life, is inspired by a mysterious **illumination,** and gives birth to the first thought. In its form, *The Thinker* owes much to Classical art, in particular to the *Torso of the Apollo Belvedere* in the

Vatican Museum as well as to the statue of the seated Lorenzo de' Medici and to Michelangelo's *Moses*. What **distinguished Rodin from** his **predecessors** is his way of expressing the effort of thought through the contraction of **each and every** muscle; the work of the mind thus becomes **palpable**.

The Three Graces Dancing

The Three Graces Dancing is the first representation of dance in Rodin's work. Here the sculptor has not troubled himself with excessive **anatomical** details. The forms are only suggested, for what is represented is not a sensation or an emotion, but an action, a movement: dance.

The Monument to Balzac

The Monument to Balzac was **commissioned** by the Societe des Gens de Lettres in 1883 as a **homage** to the novelist Honore de Balzac. Of all Rodin's works, it is this work which most clearly **inaugurates** the sculptural language of the 20th century. Rodin's *Balzac*, far ahead of its time, **paved the way for** new expressive possibilities in sculpture, **first and foremost** in its rejection of **servile** imitation, secondly in its daring simplification of form. Rodin himself said of the work: "Nothing else that I have done satisfies me as much, because nothing else cost me so much effort, nothing else so profoundly summarizes what I believe to be the secret law of my art." Photographs, **masks, dressing-gown**, nude studies, and sketches accumulated before Rodin's vast labors issued in the final version, the *Clothed Balzac*. In this work Rodin brought to a **culmination** his aspiration to record not so much the physical appearance of the writer as the very essence of his personality.

New Words

convulsive *adj.* 抽搐的，痉挛的	**predecessor** *n.* 前任，前辈
illumination *n.* 照明；启发	**palpable** *adj.* 可感知的，可触的

anatomical *adj.* 解剖的，解剖学的
commission *n.* 委托；（艺术作品制作的）委托 *v.* 委托；委托制作（艺术作品）
homage *n.* 敬意，尊敬，致敬
inaugurate *v.* 创新，开创；举行就职典礼

servile *adj.* 奴隶的；奴性的；卑屈的
mask *n.* 面具，面部模型
dressing-gown *n.* 睡衣，睡袍
culmination *n.* 顶点；高潮

Phrases

in one's own right 凭本身的力量（或能力、资格、权利等）
be intended to 打算，意图是
rise above 升到……之上，超越……；克服

distinguish from 将……与……区别开
each and every 每个，每一个
pave the way for 为……铺平道路
first and foremost 首先，首要地，第一

Notes

Gates 《门》（《地狱之门》简称）
Dante 但丁（意大利诗人）
Torso of the Apollo Belvedere 《贝尔维德雷躯干》（古希腊雕塑残段）
Vatican Museum 梵蒂冈博物馆
Lorenzo de' Medici 洛伦佐·德·美第奇
Michelangelo 米开朗琪罗（意大利雕塑家）
Moses 《摩西》（米开朗琪罗作品）

The Three Graces Dancing 《美惠三女神的舞蹈》（罗丹作品）
The Monument to Balzac 《巴尔扎克（纪念）像》（罗丹作品）
Societe des Gens de Lettres 法国文学家协会
Honore de Balzac 奥诺雷·德·巴尔扎克

Exercises

I **Discuss the following questions (pair work).**

1. What made *The Thinker* different from *Torso of the Apollo Belvedere* and *Moses* in expressing the effort of thought?

2. In which work did Rodin represent dance for the first time?

3. How did Rodin's *Balzac* pave the way for new expressive possibilities in sculpture?

II **Translate the following sentences into Chinese.**

1. The meaning of *The Thinker* developed from a representation of Dante into a more general image of man meditating: of the human who, in a convulsive effort to rise above animal life, is inspired by a mysterious illumination, and gives birth to the first thought.

2. The forms are only suggested, for what is represented is not a sensation or an emotion, but an action, a movement: dance.

3. In this work Rodin brought to a culmination his aspiration to record not so much the physical appearance of the writer as the very essence of his personality.

Space for Illustration

Use your imagination and creativity, and draw an illustration for Part A or B, after which you are supposed to explain in English why you draw it in the way you do.

插图作者：清华大学美术学院 美62班 吕金泽

　　画面元素（pictorial elements）和画面原理（pictorial principles）共同构成画面语言。艺术家和设计师在进行创作时，可以利用这些原理来调节画面构成或表达特定的思想和观念。本单元介绍画面原理的相关知识，也是本书第二单元的延续。

　　Part A 介绍平衡、强调、运动、比例、图式、多样、统一、节奏等视觉原理，它们之间有很多相通之处，在画面上往往是共同发生作用的。

　　Part B 是对于构图或构成的一些经验之谈。

Unit 14

Pictorial Principles
画面原理

Pictorial elements are the "things" involved in composition; pictorial principles are the ideas. The pictorial **principles** are: balance, **emphasis**, movement, **proportion**, pattern, **rhythm**, unity, variety, harmony, etc.

Balance: Distributing the "weight" of the forms in the composition, both **horizontally** and **vertically**, in terms of their size, color, value, shape, texture, etc. (some non-formal factors can also form the "weight", such as human beings, conflicts or activities, and certain cultural or symbolic connotations.) The aim is generally **asymmetrical** balance—meaning that the composition should be balanced, but not **symmetrical** (exactly the same on the left and right sides). For example, if you have two **identical** bottles, and place one on the left side of the composition and one on the right side in the **equivalent** position, you have symmetry. If you have one tall bottle on the left side, and two smaller bottles on the right, you have an example of asymmetrical balance.

Emphasis: Can be used to create a center of interest (**focal** point), or to make certain elements of the composition more **prominent**; also can be used to **highlight** the emotional or **narrative** significance of a work. Isolation, leading or directing, contrast, and framing are some of the strategies used to create emphasis.

Movement: Can be used to draw the viewer's eye around the composition, used often with **counter**-movement, which neutralizes movement. In a still picture such as a painting or photograph, where nothing is actually moving, various strategies can be used to give the viewer a sense of movement, or to move the viewer's eye through the work. These include contrast, directing (directional movement), **diagonals** and unbalanced elements.

Proportion: Can mean the proper **ratio** in figure drawing of various body parts; but **in a compositional sense**, it means that pictorial elements are arranged in a **pleasing** or **proper** ratio to **one another**.

Pattern: The placement of elements into a **rhythmical** or **regular** arrangement;

this often **results in** a two-dimensional quality, to the form or to the painting **as a whole**.

Rhythm: The placement of elements in the composition which creates a "rhythm" in the painting, the visual equivalent of rhythm in music. Rhythms can **be broadly categorized into** random, **alternating**, and progressive.

Unity: The composition should **combine into** a **cohesive** whole, with **theoretically** every element related to and **compatible** with all others. The strategies include: **repetition**, continuation, **proximity**, etc. Another term for the same idea is harmony. If various elements are not harmonious, if they appear separate and/or unrelated, your pattern falls apart and lacks unity.

Variety: Having enough differences in size, color, shape, etc. to create visual interest. Unity with variety is the oft-quoted artistic ideal. Shapes may repeat, but perhaps in different sizes; colors may repeat, but perhaps in different values.

Pictorial elements and principles are used in all arts, **commercial** as well as fine. Design or composition involves the consideration of abstract and concrete, **tangible** and **intangible** elements. In the design process, they interact to create the whole visual expression.

| New Words

principle *n.* 法则，原则；原理
emphasis *n.* 强调，重点
proportion *n.* 比例
rhythm *n.* 节奏，韵律，律动
horizontally *adv.* 水平地
vertically *adv.* 垂直地
asymmetrical *adj.* 不对称的
symmetrical *adj.* 对称的
identical *adj.* 同一的，同样的
equivalent *adj.* 相等的，相当的 *n.* 等价物，相等物
focal *adj.* 焦点的，有焦点的
prominent *adj.* 显著的，突出的

highlight *v.* 加亮；使显著，突出
narrative *adj.* 叙述性的，叙事性的
counter-（前缀）表示"相反，相对"之意
diagonal *adj.* 斜的，斜向的 *n.* 斜线，角线
ratio *n.* 比，比率
pleasing *adj.* 令人愉快的，合意的
proper *adj.* 适当的；正确的
rhythmical *adj.* 节奏的，有节奏感的
regular *adj.* 规则的；有秩序的
alternating *adj.* 交替的，交互的
combine *v.*（使）联合，（使）结合
cohesive *adj.* 紧密结合的；呼应的
theoretically *adv.* 理论上，理论地

compatible *adj.* 谐调的，一致的；兼容的	**commercial** *adj.* 商业的
repetition *n.* 重复，循环；复制品	**tangible** *adj.* 明确的；可触摸的，可感知的
proximity *n.* 接近，亲近	**intangible** *adj.* 不可捉摸的；难以确定的

Phrases

in a sense 在某种意义上	**as a whole** 总体上
one another 彼此，相互	**be categorized into** 分为，归类为
result in 导致	**combine into** 合为，结合成

Grammar

分词（The Participle）（Ⅲ）

分词独立结构（The Participial Absolute Construction）

分词或分词短语作状语时，其逻辑上的主语通常是句子的主语。但有时它们有自己的主语。这一主语连同分词或分词短语构成分词独立结构。试比较：

The lines can be very important in providing directional movement in the work, **leading the eye through the image**.（分词短语）

Most of his images during this early period comprise large dark areas contrasted with large blank ones, along with **areas of minute detail contrasting with areas with none at all**.（分词独立结构）

分词独立结构在句中可作状语，表示时间、原因、条件或伴随状况等。例如：

Each student had two teachers, a painter and a craftsman, **the most famous being the painters Paul Klee and Wassily Kandinsky**.（表示伴随状况）

With web technology becoming increasingly more advanced, websites today are more interactive and visually stimulating than ever.（表示原因或伴随状况）

The composition should combine into a cohesive whole, **with theoretically every element related to and compatible with all others**.（表示伴随状况）

可以这样说：分词独立结构是"名词（代词）+分词"绑定在一起形成的，其目的在于表明分词所表示的动作的逻辑主语。

Exercises

I **Discuss the following questions (pair work).**

1. Which pictorial principle is the most closely related to "harmony"? Which is (are) related to "pattern"?
2. What are the functions of "emphasis"?
3. What is the difference between the "proportion" in figure drawing and that in the compositional sense?

II **Fill in the blanks with the words given below, changing the form when necessary.**

rhythm	principle	compatible	narrative	proximity
highlight	focal	ratio	cohesive	commercial

1. Pictorial _____ are relative with and to each other.
2. The idea _____ exists in music, poetry and visual art.
3. To create visual interest, there should be isolation/separation in _____.
4. The new software is not _____ with this old computer produced in 1990s.
5. There can't be too many _____ points in a picture.
6. Le Corbusier developed a system of architectural module according to the _____ of human body.
7. Modern art tends to be less _____ and more conceptual than traditional art.
8. The distinction between _____ art and fine art is not so clear today.
9. Every part of a novel should be _____ with other parts.
10. Let's _____ one area of the picture, to make it look more prominent.

Ⅲ Choose the best word to fill in the blanks, changing the form when necessary.

1. vary, variety, various, variation

 a. _____ tools and materials are laid everywhere in his workshop.

 b. He felt that Chinese architecture is too repetitive, lack of _____.

 c. What fascinates me is not the theme of the melody, but the _____.

 d. These shapes _____ from each other in size, value, or color.

2. meter, symmetry, asymmetrical

 a. _____ is often used in decorative painting.

 b. The key to _____ balance is visual weight.

 c. The large scale statue is seven _____ high.

3. please, pleasing, pleasure

 a. A rectangle was said to be the most _____ to the eye when it possessed the mathematical ratio of 0.618:1.

 b. Which _____ your eyes more: symmetry or asymmetry?

 c. The _____ of art lies in creation.

4. regular, regulation, irregular

 a. Generally, a straight line is a(n) _____ line.

 b. When most of the elements are _____ forms, a geometric square shape breaks the pattern and becomes the focal point.

 c. There is no fixed _____ about composition.

5. theory, theoretical, theoretically, theorize

 a. _____, a picture should be visually balanced, but there can also be exceptions.

 b. Merely studying the _____ of composition is not enough; we need to practice to become an excellent artist.

 c. The _____ research on visual language had already begun a long time ago.

 d. Marcel Breuer _____ that chairs would become out of date, and be dematerialized to by supportive columns or air.

6. equal, equality, equivalent (*n.*), equilibrium

 a. The three colors on the Tricolor respectively stand for liberty, _____,

and fraternity.

b. The "area of empty paper" (留白) in Chinese painting can be considered as

the _____ of "negative space".

c. "We hold this truth to be self-evident that all men are created _____."

d. Balance refers to the _____ of opposing visual forces.

Ⅳ Translate the following sentences into English.

1. 在这幅静物画中，瓶子、水果和罐子结成一个三角形。(combine into)

2. 在某种意义上，现代主义是对于形式的解放。(in a sense)

3. 第一次世界大战的心灵创伤促使达达主义诞生。(result in)

4. 我们必须从整体上考虑视觉元素和视觉原理。(as a whole)

5. 在色环上彼此相对的色彩被称为互补色。(one another)

6. 非对称平衡可以分为水平平衡、垂直平衡和斜向平衡。(be categorized

into)

Ⅴ Cloze.

An idea perhaps _____1_____ with the Greeks was the Golden Section.
This was an aesthetic and mathematical idea concerning divine proportion, the
golden rectangle, and golden proportion. A rectangle was said to be the most
_____2_____ to the eye when it possessed a certain ratio of _____3_____ to height;
the mathematical ratio of 0.618:1. Examples of Greek _____4_____ are thought
to have contained this "divine" ratio, as well as their conception of _____5_____
relationships, for instance, from the top of hair to eyes and from the eyes to
the chin of the "perfect" face. The idea of the Golden Section continued into
the Renaissance, where Italian _____6_____ expanded the idea. I am hardly a
mathematician, but basically, you have a line, A to B; and line AB is divided at
point C, so that the ratio of the two parts of AB, the smaller to the larger, is the
same as the ratio of the larger part (CB) to the whole, AB. And this relationship is
_____7_____ expressed as 0.618:1.

1. A. originate B. originating C. original D. origin

2. A. pleasing B. pleased C. please D. plead
3. A. wide B. with C. within D. width
4. A. architect B. architecture C. architectural D. archeology
5. A. anatomical B. anatomy C. anatomically D. anatomikal
6. A. think B. thoughts C. thinking D. thinkers
7. A. mathematical B. mathematics C. mathematically D. math

Part B Specific Design Guidelines

Try to keep the viewer's eye from exiting the painting; with your arrangement of elements, learn to lead the eye around and through the image in an interesting **fashion**. If this directional movement does leave the painting **temporarily**, bring it back in nearby; **for instance**, if a line goes "off the edge", have it come back in nearby. (Note: In painting pre-1850, the image was contained within the **frame**; however, with Manet and the impressionists, images began to be more casually placed. Photography influenced painting, with its **snapshot** effects of figures accidentally being **cut off** at the edges, and the feeling that the image continues beyond the edges of the picture.)

Vertical and horizontal elements (lines, shapes) have a feeling of calm and order. Diagonals, on the other hand, are more dynamic and **suggestive** of movement.

Generally, elements or forms should not be placed in the center of the picture surface, either vertically or horizontally, because this tends to divide the image in half. (This includes the horizon in a landscape, or the back edge of the table in a still life, for instance.) There are exceptions to this rule, however, especially if other elements are designed to offset this **centering**.

The design should be balanced, without being symmetrical—this is called asymmetrical balance. This creates more visual interest than symmetry of left and right, or top and bottom.

The "weight" of elements in a work, such as shapes or forms, generally

should be toward the lower part of the canvas. However, there are many **exceptions** to this, especially in contemporary art.

Diagonals, especially in the lower part of the image, lead the viewer's eye into the space of the painting. This **is particularly true of** traditional painting, where the diagonal used might be a road or other means into the distance, as with linear perspective.

Often, an **odd** number of forms (as opposed to an **even** number) create a more interesting, less symmetrical, arrangement (e.g., five objects instead of four).

Generally, the "weight" of forms should be somewhat **equitably** distributed, as opposed to all being lumped into one area. There are exceptions, of course. Empty space can also have weight; if done **knowledgeably**, a lot of "empty" space on one side can balance a form on the other side.

The composition should ideally **be derived from** and based on the meaning of the work, from the artist's "inner **necessity**", whether the image has a subject (traditional) or is non-objective (contemporary).

New Words

guideline *n.* 方针，指导原则
fashion *n.* 样子，方式；流行，风尚
temporarily *adv.* 临时，暂时
frame *n.* 画面；框架
snapshot *n.* 快照，抓拍
suggestive *adj.* 提示的，暗示的
center *v.* 置于中心，居中

exception *n.* 除外，例外
odd *adj.* 奇数的，单数的
even *adj.* 平的，平稳的；偶数的
equitably *adv.* 平衡地；合理地
knowledgeably *adv.* 聪明地；有知识地
necessity *n.* 必要性，需要

Phrases

for instance 例如
cut off 切断，断绝

be true of 对……适用，符合于
be derived from 源自于

Exercises

I **Discuss the following questions (pair work).**

1. What was the influence of photography to painting in Western art history?

2. Why shouldn't elements or forms be placed in the center of the picture surface?

3. Do you think it necessary for composition to be derived from and based on the meaning of the work, from the artist's "inner necessity"?

II **Translate the following sentences into Chinese.**

1. Photography influenced painting, with its snapshot effects of figures accidentally being cut off at the edges, and the feeling that the image continues beyond the edges of the picture.

2. Diagonals, on the other hand, are more dynamic and suggestive of movement.

3. Generally, the "weight" of forms should be somewhat equitably distributed, as opposed to all being lumped into one area.

Space for Illustration

Use your imagination and creativity, and draw an illustration for Part A or B, after which you are supposed to explain in English why you draw it in the way you do.

素描习作（阅采尔作品）

　　素描是西方写实绘画的基础，也是一种独立的艺术形式，体现出线条之美、形体之美和光影之美。素描的方法和审美，是基于对自然的理性认识；素描的本质是形体与光照的合一。

　　Part A 谈论素描的基本方法：明暗法（shading）。文中谈到一些概念，例如明暗交界线、核心暗影、中间色调、反光、中心光点、高光等。

　　Part B 谈及透视的基本知识与形体分析的基本方法。

Unit 15 Drawing 素描

Part A Shading

In order to effectively shade form, you first need to understand the form you're shading. Organic forms found in nature, like humans, animals and trees could and should **be constructed from** the simple forms (spheres, cylinders and boxes). The primary form, such as a cylinder for an arm, should be dominant over any secondary forms. And these secondary forms should be dominant over **tertiary** forms. You don't necessarily have to draw them in that **sequence**, just make sure that your shading primarily reveals the largest forms, and the smaller forms act as details.

Form looking **three-dimensional** is a **byproduct** of correctly **capturing** the light on the form. There are two main zones on a form: **light and shadow**. The edge where the form **transitions** from light to shadow is the **terminator**. It's located just before the surface of the form starts to **face away from** the light.

Shadows

There are two types of shadows. **Form shadow** is a shadow caused by the surface turning away from the **light source**. A **cast shadow** is caused by one form **blocking** the light from **hitting** another form.

Shadows will rarely be completely black. Light **bounces off** objects in the environment and is reflected back into the shadows. This is called **reflected light**.

Along the terminator, you will see a **core shadow**. It defines the edge of the shadow. The thickness and **softness** of the core shadow can vary quite a bit. They largely depend on the angle and position of the reflecting light source. If we move the reflection source closer to the angle of the main light source, it will **illuminate** the area where the core shadow would have been.

Light Zone

Moving on to the light zone, immediately after the terminator, is the **halftone**. These are areas of the form that are **partially** hit by the direct light. As the areas get closer and closer to facing the light, they will get lighter. And the point where the form directly faces the light is called the **center light**.

The center light shouldn't **get confused with** the highlight. The difference between the two is that the center light is the area (or point) facing the light source, whereas the highlight is a reflection of the light source. It will be at the point where the light can bounce off the surface of the form and reach the viewer's eyes. The reflection will move **depending on** where the viewer is.

Reflected Light

The reflected light is lighter than the core shadow, because of reflections from the environment illuminating the shadow side.

Halftones

The halftones appear as a gradation darkest near the core shadow and lightest at the center light.

Highlight

The highlight is different from the center light, but sometimes appearing to **fall very close to** the center light. The value of the highlight depends on the **reflectivity** of the material. A **glossy** surface will have brighter highlights whereas a highlight on a **mat** surface might not be **visible** at all.

| New Words

tertiary *adj.* 第三的，第三位的
sequence *n.* 次序，顺序，序列
three-dimensional *adj.* 三维的，立体的

byproduct *n.* 副产品
capture *v.* 捕获，捕捉到
light and shadow *n.* 在这里指亮部和暗部

transition *v.* 转变，过渡；变调

terminator *n.* 明暗交界线

form shadow *n.* 形体暗影；暗部

light source *n.* 光源

cast shadow *n.* 投影

block *v.* 阻挡，阻塞

hit *v.* 击中；（光）直射

bounce *v.* 反跳，弹起，弹跳

reflected light *n.* 反光

core shadow *n.* 核心暗影

softness *n.* 柔和，柔和度

illuminate *v.* 照明，照亮；阐明，说明

halftone *n.* 中间色，中间色调

partially *adv.* 部分地

center light *n.* 中心光点

reflectivity *n.* 反射率

glossy *adj.* 平滑的；有光泽的

mat *adj.* 粗糙的

visible *adj.* 看得见的，可见的；显著的

Phrases

construct from 用……建造……

face away from 背向，背转

bounce off 从……弹起（弹离……）

get confused with 与……混淆

depend on 依据，取决于

fall close to 接近；近乎

Note

shading 明暗法（用涂明暗调子的方式在画面上塑造形体）

Grammar

宾语从句（The Object Clause）（Ⅱ）

宾语从句除了用在谓语动词之后外，还可以用在介词和非谓语动词之后以及复合宾语结构中。我们可以这样理解：介词后的成分是介词宾语，而现在我们用一个从句来充当该介词的宾语；动词在变为非谓语动词之后，仍然保留着动词的某些属性，比如可以"带出"它逻辑上的宾语，而现在充当逻辑宾语的是一个从句。

1. 用在介词之后

宾语从句可以用在介词之后，作介词宾语。（这样，介词就和宾语从句一

起构成了介词短语。）例如：

The article is about **how Xu Beihong brought the Western academic system to China**.

... some metaphysical theory of **what art should be**.

"I stroll to **where the stream begins** / then sit and watch the cloud banks turn."

2. 用在非谓语动词之后

宾语从句可以用在非谓语动词之后，作非谓语动词逻辑上的宾语。（这样，非谓语动词就和宾语从句一起构成了非谓语动词短语。）例如：

The brave citizens walked towards the king's camp, thinking **that they were taking their last steps**.

This is not to say **that Greeks were wholly without emotion**.

3. 用在复合宾语结构中

在复合宾语结构中，如果由从句来充当宾语，则宾语从句常常放在补语的后面，而原来宾语的位置上由 it 来作形式宾语。这是为了使句子平衡。例如：

I want to make it clear **that no one should go across this line**.

Exercises

I Discuss the following questions (pair work).

1. Where is the terminator located?

2. Why won't shadows be completely black?

3. Tell the difference between the center light and the highlight.

4. How does the material affect the value of the highlight?

II Fill in the blanks with the words given below, changing the form when necessary.

hit	light source	block	center light	glossy
capture	terminator	bounce	core shadow	mat

1. Ordinarily, _____ refers to the boundary between day and night.

2. The _____ can be defined as the point/area that faces the

_____ directly and perpendicularly.

3. The _____ is where both the main light and the reflected light can hardly reach.

4. The ping-pong player _____ the ball so hard that it _____ off the table and shot to the spectators.

5. This building _____ my view of the beach.

6. The sculptor precisely _____ the features of the model.

7. The Rococo artist Watteau（华托）liked to represent the _____ surface of silk.

8. She favored the _____ texture of the linen and used it in her fashion design.

III **Choose the best words to fill in the blanks, changing the form when necessary.**

1. dimension, 3-dimensional, 3-dimensionality
 a. The "depth _____" of relief is very limited.
 b. _____ printing has brought a lot of changes to design.
 c. In a way, the goal of drawing is to show the _____ of the object(s).

2. product, byproduct, produce
 a. Good _____ design can certainly upgrade the image of the brand.
 b. Smog is a _____ of excessive industrialization.
 c. During these years, he _____ some of his best drawings.

3. illuminate, illustrate, illusion
 a. The archeologist tried to _____ the cliff murals with his torch.
 b. Colors can often form visual _____.
 c. Emperor Huizong asked the candidates（举子，考生）to _____ the poetic lines.

4. part, party, partially
 a. Renoir, one of the greatest impressionists, portrays ordinary Parisians in *Luncheon of the Boating _____*.

b. The murals painted in Tang Dynasty have been _____ covered by those done in Song and Yuan.

c. The best _____ of the work is neglected by the audience.

5. reflect, reflection, reflectivity, reflector

a. The _____ of a surface depends on the texture of the material.

b. I saw a perfect _____ of arch bridge in the pond.

c. The white tablecloth can _____ more light into the shadows of the pot.

d. Using his _____, the photographer created various light effects.

6. halftone, tone, toned

a. He likes to use _____ papers to draw, and white charcoal pencil to mark the highlight.

b. When you are shading a form, the _____ is perhaps the most subtle and difficult to render.

c. The _____ is what makes a drawing vital and vivid.

Ⅳ Translate the following sentences into English.

1. 在明暗交界线处，物体表面开始背转光源。(face away from)

2. 高光与中心光点不能彼此混淆。(get confused with)

3. 明暗交界线的定位取决于形体的结构和光照的角度。(depend on)

4. 躯干是由胸腔、腰椎和骨盆构建而成的。(construct from)

5. 球击中桌面的角度接近它弹离桌面的角度（ fall close to，bounce off）

Ⅴ Cloze.

Planes can be thought of as flat _____1_____, arranged in 3D space to create a form. For example, a sphere has a front plane, top plane, side planes, and many more between that together _____2_____ a sphere. Though really a sphere is rounded, without any flat planes, thinking of it in this way will help to imagine the sphere _____3_____ a 3D object and aid in the _____4_____ process. You can

think of each section and imagine which direction that plane faces. Then compare it to the direction of the light source. The plane facing the light is the lightest and _____5_____ gets darker as they turn away. This _____6_____ of tone gives a sense of light on the form and helps to show the 3-dimensionality of the sphere.

1. A. tiles B. titles C. tires D. types
2. A. reusable B. assembly C. resemble D. assemble
3. A. with B. into C. on D. as
4. A. shading B. shaping C. shade D. to shaded
5. A. process B. progressively C. progressive D. progress
6. A. gradation B. grade C. grading D. gray

Part B Perspective and Building Blocks

Perspective

In the European Renaissance period, artists wanted to show the importance of individual person with realism. The flat medieval style couldn't show this level of reality and the artists needed a new technique. It was the Italian artist Brunelleschi who discovered the technique of perspective drawing. At first the artists of the Renaissance only had single-point perspective. Later they realized that they could have two-point perspective and still later multi-point perspective.

Imagine you are standing in an absolutely flat desert. The far edge of the desert which you can see is your "eye level". If you **crouch down**, your eye level, of course, lowers. If you stand in the middle of a long, straight street, the far end of the street will be on your eye level. The two sides of the road seem to come together on your eye level. And indeed most of the lines seem to **come down to** your eye level: the tops of the buildings, the tops and bottoms of windows, etc.

Wherever you are now, you can probably see an example of these "perspective lines" coming down or up to your eye level. However, perspective

is not as easy as that! There are exceptions! Only vertical and horizontal **surfaces** seem to meet on eye level. The sides of **sloping rooftops**, for example, don't meet on eye level!

Basic building blocks

A structure has three basic building blocks, spheres, cylinders and **cubes**. You can simplify **pretty much** any organic object into these three forms or a combination of these three forms.

You can also stretch and bend these forms to better fit the character of the subject. A sphere can be **modified** to an egg shape; a cylinder can **taper** thinner to one end like you'd see in a leg. At its extreme, a tapering cylinder would become a cone.

A cube can be stretched to be more rectangular. And the sides don't have to be the same size. Basically, think of these forms as if they're made of **play-dough**. You can **deform** them as you wish.

We construct from these basic building blocks because it's a lot easier to imagine simple forms **three-dimensionally** than complex forms.

Having established this 3D idea allows you to visualize and construct the finer details in perspective more accurately.

▌New Words

crouch v. 蜷缩；蹲伏	**modify** v. 更改，修改
surface n. 表面，形体的面	**taper** v. 逐渐变细；逐渐减少
sloping adj. 倾斜的，有坡度的	**play-dough** n. 橡皮泥
rooftop n. 屋顶	**deform** v.（使）变形
cube n. 立方体，立方	**three-dimensionally** adv. 三维地，立体地

▌Phrases

crouch down 下蹲	**pretty much** 几乎，差不多
come down to 归结为，汇聚为	

Notes

Brunelleschi 布鲁内莱斯基（意大利画家、建筑师）
single-point perspective 单点透视

two-point perspective 双点透视
multi-point perspective 多点透视
eye level 视平线

Exercises

I **Discuss the following questions (pair work).**

1. What is the reason why the technique of perspective was generated?
2. Where may the sides of a sloping rooftop meet?
3. Have you ever played play-dough? What does the word "play-dough" in the sixth paragraph indicate?

II **Translate the following sentences into Chinese.**

1. The flat medieval style couldn't show this level of reality and the artists needed a new technique.
2. Indeed most of the lines seem to come down to your eye level: the tops of the buildings, the tops and bottoms of windows, etc.
3. You can also stretch and bend these forms to better fit the character of the subject.

Space for Illustration

Use your imagination and creativity, and draw an illustration for Part A or B, after which you are supposed to explain in English why you draw it in the way you do.

《免于匮乏的自由》(罗克威尔作品)

　　罗克威尔是美国家喻户晓的插图画家和风俗画家。说起罗克威尔，人们就会想起他那精湛的写实技巧、妙趣横生的叙事画面。他的绘画每每能传达出生活中善意的、单纯的以及幽默的一面。

　　Part A 是一篇纪念性文章，着重介绍了罗克威尔以"四大自由"命名的系列插画（illustration）以及他的绘画与美国梦这个概念之间的关系。在某种程度上，他的画是美国梦的图像。

　　Part B 介绍罗克威尔的另外几幅作品，分别是：《三重像》《持守己见》《金科玉律》。

Unit 16 Norman Rockwell
诺曼·罗克威尔

Part A Norman Rockwell

In a simple room, generations gather for a **bountiful** Thanksgiving **feast**. In a **dimly** lit bedroom, a mother and father **tuck their children safely into** bed. At a town meeting, a man stands tall and proud among his neighbors. In a crowd, every head is bent in **fervent** prayer. This is Norman Rockwell's America as depicted in his famous *Four Freedoms* series. More than one hundred years after his birth, he is achieving a new level of recognition and respect around the world.

Norman Rockwell thought of himself first and foremost as a commercial illustrator. **Hesitant** to consider it art, he **harbored** deep **insecurities** about his work. What is **unmistakable**, however, is that Rockwell **tapped into** the **nostalgia** of a people for a time that was kinder and simpler. His ability to create visual stories that expressed the wants of a nation helped to **clarify** and, in a sense, create that nation's vision. His prolific career spanned the days of horse-drawn **carriages** to the **momentous** leap that landed mankind on the moon. While history was in the making all around him, Rockwell chose to **fill his canvases with** small details and **nuances** of ordinary people in everyday life. Taken together, his many paintings capture something much more **transcendent**—the essence of the American spirit. "I paint life as I would like it to be," Rockwell once said. **Mythical**, idealistic, innocent, his paintings evoke a **longing for** a time and place that existed only in the **rarefied** realm of his rich imagination and in the hopes and **aspirations** of the nation. According to **filmmaker** Steven Spielberg, "Rockwell painted the American dream—better than anyone."

Born in New York in 1894, Rockwell had early hopes of becoming an artist. As a young man he left high school to attend art school. By 1916 Rockwell had created his first of many *Saturday Evening Post* covers. In 1942, **in response to** a speech given by President Franklin Roosevelt, Rockwell made a series of paintings that **dealt with** the *Freedom of Speech*, *Freedom of Worship*, *Freedom*

from Want, and *Freedom from Fear*. In the 1960s, **prompted** by his third wife, new markets, and by the times, Rockwell began to exhibit a strong sense of social consciousness. His images, which had **primarily** dealt with a **utopian** vision of the country, began to **address** realistic concerns.

Today, more than twenty years after his death, in 1978, Norman Rockwell's star is once again rising. *Freedom from Want*, that **inviting** portrait of a New England Thanksgiving dinner, was recently the centerpiece of an exhibit at the National Museum of American Art in Washington, D.C. In an era of abstract expressionism, Rockwell never achieved the critical height of contemporaries like Jackson Pollock, but his familiar images have found a **permanent** place in the American **psyche**.

New Words

bountiful *adj.* 慷慨的，宽大的
feast *n.* 盛宴，筵席，宴会，酒席
dimly *adv.* 微暗地，朦胧地
fervent *adj.* 炽热的，表现出极大热心的
hesitant *adj.* 犹豫的，迟疑不决的
harbor *v.* 持有，抱有
insecurity *n.* 不安全，不安全感
unmistakable *adj.* 明白无误的，不会弄错的
nostalgia *n.* 乡愁，怀旧之情
clarify *v.* 澄清，阐明
carriage *n.* 马车，客车
momentous *adj.* 重大的，重要的
nuance *n.* 细微差别，微妙之处

transcendent *adj.* [宗]（神）超验的
mythical *adj.* 想象的；神话的；虚构的
rarefied *adj.* 纯净的；稀薄的
aspiration *n.* 热望，渴望
filmmaker *n.* 电影摄制者
prompt *v.* 提示；鼓动，促使
primarily *adv.* 首先，起初；主要地，根本上
utopian *adj.* 乌托邦的；理想化的
address *v.* 从事，忙于
inviting *adj.* 引人动心的，有魅力的
permanent *adj.* 永久的，持久的
psyche *n.* 灵魂；精神

Phrases

tuck into 藏进
tap into 进入（某种领域）
fill with 使充满

long for 渴望
in response to 响应，适应
deal with 处理；涉及

| Notes

Norman Rockwell 诺曼·罗克威尔（美国画家）

Steven Spielberg 史蒂文·斯皮尔伯格（美国电影导演）

Saturday Evening Post《星期六晚邮报》

New England 新英格兰（美国东北地区）

abstract expressionism 抽象表现主义

Jackson Pollock 杰克森·波洛克（抽象表现主义画家）

Grammar

宾语补足语和主语补足语
（The Object Complement and the Subject Complement）

1. 宾语补足语

英语中有些及物动词（如 call, let, consider, make, see 等）有时带了宾语后意义仍不完整，还需再有一些词或词组来补充说明宾语所做的动作或所处的状态，这部分补充的内容与宾语在逻辑上构成主谓关系，称为宾语补足语。

宾语补足语可以由名词、形容词、副词、介词短语、动词不定式、分词等充当。例如：

Looking at the stars always makes me **dream**.（动词不定式作补足语）

To make graphic design **more effective**...（形容词作补足语）

Norman Rockwell thought of himself first and foremost **as a commercial illustrator.**（介词短语作补足语）

Being a potter makes one automatically **interested in what other potters have done**.（分词短语作补足语）

Science makes us **real**.（形容词作补足语）

2. 主语补足语

带宾语补足语的句子，改为被动语态时，原来的宾语成为主语，而原来的宾语补足语成为补充说明主语的部分，称为主语补足语。例如：

His work has been largely considered **abstract**.（形容词作补足语）

Copying in China, on the other hand, was seen **as a valuable educational tool**. （介词短语作补足语）

注意：不带to的动词不定式补足语只存在于宾语补足语中，在主语补足语中，必须带to。例如：

主动语态：Looking at the stars always makes me **dream**.

被动语态：I was made **to dream**.

Exercises

I **Discuss the following questions (pair work).**

1. What is the significance of Rockwell's work?
2. When did Rockwell start to concern about social reality?
3. Which do you prefer, Jackson Pollock or Norman Rockwell?

II **Fill in the blanks with the words given below, changing the form when necessary.**

feast	nostalgia	carriage	nuance	dimly
bountiful	momentous	permanent	utopian	inviting

1. He is good at capturing the _____ of colors and shades.
2. What is represented in this novel is a wave of _____ for the age of handicrafts.
3. "Model-T" took place of horse-drawn _____ in 1920s, thanks to Fordism.
4. The gardens in Suzhou are small but _____.
5. The Statue of Liberty was _____ visible in the morning gloom.
6. They need to offer a(n) _____ solution to the problem of smog.
7. His hard work is bringing _____ reward.
8. Besides *Last Supper*, do you know any other paintings about _____?
9. The speech by Roosevelt was _____ for Rockwell, for World

War II, and for the post-war history.

10. Tao Yuanming depicted a(n) _____ world in his prose.

Ⅲ Choose the best words to fill in the blanks, changing the form when necessary.

1. hesitate, hesitant, hesitance

 a. The historian _____ to give a judgment on that period of time.

 b. Don't be _____; there is no time for _____.

2. secure, security, insecurity

 a. In the logo, "s" stands for _____.

 b. She has strong sense of _____, which is why she prefers to stay at home.

 c. "In the future days, which we seek to make _____, we look forward to a world founded upon four essential human freedoms." (Roosevelt)

3. mistake (*n.*), mistake (*v.*), unmistakable

 a. He often _____ me for somebody else.

 b. We do make many _____, yet we learn from them.

 c. It's _____ that this is a product of Apple, Inc.

4. clear (*adj.*), clarity, clarify

 a. A good graphic design needs to be _____ and clever.

 b. Before working, I need to _____ my mind.

 c. The photographer caught such a fleeting event with such stark _____.

5. mythology, mythical, mysterious

 a. A lot of classical artworks were based on Greek _____.

 b. He was interested in this _____ pattern and used it his design.

 c. The American scholar is fond of oriental culture, which is _____ and fantastic in his eyes.

6. psyche, psychology, psychological

 a. The _____ research of Sigmund Freud greatly influenced modern art.

b. The artist used to be majored in _____.

c. He is exploring the mysteries of human _____.

IV Translate the following sentences into English.

1. 他把画笔、颜料以及水塞到旅行包里，准备出发了。(tuck into)

2. 在某种意义上，罗克威尔的画延伸和丰富了罗斯福的"四大自由"。(in a sense)

3. 人类的历史充满了矛盾、荒诞与不可思议。(fill with)

4. 高更渴望自然、纯朴的生活，因而离开了巴黎。(long for)

5. 响应党的号召，他到西部去支教了。(in response to)

6. 这本书论及第二次世界大战以及"冷战"。(deal with)

V Cloze.

The speech of Roosevelt so inspired the _____1_____ Norman Rockwell that he _____2_____ a series of paintings on the "Four Freedoms" theme. In the series, he translated abstract concepts of freedom _____3_____ four scenes of everyday American life. Although the government initially rejected Rockwell's offer to create paintings on the "Four Freedoms" theme, the _____4_____ were publicly circulated when the *Saturday Evening Post*, one of the nation's most popular magazines, commissioned and reproduced the paintings. After _____5_____ public approval, the paintings served _____6_____ the centerpiece of a massive U.S. war bond drive and were put into service to help explain the war's aims.

1. A. illustrator B. illustration C. illustrate D. illustrating

2. A. invented B. created C. discovered D. manufactured

3. A. as B. into C. to D. for

4. A. imagery B. imagination C. imaginative D. images

5. A. winning B. win C. won D. wins

6. A. to B. as C. against D. for

Part B Other Works of Rockwell

Triple Self-Portrait

Rockwell **pokes fun at** himself in 1960's *Triple Self-Portrait*.

There are a lot of interesting details in this picture. Rockwell had self-portraits of masters pinned to the upper right of his work, where we see Durer, Rembrandt, van Gogh, and a **funky** post-cubist Picasso. Influenced during his student years by Durer's superb **draftsmanship**, Rockwell puts him at the top of his canvas. Next **in line** is Rembrandt, whose painting style Rockwell admired above all others. Below it is Picasso, whom Rockwell admired greatly but whose work, he admitted, was opposite to his own. Last is van Gogh, a painter with whom Rockwell never identified, and whose style his own work never resembled. Unlike Rockwell, all four artists produced numerous formal self-portraits—Rembrandt is known to have done more than 90. Rockwell produced only three full-color self-portraits. Rockwell was thrilled when, on a trip to Paris, he saw the **helmet** that sits atop his easel in an antique shop. He was sure it was centuries old, of Greek origin… or perhaps Roman. After purchasing it, he stopped to observe a fire. He realized that the same helmet that he was sure was a precious antique was typical Parisian fireman's **gear**.

The Holdout

There is a **holdout** in this tense jury scene. It has been a long hard **deliberation** if we read the table **detritus** and **debris** on the floor. A lone but determined female is **wreaking havoc** in the man's world of 1959.

Most of the models are Rockwell's friends and neighbors. The artist enjoyed his small-town life as he knew many of the faces and could often find just the right one for a particular scene right at home. The gentleman leaning down behind the woman and attempting to be **persuasive** is our beloved artist and model himself. Rockwell made a sort of Jack Benny joke about it—he appeared in the painting because he wouldn't have to pay himself a model's fee.

The Golden Rule

This painting can be taken as a statement of Norman Rockwell's **credo**. To illustrate the saying "Do unto others as you would have them do unto you," he crowded his canvas with a symbolic catalogue of the family of man. Christians and **Hindus**, Muslims and Jew, **Buddhists** and **Shintoists** stand shoulder to shoulder in a **hieratic** composition that draws its strength from its solemnity.

Although not unique in Rockwell's work, this kind of painting is certainly **atypical**. Usually his work is designed to be seen to maximum effect on the printed page. In this instance we can imagine that the composition might have succeeded just as well—perhaps even better—if it had been executed as a mural.

▎New Words

poke *v.* 戳，捅，刺

funky *adj.* 新潮的，时髦的

draftsmanship *n.* 绘画技巧

helmet *n.* 头盔，钢盔

gear *n.* 齿轮，传动装置

holdout *n.* 坚持

deliberation *n.* 熟思，商议，考虑；从容

detritus *n.* 碎石

debris *n.* 碎片，残骸

wreak *v.* 发泄（怒火）

havoc *n.* 大破坏，浩劫

persuasive *adj.* 善说服的

credo *n.* [宗] 信条

Hindu *n.* 印度人，印度教教徒

Buddhist *n.* 佛教徒

Shintoist *n.* （日本）神道教徒

hieratic *adj.* 僧侣的；神圣风格的（构图）

atypical *adj.* 非典型的

▎Phrases

poke fun at 开玩笑，凑趣

in line 一致，协调，有秩序

wreak havoc 造成破坏

▎Notes

Triple Self-Portrait 《三重像》（罗克威尔作品）

Durer 丢勒（德国画家）

The Holdout 《持守己见》（罗克威尔作品）

Jack Benny joke 杰克·本尼式笑话

The Golden Rule 《金科玉律》（罗克威尔作品）

Exercises

Ⅰ **Discuss the following questions (pair work).**

1. What did the helmet that he was sure was a precious antique turn out to be?

2. In *The Holdout*, who is Rockwell himself among the twelve figures?

3. Why is *The Golden Rule* atypical of Norman Rockwell?

Ⅱ **Translate the following sentences into Chinese.**

1. It has been a long hard deliberation if we read the table detritus and debris on the floor.

2. "Do unto others as you would have them do unto you."

3. In this instance we can imagine that the composition might have succeeded just as well—perhaps even better—if it had been executed as a mural.

Space for Illustration

Use your imagination and creativity, and draw an illustration for Part A or B, after which you are supposed to explain in English why you draw it in the way you do.

百斯特连锁店

　　"二战"之后，现代主义成为设计的基本面，国际风格欲将覆盖全球。但是，现代主义有其短板，例如，它冰冷且缺少情感，而人生活在纯粹现代主义的环境和产品中也未见得是舒适的。此外，现代主义容易造成设计形态的同质化。于是，在注重情感表达与力求多样的努力中，出现了后现代主义设计，成为对现代主义的反动与修正。

　　另一方面，由于经济和工业的发展，人类进入消费社会，消费的欲望超出了人们对于产品的功能性需求，而设计也在有意无意地迎合这种趋势，打造出千奇百怪的时尚。生产与消费的狂潮势必会造成诸多社会、文化和环境问题。于是，设计伦理与设计价值的研究应运而生，为需求的（而非为欲求的）设计、基于社会责任的设计、可持续设计等观念不断跃入设计的视野。

　　Part A 概述了现代主义之后设计的演变，主要体现在几个方面：1）现代主义理念的延续；2）后现代主义的出现；3）设计伦理—绿色设计理念的形成。

　　Part B 是对后现代主义设计的概述。

17 Design After Modernism
现代主义之后的设计

Part A Design After Modernism

The years following World War II **were characterized by** enormous change on every level. The most marked changes occurred in America, Italy, **Scandinavia**, and Japan. A growing number of American firms such as the Herman Miller Furniture Company began to build a reputation for manufacturing and marketing well-designed, high-quality, inexpensive furniture made from new materials like fiber, glass and plastics for the consumer market in the postwar years. In an effort to revive their **depressed** postwar economy, Italian designers **made a self-conscious effort** to establish themselves as leaders in the international market place for domestic design. While initially they **looked to** traditional forms or materials for inspiration, they also soon **embraced** new materials and technologies to produce **radically** innovative designs. **Scandinavian** designers preferred to combine the traditional beauty of natural materials with advanced technology, giving their designs a warm and **domestic** yet modern quality. Japanese designers strove to create a balance between traditional Asian and international modern aesthetics.

At the same time, **in reaction to** the **impersonality** of mass production, a group of artist-designers who were interested in **keeping alive** the **time-honored** practices of hand-working traditional materials emerged during the 1960s. Their **one-of-a-kind** objects, helped elevate design to the status of art.

The last quarter of the twentieth century saw a **surge** of **unbridled consumerism** manifested in a number of diverse, often **contradictory**, design currents. Some designers chose to conform to modernism, seeking expression through form rather than applied ornament. Others developed a postmodernism that **celebrated** the **vernacular** and **reinterpreted** motifs of the past. Many designers consciously abandoned the creation of useful objects in favor of **nonfunctional** design. Toward the end of the 1980s, some designers, recognizing the **inherent** beauty of materials developed for science, began to **employ**

them in a wide range of consumer products. In the century's last decade, the environment became a major concern for designers who offered "green" and socially responsible solutions to design problems.

Late Modernism

International Style developed in Europe between the two world wars and dominated design throughout the twentieth century. From 1975 onward, late modernist projects were guided by the **conviction** that **rationalist** design had yet to be fully realized.

Historicism

From the late 1970s to the 1980s, many architects and designers, **reacting against** the **dictates** of modernism, looked to **Neoclassical** forms and materials for inspiration. Visual references derived from art and architecture **superseded functionalism,** and historical references and decoration transformed architecture, furniture, tabletop accessories, even jewelry, into objects of fantasy.

Memphis School

An anti-design movement **energized** Italian design throughout the 1960s and 1970s. Radical design groups were established **in opposition to** the pure functionalism of the International Style. In 1981, Ettore Sottsass formed a loosely organized group to pursue an ironic approach to design. Struck by the diverse implications of "**Memphis**", the designers adopted the name. It suggested not only the typical American city, the blues, and **suburbia,** but also the visions of the ancient Egyptian capital, thus **signaling** contemporary and historical meanings as well as high and low cultures.

New Words

Scandinavia *n.* 斯堪的纳维亚（半岛）

depressed *adj.* 情绪低落的，沮丧的；萧条的

embrace *v.* 欣然接受

radically *adv.* 根本地，彻底地

Scandinavian *adj.* 斯堪的纳维亚（人）的

domestic *adj.* 家庭的，家的；国内的

impersonality *n.* 非人性化；缺少人情味

time-honored *adj.* 历史悠久的，源远流长的

one-of-a-kind *adj.* 独特的，独一无二的

surge *n.* 汹涌；激增

unbridled *adj.* （马等）无辔头的；不受约束的

consumerism *n.* 消费主义

contradictory *adj.* 对立的，互相矛盾的

celebrate *v.* 庆祝；称颂

vernacular *adj.* 民间风格的；当地风格的

reinterpret *v.* 重新解读，重新诠释

nonfunctional *adj.* 非功能性的

inherent *adj.* 固有的，内在的

employ *v.* 雇佣；采用，利用

conviction *n.* 确信；信念

rationalist *adj.* 理性主义的

historicism *n.* 历史主义

dictate *n.* 命令；规定，规则

Neoclassical *adj.* 新古典主义的

supersede *v.* 取代，替代

functionalism *n.* 功能主义

energize *v.* 加强，给……以活力

Memphis *n.* 孟菲斯（古埃及城市；美国城市）

suburbia *n.* <贬> 郊区及其居民；郊区习俗

signal *v.* 发信号；示意；昭示

Phrases

be characterized by 以……为特征

make an effort 作出努力

look to 指望；依靠

in reaction to （作为）对……的回应

keep alive (keep...alive) 使……活着；使……继续

react against 反对，反抗

in opposition to （作为）对……的反对

Notes

Herman Miller Furniture Company 赫尔曼·梅勒家具公司

Late Modernism 新现代主义（或：后期现代主义）

Memphis School 孟菲斯设计学派

anti-design movement 反设计运动

International Style 国际风格

Ettore Sottsass 埃托·索特萨斯（意大利设计师）

Grammar

定语从句（The Attributive Clause）（Ⅱ）

1. 关系代词前带介词的定语从句

关系代词 which/whom 引导的定语从句作介词宾语。此时，我们也可以说这是由介词 + which/whom 引导的定语从句。例如：

Last is van Gogh, a painter **with whom Rockwell never identified**, and whose style his own work never resembled.

这类定语从句的介词也可放在从句的末尾。例如：

It is the scaffolding **which the visual forms hang on**.

由名词（代词或数词）+ 介词 + which/whom 引导的定语从句。例如：

There are other numerous viewpoints, **each of which can be further subdivided**, depending on a particular emphasis.

The products of design that result from this multi-faceted process are not the outcome of individual designers, but the outcome of teams of individuals, **all of whom have their own ideas and attitudes about how things should be**.

2. 关系代词 as 引导的定语从句

as 也可以用作关系代词，在引导定语从句时，常与主句中的 the same 或 such 相呼应。例如：

He did not attach **the same** importance **as they do to rigorous accuracy on this point** because he aspired to surpass nature.

Do you like **such** bold composition **as Whistler made**?

3. 限定性定语从句和非限定性定语从句

有些定语从句对先行词具有限制的作用，使该词的含义更具体、更明确，这种定语从句称为限定性定语从句。这类定语从句不能省略，否则句子的意义就不完整。例如：

A great many people **who want to retire me now** were never very eager to advance me.

Employers are seeking designers **who are well trained, open to new ideas, and can adapt well to changing trends**.

有些定语从句跟先行词的关系并不十分密切，只是作一些附加说明，这种定语从句称为非限定性定语从句。这类定语从句往往用逗号与主句隔开。例如：

He first presented *The Vanquished* in Brussels, **where critics were suspicious of the statue's incredible realism**.

The first revolutionary was U.S. architect Robert Venturi, **who declared abruptly in the early seventies: "less is a bore."**

有时这类定语从句所修饰的不是前面某一个词，而是整个主句所讲的内容。例如：

Shapes also can vary in size, **which helps to establish spatial depth**.

These differences put Cézanne in the category of post-impressionism, along with Gauguin, van Gogh and others, **which means that as a group they were much influenced by impressionism, but their works moved forward from it to other artistic concerns.**

Exercises

I **Discuss the following questions (pair work).**

1. Where did Italian designers try to establish themselves as leaders? Why did they do so?
2. Who helped elevate design to the status of art in 1960s?
3. List some design trends that appeared during the last quarter of the 20th century.
4. What does the word "Memphis" imply?

II **Fill in the blanks with the words given below, changing the form when necessary.**

embrace	domestic	time-honored	Neoclassical	surge
unbridle	vernacular	conviction	supersede	employ

1. He painted some of his works in prison, which represented his political _____ .

2. In a way, it is online-shopping and online-payment that _____

people's consumption.

3. Being a(n) _____ handicraft, Xiang Embroidery（湘绣）is now identified as an intangible cultural heritage.

4. He could neither conform to the past, nor could he _____ the present.

5. This design studio specializes in _____ appliances (utensils).

6. He is fascinated with _____ architecture and furniture, in pursuit of which he has travelled all over the world.

7. The furniture company _____ plywood instead of metal tube.

8. This spring saw a(n) _____ of the epidemic.

9. David（达维德）is considered as a representative of _____ painting.

10. Artificial intelligence has begun to _____ man's artistic creation.

Ⅲ **Choose the best words to fill in the blanks, changing the form when necessary.**

1. consume, consumer, consumption, consumerism

 a. _____ is poisoning the minds and souls of people as if by magic.

 b. In the _____ society, man's desire for _____ is "made" and "guided"; people _____ for the symbolic meaning of products, that is, the social identities, the fashions and the lifestyles.

2. history, historical, historically, historicism

 a. _____, painters tended to gather together to form "schools" of painting.

 b. You must place these designs in their _____ context when you are making a study over them.

 c. The 1970s saw a revival of _____ and eclecticism in design.

 d. The _____ of design is an all-embracing subject.

3. function (n, v), functional, nonfunctional, functionalism

 a. The _____ of adjective is to describe or add to the meaning of noun.

b. The old machine won't _____ properly if you don't oil it regularly.

c. Besides being _____ , a product should also be visually pleasant.

d. To react against the dominance of Bauhaus _____ , these Italians deliberately designed some _____ products.

4. energy, energetically, energize

a. Design must take ecology, _____ conservation, recyclability, durability, and ergonomics into consideration.

b. These new materials will _____ our light industry.

c. This company is _____ producing respirators.

5. personality, impersonal, impersonality

a. A design work is also a mirror of the designer's _____ .

b. These architectures look sparse, repetitive and _____ , which was a consequence of the building boom in 1980s.

c. Scandinavian domestic design, which is warm, fresh and natural, serves to heal the _____ of the urban life.

6. dictate, contradiction, contradictory

a. Many young people's "street fashions" reject the _____ of the fashion industry.

b. In his *Complexity and* _____ *in Architecture*, Robert Venturi criticized the International Style.

c. He is notorious for making _____ statements.

IV Translate the following sentences into English.

1. 德国设计总是以理性、严谨为特征，这尤其体现在产品设计上。(be characterized by)

2. 针对他们的封锁和制裁，我们努力建立重工业，并开采石油。(in reaction to，make an effort)

3. 为了使这种历史悠久的手工艺薪火相传，他们不遗余力。(keep... alive)

4. 文丘里宣称："少则乏味"，反对米斯的建筑理念。(in opposition to)

5. 历史主义往往意味着在先前的风格与形式中寻找灵感。(look to...for)

Ⅴ Cloze.

One of the great success stories of consumer-led design in the 1980s was the Swatch watch. Swatch watches were ___1___ in 1983, a new product development created to ___2___ a viable future for the Swiss company Eta. In the 1970s, the Swiss watch industry was threatened with collapse under the weight of cheap, accurate quartz（石英）digital watches that were manufactured in the Far East. Swiss companies, with higher labor and production ___3___, could not compete on price; instead, Swatch was marketed as a lifestyle product— a fashion ___4___ for the young, design-conscious consumer ___5___ the world. By the way, the variety of appearances we have come to associate with the Swatch belies the standardization of the underlying ___6___ construction.

1. A. launch B. lunched C. launching D. launched
2. A. ensure B. sure C. surely D. ensured
3. A. costs B. coasts C. coats D. casts
4. A. access B. accessible C. accessory D. assessment
5. A. cross B. across C. crossing D. crisis
6. A. modern B. modular C. model D. module

Part B Postmodernism

Postmodernism is the term that describes the **stylistic** developments that emerged **in response to** the rationalism of modernist design. The move toward postmodernism was initiated in the 1960s. Postmodernists believed that the efforts of modernism had resulted in the creation of **incomprehensible** works of art, soulless objects, and unwanted buildings that people could not bear to **live with**. In Robert Venturi's 1966 book, *Complexity and Contradiction in Architecture*, he questioned the validity of the emphasis that modernists placed on logic, simplicity, and order, suggesting that **ambiguity** and contradiction also had a valid place. Venturi argued that modern architecture was essentially

meaningless. Early postmodernists regarded the lack of ornament and geometric abstraction **championed** by the modernists as **dehumanizing** architecture, and, as a result, alienating it.

Postmodernism advocated the merging of fine art and mass culture, **highbrow** and **populist** art. Surface decoration was once again admired, and other styles were **drawn upon** freely. By the mid-1970s, American architects such as Michael Graves had begun to introduce decorative and often ironic motifs into their works. These regularly **referenced** past decorative styles, such as Art Deco, Constructivism, and De Stijl. The introduction of color, decoration, texture, references to historical styles, and the eccentric elements characterized by the work of Memphis School quickly became integral to the postmodern style. Bright, bold designs were applied to everything; ceramics, textiles, jewelry, **silverware**, furniture, and lighting were all produced in limited editions. The Memphis group produced a number of smaller objects and furniture pieces that displayed postmodern characteristics. Playful and humorous in their approach, postmodernists loved decoration and color as much as modernists hated them, and with their **irreverent, audacious** approach to design, played by their own rules.

While modernists rejected historicism, decoration, and the vernacular, postmodern designers drew upon these resources to expand their range of design possibilities. Collage, **photomontage** inspired by Cubism and dada, and the **assimilation** of the vernacular all contributed to postmodern design of the late 1970s and early 1980s, as designers, sensing that the modern aesthetic no longer held relevance in postindustrial society, began to broaden their visual vocabulary by breaking established rules and exploring different periods, styles, and cultures.

Postmodernism flourished during the **decadent** 1980s as the style became increasingly diverse, encompassing **deconstructionism**, high-tech and post-industrialism. However, by the early 1990s, as the recession **loomed**, designers began looking for a more rational approach.

New Words

stylistic *adj.* 风格上的；创作技巧的

incomprehensible *adj.* 难以理解的，难懂的

ambiguity *n.* 歧义；不明确，模棱两可

champion *v.* 支持；为……而斗争，捍卫

dehumanize *v.* 使失去人性，使非人化

highbrow *adj.* 文化修养高的；高雅的

populist *adj.* 平民主义的；平民化的

reference *v.* 引用

silverware *n.* 银器，镀银器皿

irreverent *adj.* 不敬的，不惧权威的

audacious *adj.* 大胆的，大胆创新的

photomontage *n.* 蒙太奇照片

assimilation *n.* 吸收；接受

decadent *adj.* 堕落的，颓废的

deconstructionism *n.* 解构主义

loom *v.* 隐约地出现；迫在眉睫

Phrases

in response to 对……作出反应

live with 学会去适应；接受并忍受

draw upon 利用，使用，采用

Notes

Robert Venturi 罗伯特·文丘里（美国建筑师）

Complexity and Contradiction in Architecture 《建筑的复杂性和矛盾性》（罗伯特·文丘里著）

Michael Graves 迈克尔·格雷夫斯（美国建筑师）

Art Deco 装饰派艺术

Constructivism 构成主义

Memphis group 孟菲斯小组

Exercises

I Discuss the following questions (pair work).

1. What had the efforts of modernism resulted in according to postmodernists?

2. Where did Michael Graves's decorative motifs originate from?

3. Why did postmodern designers draw upon historicism, decoration, and the vernacular according to the third paragraph?

Ⅱ Translate the following sentences into Chinese.

1. Early postmodernists regarded the lack of ornament and geometric abstraction championed by the modernists as dehumanizing architecture, and, as a result, alienating it.

2. Postmodernists loved decoration and color as much as modernists hated them.

3. While modernists rejected historicism, decoration, and the vernacular, postmodern designers drew upon these resources to expand their range of design possibilities.

Space for Illustration

Use your imagination and creativity, and draw an illustration for Part A or B, after which you are supposed to explain in English why you draw it in the way you do.

"White herons drift across flooded rice fields."
插图作者：清华大学美术学院 美211班 李佳娟

　　诗与画有很多不同之处，但在艺术上，它们都寻求超乎语言、形式、物象之外的境界和意蕴，所谓"言外之意，象外之象，韵外之致"。

　　本单元介绍两位艺术家，温斯洛·霍默和王维。霍默是 19 世纪伟大的水彩画家。他描绘北美的荒野、巴哈马的海滩，画面体现出含蓄的诗性。

　　中唐以后，由于禅宗的介入和社会生活的变化，中国的诗歌与绘画逐渐形成了一种体悟的、禅意的审美形态，这可以上溯至诗人兼画家王维。他最为人称道的是那些禅意诗，空灵而明澈，有着鲜活和敏锐的感受性，对后世产生了深远的影响。

　　Part A 介绍霍默的水彩画，文中也有许多关于水彩画的语汇，兼具实用性。

　　Part B 简述王维的生平和诗画。文后附加一首小诗，名为《诗是什么？》。

Unit 18 Poetry and Painting 诗与画

Part A Winslow Homer, a Master of Watercolor

The second half of the 19th century was one of the greatest periods for painting in the history of the Western world, and one of the great painters of the era was Winslow Homer. His works, especially the seascapes of his old age, constitute a major American contribution to the artistic treasures of the human race.

Homer was a contemporary of such great French impressionists as Manet, Renoir and Degas, and he worked in a manner that bore some resemblance to theirs but was at the same time quite different.

Homer was never more relaxed, nor more completely himself, than in his **watercolors.** They are fresh, spontaneous, and alive. He gave many summers to their creation, finding his subjects on fishing trips in the Adirondacks and the Canadian **wilderness.** And during the winter he occasionally **slipped away** to the **tropics,** with his paint-box **packed** in his bags.

What makes Homer's watercolors so outstanding is not their subject matter—woods, lakes, rivers, hunters and fishermen, **tropical** waters and Negros—but their simplicity and freedom, their **transparency** and **luminosity,** their extraordinary color sense, and their **celebration** of physical sensations. They **distill** nature, and while they often include the savage cruelty of the **outdoors,** they remain consistently beautiful.

As he increased his control over the watercolor medium, Homer was able to convey, through the most economical means possible, the spirit of the living moment. This is his achievement in *Shooting the Rapids*, a Canadian scene painted when he was 66. Here, the vigor of his brush conveys the fury of the water; white paper breaking through thin washes catches the reflected light of an **overcast** sky; a **bleeding** area of watery paint in the background **conjures** the dense **foliage** of a hillside. And **throughout,** muted color captures the dullness and coolness of the day—black, brown, dark blues and greens.

Of the many watercolors Homer produced from the 1880s onward, the most brilliant are those he painted in the tropics. The sun shines in them with a shimmering brightness new to his work, as though its southern warmth had melted the aging artist's **Yankee reserve**. Colors appear which were **denied him** in the north woods—fresh greens, reds, and bright blues—and often a figure is prominent in the foreground, as in *Under the Coco Palm*.

One of the qualities that **distinguish** Homer's watercolors is their sense of design. In *Sloop, Bermuda*, for example, rhythms **lace** through the picture— the loops of sail, the clean lines of the boat repeated in the **dinghy** behind it, the **undulating swells** of water, and the churned **turbulence** of the sky.

Another quality **setting Homer's watercolors apart** is their ability to suggest, through mere **flicks** of the brush, the bodies and features of men. Because of the skill with which he painted them, they are not just types but carry the weight of real men. Homer **built up** the faces with washes of color and still preserved a transparency.

New Words

watercolor *n.* 水彩；水彩颜料；水彩画

wilderness *n.* 荒野

tropics *n.* 热带地区

pack *v.* (把……)打包；塞进

tropical *adj.* 热带的；炎热的

transparency *n.* 透明；透明度；透明性

luminosity *n.* 光感

celebration *n.* 赞扬，赞美，颂扬

distill *v.* 提取……的精华；提炼

outdoors *adv.* 在户外 *n.* 户外，野外

overcast *adj.* 天阴的，多云的

bleed *v.* (颜色)渗开，弥散

conjure *v.* 变魔术般地创造出

foliage *n.* 植物的叶子(总称)；灌木丛

throughout *prep.* 贯穿……期间；遍及……地域 *adv.* 处处；始终

Yankee *adj.* 美国北方人的；美国佬式的

reserve *v.* 储备，保留；预约 *n.* 寡言，矜持，内敛

deny *v.* 拒绝给予

distinguish *v.* 区分，辨别；(使)杰出

lace *n.* 蕾丝；透孔织品 *v.* 用带子穿过，在……上穿带子

dinghy *n.* 小艇

undulate *v.* 起伏，波动

swell *n.* 汹涌，浪潮，浪涌

turbulence *n.* [物]湍流；动荡

flick *n.* 轻弹，轻拂

| Phrases

slip away 溜走 **build up** 塑造
set apart 使与众不同；使突出

| Notes

Winslow Homer 温斯洛·霍默（美国画家） ***Under the Coco Palm***《椰子树下》（温斯
Adirondacks 阿迪朗达克山脉 洛·霍默作品）
Shooting the Rapids《激流涌进》（温斯 ***Sloop, Bermuda***《单桅纵帆船，百慕大》
洛·霍默作品） （温斯洛·霍默作品）

Grammar

冠词的用法（The Use of the Article）（I）

1. 不定冠词的用法

1）用于单数可数名词前，表示泛指的"一个"的意思。例如：

When viewing **a** painting, we may be drawn to it for its poetic inclination.

This is his achievement in *Shooting the Rapids*, **a** Canadian scene painted when he was 66.

2）用于单数可数名词前，表示类别。例如：

While he was neither as brilliant **a** craftsman as Tu Fu nor as exuberant **a** genius as Li Po, he excelled in imagery.

An artist who captures the essence of **a** poem will naturally be able to convey it through **a** visual image.

*Not **a** rose, but the scent of the rose...*

3）不可数名词前一般不用不定冠词，如果用，则表示"一种"。例如：

His poems often hold **a** subtle metaphysical flavor testifying to his long study of Buddhism.

The sun shines in them with **a** shimmering brightness new to his work, as though its southern warmth had melted the aging artist's Yankee reserve.

4）用于一些固定词组中。例如：

in **a**... manner

make **an** effort to

The old gentleman was making **a** good point here.

2. 定冠词的用法

1）用于可数或不可数名词前，表示特指某人或某事物。例如：

The architectural elements themselves are decorative.

In illustrating **the** line, "*Scattered peaks conceal an ancient temple*", for example, most painters showed **the** tip of a pagoda, a roof, or even an entire building.

2）用于单数可数名词前，表示类别。例如：

The poet just like the painter, he must represent things in one of the three aspects.

Not **the** *fly, but* **the** *gleam of the fly...*

3）用于形容词或分词前，也可以表示类别。例如：

the young

the profited

the privileged

4）用于表示世界上独一无二的事物的名词前。例如：

Not **the** *sky, but the light in* **the** *sky...*

Not **the** *sea, but the sound of* **the** *sea...*

5）用于序数词或形容词最高级前。例如：

One of **the** most common ways to make a Chinese home more elegant was to develop one or more compounds into a garden.

It was **the** first book of descriptive science to be printed.

Exercises

I **Discuss the following questions (pair work).**

1. Find your favorite work of Winslow Homer in the web and give a comment on it.

2. What make Winslow Homer's watercolors outstanding according to the fourth paragraph?

3. What make Homer's tropical paintings different from those done in the North?

II **Fill in the blanks with the words given below, changing the form when necessary.**

pack	foliage	flick	watercolor	deny
outdoors	wilderness	swell	dinghy	conjure

1. Since the impressionists made little use of _____ , it remained for Homer to develop the medium's potential for rendering the impression of a moment's glance.

2. The _____ gathered speed as the wind filled its sails.

3. In the eyes of this landscape painter, the _____ is not something to be tamed or escaped, but to be admired for its own sake.

4. Dense _____ shrouds the hills.

5. In the foreground, _____ of red represent a cluster of tropical herbs (*Under the Coco Palm*).

6. He is trying to _____ into his luggage the must-haves for painting _____ .

7. Before the 20th century, women were mostly _____ the opportunity to become professional artists.

8. The Christian artists were seeking a means to _____ a spiritual world before the eyes of the faithful people.

9. A boat rocking in _____ is perhaps the most frequent subject in Homer's seascape paintings.

III **Choose the best words to fill in the blanks, changing the form when necessary.**

1. wide, wild, wilderness

a. Homer's painting had a _____ range of subjects.

b. Gobi Desert has a _____ , weather-beaten beauty and a tough, dramatic character.

 c. With the new railroad lines, _____ became accessible to more tourists.

2. illuminate, illumination, luminous, luminosity

 a. The rose windows provide necessary _____ and ventilation for the cathedral.

 b. Johannes Vermeer created a couple of _____ paintings of domestic scenes.

 c. With the whole scene bathed in light, this painting shows high _____ .

 d. To _____ the cave walls and ceilings while working, the primitive painters lit fires on cave floors and used stone lamps.

3. celebrity, celebrate, celebration

 a. Cassatt's canvases _____ the tender relationship between a mother and her child.

 b. In _____ of the hundredth anniversary of his birth four major exhibitions were held.

 c. The famous *Preface of Orchid Pavilion* was written during a gathering of the _____ in Eastern Jin.

4. reserve (*n.*), reserve (*v.*), reservoir, preserve

 a. Chinese history is a deep _____ from which we draw strength.

 b. The archaeological discoveries have been roofed over and well _____ .

 c. In contrast to his _____ and self-consciousness, his brother is a talkative and pompous man.

 d. The artist _____ the area from any wash, thereby allowing the white of the paper itself to become the lightest part.

5. sensitive, sensitivity, sensation

 a. He was born _____ to colors.

 b. One's _____ to colors can be developed in painting practice.

 c. When painting the wilderness, Homer expressed not subjective sentiments but physical _____ .

6. turbulent, turbulence, disturbing

 a. In this period, Homer's interest shifted from the _____ sea to the sparkling blue skies of the Caribbean.

 b. In our history, when political _____ led to social unrest, Buddhism and Daoism would prevail and attract wide followings.

 c. Some of the Gothic prints are quite terrifying and _____.

Ⅳ Translate the following sentences into English.

1. 那个讲座索然无味，我借故溜走了。(slip away)
2. 芝加哥有许多经典建筑，这使得它在美国大城市中卓尔不群。(set apart)
3. 他用（国画的）笔墨塑造出头部的立体感和面部特征。(build up)
4. 与早期的边塞诗形成对照，王维后期的诗作灵动而充满禅意。(in contrast with)
5. 那些高僧们常常借助诗歌来阐释禅理。(by means of)
6. "举杯邀明月，对影成三人。"(along with)

Ⅴ Cloze.

I have an idea that some men are born out of their due place. Accident has cast them amid certain surroundings, but they have always a _____1_____ for a home they know not. They are strangers in their birthplace, and the leafy lanes they have known from childhood or the _____2_____ streets in which they have played, remain but a place of passage. They may spend their whole lives aliens among their kindred and remain aloof among the only scenes they have ever known. Perhaps it is this sense of strangeness that sends men far and wide in the search for something permanent, _____3_____ which they may attach themselves. Perhaps some deep-rooted atavism (返祖性) _____4_____ the wanderer back to lands which his ancestors left in the dim beginnings of history. Sometimes a man hits _____5_____ a place _____6_____ which he mysteriously feels that he belongs. Here is the home he sought, and he will settle amid scenes that he has never seen before, among men he has never known, as though they were familiar _____7_____

him from his birth. Here at last he finds rest. (*The Moon and Six Pence*)

1. A. nostalgia B. nostalgic C. nustalgia D. nustalgic
2. A. popular B. populous C. population D. popularity
3. A. in B. along C. at D. to
4. A. urge B. urges C. argue D. argues
5. A. upon B. up C. of D. to
6. A. up B. on C. to D. in
7. A. with B. to C. for D. in

Part B Wang Wei

Wang Wei **is recognized as** one of the earliest masters of **achromatic** landscape painting, though only copies of his work exist today to **justify** it. His style was based upon a use of ink and water, **in contrast with** the richly colored paintings of Li Sixun. In Tang Dynasty when Wang Wei lived, the **Meditative** School of **Buddhism** was prevailing, which led men to personal enlightenment through quiet **contemplation**. Wang Wei was typical of his time in terms of religious life.

Wang Wei is sometimes classed as one of the three greatest poets of the Tang Dynasty, **along with** Tu Fu and Li Po. While he was neither a **craftsman** as Tu Fu nor a **genius** as Li Po, he **excelled** in **imagery,** and his poems often hold a subtle **metaphysical** flavor **testifying** his long study of Buddhism. Many of his works are such perfectly **crystallized** visual images that they became favored subjects of later artists, as in this **couplet**: "White **herons drift** across **flooded** rice fields/Yellow **orioles warble** in shadowed summer trees." (Another version: Over the spacious water fields egrets glide / In the shaded summer woods yellow orioles cry.) Or: "No **wight** is seen in the lonely hills round here / but **whence** is **wafting** the human voice I hear?"

Just as his older contemporary Wu Tao-tzu carried painting to new levels through his study of calligraphy, so too did Wang Wei achieve a **breakthrough**

because of his understanding of poetry. His poems convey thought **by means of** carefully chosen visual images; his paintings borrow the same technique.

According to Su Tung-po, an artist should be more a poet than a painter. This is implied by his **preference** for the art of Wang Wei over that of Wu Tao-tzu, a professional artist, as is shown in following lines: "Although Master Wu was supreme in art, he can only be regarded as an artisan painter. / Mo-chieh has soared above the images, like an immortal crane released from the cage."

What Is Poetry?

—*Eleanor Farjeon*

*Not a rose, but the **scent** of the rose;*
Not the sky, but the light in the sky;
*Not the **fly**, but the **gleam** of the fly;*
Not the sea, but the sound of the sea;
*Not myself, but what makes me see, hear, and feel something that **prose** cannot:*
And what it is, who knows?

▍New Words

achromatic *adj.* 消色差的，非彩色的

justify *v.* 证明……有理；证明合法

meditative *adj.* 沉思的，冥想的（这里指禅宗）

Buddhism *n.* 佛教

contemplation *n.* 沉思

craftsman *n.* 工匠，手艺精巧的人；巨匠

genius *n.* 天才，天才人物；天赋

excel *v.* 优秀，胜过他人

imagery *n.* 肖像（总称）；形象（总称）；意象（总称）

metaphysical *adj.* 形而上学的，玄学的

testify *v.* 证明，证实，作证

crystallize *v.* 结晶，晶化

couplet *n.* 对句，对联，联

heron *n.* 鹭

drift *v.* （使）漂流；滑翔

flood *n.* 洪水，水灾 *v.* 淹没，注满

oriole *n.* 黄鹂

warble *v.* 鸟鸣；用柔和的颤声唱

wight *n.* 人类，人

whence *adv.* 从何处，从哪里

waft *v.* 吹送，飘送

breakthrough *n.* 突破

preference *n.* 偏爱；偏爱的事物

scent *n.* 气味，香味

fly *n.* 萤火虫

gleam *n.* 微弱的闪光，一丝光线

prose *n.* 散文

Phrases

be recognized as 被认为是…… along with 连同……一起
in contrast with 和……形成对比（对照） by means of 依靠

Notes

Wang Wei 王维（唐代诗人、画家） **Tu Fu** 杜甫
achromatic landscape painting 水墨山水 **Li Po** 李白
Li Sixun 李思训（唐代画家） **Wu Taotzu** 吴道子
Meditative School of Buddhism 禅宗 **Eleanor Farjeon** 依尼洛·法吉恩（英国
Su Tung-po 苏东坡（苏轼） 作家）

Exercises

I Discuss the following questions (pair work).

1. Which is your favorite among all Wang Wei's poems?

2. How is Wang Wei different from Li Sixun in terms of coloring?

3. What contributions did Wang Wei make to the evolution of Chinese painting?

II Translate the following sentences into Chinese.

1. In Tang Dynasty when Wang Wei lived, the Meditative School of Buddhism was prevailing, which led men to personal enlightenment through quiet contemplation.

2. While he was neither a craftsman as Tu Fu nor a genius as Li Po, he excelled in imagery, and his poems often hold a subtle metaphysical flavor testifying his long study of Buddhism.

3. "Although Master Wu was supreme in art, he can only be regarded as an artisan painter. / Mo-chieh has soared above the images, like an immortal crane released from the cage."

Space for Illustration

Use your imagination and creativity, and draw an illustration for Part A or B, after which you are supposed to explain in English why you draw it in the way you do.

漫话单词 *

angle: 角

angular 意为"有棱角的"，可以用来形容魏碑的棱角分明（方笔斩截）。唐楷也有这种特征，这使它有别于钟、王的魏晋楷书。由 angle 派生的、与几何学相关的词汇，往往涉及构成 / 构图的问题，如 triangle（三角形）。在视觉上，等腰三角形（isosceles triangle）具有稳定感和"上指"的感觉，底边越长，稳定感越强，常用来体现某种尊严感和崇高感。非等腰三角形（即斜三角形，oblique triangle）则有很强的"牵引力"，常用于史诗性的作品中，如《梅杜萨之筏》《自由引导人民》等。rectangle 是矩形（正角形）。pentagon 是五角形（agon 是 angle 的变体）。diagonal 是对角线、斜线。斜线在视觉上产生运动感和失衡感。

arch: 最初的，第一的；古代的；统治的

arch 的本意是"最初的""第一的"，而后引申为"古代的""统治的"。古希腊艺术可以分为四个阶段，其中第二个阶段称为"古风时期"（Archaic Period）。archeology 意为"考古学"。古希腊人将建筑视为"百技之首"，因此才有了后来 architecture 一词的构成形式。archetype 意为"原型"，常用于戏剧领域，指一种循环往复的命运和人生模式。这种理论也可以用来解读绘画，如列宾的《伏尔加河上的纤夫》。

art: 技巧 = skill

将 art 译为"艺术"的并不是中国人，而是日本人。现代汉语中很多重要的词汇都是日本人翻译过来的，如"哲学""革命"等。这种词汇被称为"和制汉语"。然而，中国文化对于"道"和"术"向来是有区分的，所谓"形而上谓之道；形而下谓之术"。或许，art 更为恰当的翻译是"艺道"。但日本人将 art 译

为"艺术"也是经过了一番考量的。他们的根据在于，art 这个词原本的意思就是"技巧""技术"。的确，在文艺复兴之前，它只有这个意思；文艺复兴之后，这个词才逐渐被赋予了"艺术表现"的含义。而 artist 一词直到 18 世纪才出现，以前只有 artisan（技工，工匠）。

artistic 的意思是"艺术的"或"具有艺术性的"。"意境"一词可译为 artistic state。副词 artistically 意为"在艺术上""从艺术的角度"等。artless 和 artlessness 并不是"没有艺术性的"，而是"自然拙朴""无雕饰"之意。这让我们想到中国书法史上的古文字（甲骨文、钟鼎文和小篆）。fact 是"制作"的意思，那么 artifact 就是"人造物"。fict 是 fact 的变体，artificial 则是"人工的""人造的"，进而引申为"做作的"。

cept, ceiv: 拿，抓取 = to take, to seize

前缀 con 是"共同""（向内）聚合"的意思，conceive 则指在头脑中思考后得出某种想法或方案的过程，即"构想""构思"，其名词形式为 conception。就设计作品而言，有了构想之后，还要有"实施"（execution）。而对于既成的设计方式、设计形态进行"重新构想""再构想"，可用 re-conceive 和 re-conception 来表示。concept 是名词"观念"，conceptual 是形容词。"观念艺术"（conceptual art）是"当代艺术"（contemporary art）的一种形态。动词 conceptualize 意为"形成概念"。为了题解和把握形体的结构与光照，我们会将形体看作是由一些面（facet）所组成的，而这些面实际上是概念中的（conceptualized）面。

前缀 per 除了"完全""彻底"之意外，还有"通过"（=through) 的意思，那么 perceive 则是"（通过某种过程）察觉，感知"的意思。画面语言中的"精神线"（psychic line）可定义为"不可见，但可以感知的线"。perceptual 是形容词"感知的"，perceptually 是副词，意为"在感知层面上"。形容词 perceptible 意为"可感知的"，名词 perception 意为"感知"。

cess: 行，行进 = go

前缀 ac 在含义上相当于介词 to，是"至""到"的意思；与之相类似的前缀有 ag, ad, af 等。access 可作动词，意为"进入""到达"。accessible 是形容词，意为

"可进入的""可到达的""可以理解的"; inaccessible 是它的反义词。accessibility, inaccessibility 是它们的名词形式。现代设计注重人性化，关照残疾人和老龄人口，Accessible Design 这一概念便应运而生，译为"无障碍设计"（这是一个很好的反向翻译的例子）。名词 accession 有"登记入册"的意思，accession number 指博物馆中藏品或展品的注册号。

前缀 ex 是"超出""多出"的意思，excess 是"过度""过分"的意思。excessive 是形容词"过分的""过度的"。在艺术或设计审美上，往往要摒弃 excess 或 excessiveness，反对 excessive ornament（过度装饰）。前缀 pro 是"向前"的意思，process 意为"进程""程序"，引申为"生产流程"。好的产品设计师既要有设计美学（design aesthetics）上的修养，又要熟悉产品的生产流程。

词根有"变体"，cess 的变体有 cede, sede 和 ceed，它们均构成动词。前缀 pre 的意思是"在……之前"，precede 就是"前于""先于"的意思。中国书画中的重要概念"意在笔先"可译为: The idea precedes the strokes (the application of strokes)。recede 是"后退""推远"的意思。一般来说，冷色和纯度较低的颜色在视觉上有"推远"的感觉。supersede 意为"取代"，可以用来表述新的设计形态对于旧的形态的取代。

chrom: 颜色，色彩 = color

chroma 译为"色度"，指颜色距离黑色或白色的程度（距离越远，色度越高）。chromatic 是"色彩的""有色彩感的"。chromatic relation 意为"色彩关系"。后缀 ics 表示某种"学问""理论"，chromatics 是"色彩学"。achromatic 是"非色彩的""无色的"，前缀 a 表示否定。西方人认为，中国水墨画是"非色彩的"（achromatic）。此外，这个词也可以指"缺少色彩感的"。在中国美术史上，绘画一度是有色彩的，如汉代的帛画、敦煌壁画、宋代的院体画；中国画的别称是"丹青"，这足以说明中国画的色彩性。但是，与院体画并立的文人画追求精神意趣，认为色彩是"视觉的""眼目的"，因而抛开了色彩，仅用水墨绘画。

monochromatic 是"单色的"，就是画面看起来只有一种色相，在明度等方面有所变化。所谓"单色构成"（monochromatic scheme）是一个相对的概念，在色彩绘画中不可能有绝对化的单色构成。polychrome 是"多色的"，作动词时意为"彩绘""彩饰"。《米洛的维纳斯》原本很可能是"多色彩绘的"（polychromed）。

circ, cycl: 圆，环，轮

circle 意为"圆形"。在视觉上，较大的圆形能够产生向心力，较小的圆形（或圆点）没有方向和力的暗示，因而显得较为平静、柔和。此外，circle 指二维意义上的"圆形"，而三维的"球体"用 sphere 表示。circulation 意为"流通"，可以指建筑在通道、出入口等方面的设计，还可译为"循环往复"。

cycle 有"循环"的意思，cyclical design 是"循环设计"。当我们能够实现生产、消费、回收以及生物降解的循环链，就等于实现了设计的可持续，有人称之为"从摇篮到摇篮"（from cradle to cradle）。recycle 是可持续设计 3R 原则（reduce，reuse，recycle）之一。encyclopedia 意为"百科全书"。在这里，cycl 引申为"全面的""广博的"。有些历史悠久的建筑群和雕塑群堪称"视觉百科全书"（visual encyclopedia）。cycle 还有"自行车"的意思，monocycle 是"独轮的"，bicycle 是"双轮的"，tricycle 是"三轮的"。

cyclone 是"气旋"的意思。1871 年，芝加哥一场大火，将这个城市烧成灰烬。气旋使得大火蔓延至芝加哥河的东岸，火灾的毁坏程度大大加剧。当然，因火灾之后需要大规模的重建，这也成就了一个建筑学派，即以沙利文为代表的芝加哥建筑学派（Chicago School of Architecture）。此外，玛丽·卡萨特当时为躲避普法战争正巧在芝加哥，她的画不幸在火灾中毁于一旦。

clud: 关闭 = close，shut

前缀 ex 是"向外"的意思，exclude 则是"排斥""把……排除在外"，与 include 相反，exclusively 是副词，意为"专门地""排他地"。古代有一些装饰形式为帝王或宫廷专属，可以表述为"reserved exclusively for the king / imperial court"。

前缀 se 是"分开"的意思，secluded 原本是"偏僻""宁静"的意思，可以用来指称某种"隐居的""隐逸的""幽僻的"意趣或取向。

contra，counter: 反对，相反 = against

contrast 意为"反差""对比"。绘画中的对比主要包括色彩对比（color

contrast）和明暗对比（value contrast），其中色彩对比主要包括补色对比（complementary contrast）和冷暖对比（temperature contrast）。

contrapposto 是一个雕塑术语，意为"对立式平衡"，词根 pos 意为"摆放"。从解剖学的角度看，对立式平衡涉及三个问题：旋转（rotation）、重心（weight）、力（force）。旋转：人体骨骼最重要的结构关系是脊椎（spine）—胸腔（rib cage）—骨盆（pelvis）之间的关系；骨盆与胸腔以脊椎为中轴来进行旋转，它们的旋转方向往往是相反的，这样人才能够获取平衡和力量。因而，当骨盆向右旋转时，胸腔要向左旋转；反之亦然。重心：站立时，人体的重心常常会汇聚到一条腿上，另一条腿会相对放松。力：人体的力往往体现为某种拮抗力（counter-acting force），也就是力的对立统一。站立时，当下身肌肉的力汇聚于右胯时，上身的力汇聚于右侧胸部和右肩。

由对立式平衡（contrapposto）这个概念，我们可以切入希腊艺术史。古希腊艺术分为四个阶段：几何化时期、古风时期、古典时期和希腊化时期。由古风时期（Archaic）到古典时期（Classical）过渡的标志就是对立式平衡的使用。雕塑《克雷提奥斯少年》（*Kritios Boy*）产生于这两个时期之间。这件作品虽未摆脱古埃及雕塑的遗风，身体仍显得呆板僵硬，但已经初步体现出自然的站姿以及对立式平衡的使用。古典时期的雕塑《里亚切青铜武士像》（*Riace Warriors*）则非常充分地使用了这种平衡方式，身体自然、生动，富有"力感"。文艺复兴时期的《大卫》也是基于这种原理。当然，由于米开朗基罗对人体解剖的深刻理解，《大卫》相较于《里亚切青铜武士像》显得更富于活力和力感，它的每一处筋脉和肌肉都是富于表情的，周身的力是贯通的。

counterpart 意为"对等物""对应物"，在文化比较的论述中经常可以用到这个概念，如中国画中的"留白"是西方画面语言中"虚空间"的对等物。艺术史中有一个有趣的现象：艺术家常常要找到艺术心灵在地理空间中的视觉"对应物"，如德拉克罗瓦的非洲，高更的塔希提，凡·高的阿尔勒。

craft：工艺，技巧

在美术的范畴中，craft（工艺），handcraft（手工艺，也可拼写为 handicraft）和 arts and crafts（工艺美术）的含义大同小异。craftsman 是"手工艺者"；craftsmanship 指"手工生产方式"或"工艺品质"。

Fine Art, Artistic Design, Arts and Crafts 是美术领域的三个板块。在工业革命之后，先前的手工艺为机器生产所取代，但作为某种情感纽带和文化传承方式，人类仍然需要手工艺，arts and crafts 便是人类对于手工艺的留恋和保存。设计史上的第一场运动名为 Arts and Crafts Movement（工艺美术运动），它以手工艺为依托，或者说是一种"手工艺复兴"（Handcraft Revival）。这体现出一些艺术家和知识分子对工业化的不安与质疑，他们想要回到过去，以手工替代机器。工艺美术运动可以定性为是对于工业化的"反动"（reaction）。

dict: 说，言说 = say

dict 是"言""说"的意思。看到它，我们会马上联想到 dictionary（字典，用以辅助"言""说"的工具）。diction 则是"措词""选词""遣词"的意思。在文学、翻译、乃至日常说话中，都要注重 diction，首先要用词准确、达意，进而要传达出某种感觉、氛围或境界。前缀 contra 是"反""相反"的意思，contradict 则是"同……相矛盾""与……相对立"。contradictory 是"矛盾的""对立的"，它可以形成词组 contradictory space（矛盾空间）。第一个将矛盾空间作为绘画主题的是荷兰画家埃舍尔。前缀 pre 是"预先"，predict 则是"预言""预告"，unpredictable 是"不可预料的"。色彩的直觉性和彼此的相互影响产生色变和余象，而且其影响因素多重，画面上的色彩效果往往是"不可预料的"。

divid: 分隔

in 是否定前缀，"不可分割的东西"便成为"个体"（individual）。individuality 意为"个性""个体性"。现代社会追求个性，但在机械复制的时代，许许多多貌似"奇葩"的东西，不过是对于复制的反动，本质上还是复制的。individualism 是"个人主义"，这个概念是西方近现代文化的一条主线；individualist 是"个人主义者"；individualize 是"个性化"。

divide 指"分割"，division 是其名词形式。在画面空间内，形状（shape）和线条有分割空间的功能，将画面分割为具有某种关系的部分。division of labor 意为"劳动分工"，这是现代社会劳动异化的根本原因之一。divisionism 是"分

离主义"，主要指修拉的点彩派。历史上还有一个"维也纳分离派"，英文是Secessionism，词根为 cess。形容词 divisive 可以翻译为"引起分化的"。消费时代的消费主义设计往往是引起社会分化的（socially divisive）因素。

duc，duct：引导 = lead

由此词根形成的一系列词汇与工业生产和工业设计极为相关：前缀 pro- 是"向前"的意思，produce 则为"向前引导"，即"生产"，让我们想到流动生产线（assembly line）；production 是名词"生产"；product 是"产品"，by-product 是"副产品"。productive 可以指产量高，即"多产的"，productivity 为"生产力（生产能力）"。product design 是"产品设计"。

mass production 是"规模化生产"，这是现代工业的本质特征。现代工业产品都是"规模化生产的"（mass-produced），也都是"可规模化生产的"（mass-producible）。在设计史上，违背这一原则的产品设计往往昙花一现，不能持久，如后现代主义的某些流派。

规模化生产包含两个要素：系统化（systemization）和标准化（standardization）。非如此，不能够提升效率（efficiency）和降低成本（cost）。现代工业就是要不断地通过系统化和标准化的方式来提高效率和降低成本，这是现代工业的逻辑，也是在现代设计的演变过程中，简单、平直的现代主义设计最终胜出，并成为主流的内在原因（尽管由于技术的进步和人类需求的多元化，现代主义受到了挑战和冲击，但这种形态在当代，在可以预见的将来，仍是设计的基本形态。）。"二战"以后（可上溯至福特时代），西方世界逐渐进入了一个规模化生产—规模化消费的模式（a mode of mass production - mass consumption），这成为时代的"最强逻辑"，并改变了人的文化方式。这种模式在为人类带来大量物质财富的同时，也带来了诸多问题，尤其是环境与资源的问题，进而使"设计伦理"（design ethics）和"可持续设计"（sustainable design）等概念得以提出。动词 reduce 是"减少"的意思，减少排放与能耗是可持续设计的 3R 原则之一。

另外，这一系列词汇也可用于艺术领域：produce 有时也可以指创作艺术，接近于 create；product 也可以指艺术作品；productive 可以指艺术家很多产，相当于prolific。

dyn: 力量

中国历史上的南北朝（Northern and Southern Dynasties），是一个在政治上极其纷乱，在文化上却极其精彩的时代。南朝的许多建树，都成为中国文化史上不朽的经典，如《兰亭序》《谢赫六法》《文心雕龙》等。武帝萧衍是梁朝的君主（dynast），他不仅有杰出的政治智慧，在艺术方面也是一位大家。北朝对于艺术史的贡献，与佛教的引入有着莫大的关联。北朝佛教大兴，由此产生了一些的著名石窟群（grottos）和造像群（statues），以及著名的北朝碑刻。

形容词 dynamic 有两个意思：动态的；力的，力学的。

eco: 家 = home

eco 是"家"的意思。economy 最原始的意思是"一个家庭的吃穿用度"，有"节俭""节省"的意思，可引申为文学、艺术创作中的简约，所谓"惜墨如金"。ecology 这个词最早出现于 19 世纪，是个人造的词汇。19 世纪后半叶，人们开始注意到地球上各个物种应该像一个大家庭一样共存共处，于是有人提出 ecology 这个概念。ecological 是其形容词形式；eco-friendly 等同于 earth-friendly，意为"环保的"；eco-efficiency 则指"生态效益"。

fac: 面部，正面 = face

surface 指"物体的表面"。在画素描时，我们要考虑形体表面的起伏和朝向。在设计中，我们也会谈及物体的表面，如"表面装饰"（surface decoration）。此外，surface 还可以指用来作画的种种表面。纸张和画布是常用的绘画表面，在纸张广泛使用之前，人们也会以其他材料作为绘画表面。

facet 指"形体表面上的局部的面"，这种面在多数情况下是"构想出来的"，目的是理解和把握形体结构和光照角度。interface 意为（交互）界面。façade 指"建筑立面"。

fact: 做 = do, make

arti 是"人工 / 技术"的意思，artifact 则泛指"人工制造的东西"，在很多时

候指"展品",相当于 exhibit。词根往往会有"变体",fact 的变体是 fect。前缀 af 在含义上相当于介词 to,那么 affect 就是"对……做",也就是影响。色彩受光的影响,而且色彩彼此之间会相互影响(见第 2 单元)。前缀 e, ex, ef 都是"向外"的意思,那么,(做出来的)"效果"则是 effect。de 是"向下"的意思,引申为"变坏",defect 则是"瑕疵""缺陷"。

fin: 结束,终结

法语中的 fin 等同于英语的 end,法语老电影末尾会出现"La Fin"的字样(相当于 The End)。在语言演变的过程中,fin 逐渐有了"完成"的意思,于是出现了 finish 这样的词汇。后来"完成"又逐渐演化为"精美的""纯净的"。fine art 意为"纯艺术",有别于 applied art(实用艺术)。后者主要指设计,这是与生产生活紧密结合的艺术,它的"媒介"就是生产生活中的一切:一件产品、一处空间、一条信息。finish 还可以作名词,意为"产品的外表面"。现代主义产品设计追求"光洁的产品表面"(smooth finish),也就是极简、整合、无装饰的产品表面。前缀 de 表示"向下",进而可以引申为"强调""着意",如 define, definition,让人想到"画地为牢"这个成语。

flect, flex: 折,弯 = bend

前缀 re 是"相反""返回"的意思,reflect 可表示光的反射,reflection 为名词。素描中要研究两种反射现象,一个是反光(reflected light,从环境中投向暗部),一个是高光(highlight,直接反射到观者的眼中)。词组 reflected light 既可以指"反射光",也可以指"受到反光照射的区域"。高光的强弱取决于物体的反射率(reflectivity),如果物体表面明度高或比较光滑,那么它就会有反射性(reflective),高光就会很强。色彩实际上也是一种反射现象:我们看到物体上有各种色彩,是因为物体上的色素会反射某种特定波长的光线,而吸纳(subtract)其他所有光线。reflector 是指摄影师使用的反光板,功能在于获得一种可控光源。

动词 flex 有"(肌肉)收缩"之意,如"收缩二头肌"(to flex the bicep)。flexor 意为"缩肌"。人体的肌肉可以划分为"缩肌"和"伸肌"(extensor)这两类,正是由于它们的拮抗运动,身体才能够发力。flexibility 是"灵活性""柔韧

性"。书法要充分利用毛笔的柔韧性，产生力感与美感，所谓"唯笔软而奇怪生焉"
（《九势》）。

foli: 叶

foil 是 foli 的变体，意为"叶形装饰"（名词），引申为"衬托""反衬"（动词）。foliage 是"叶簇"或"叶丛"的意思，可用于风景画的描述。叶子沿中脉分为两部分，让人想起对折的书页，folio 便是（装订在一起的）对开页。词根 port 是"拿"的意思，portfolio 是"可以手持的叶形物 / 对开页"，即文件夹，也可以引申为"作品集"。portfolio case 是"画夹"的意思。

form: 形状，形式

form 可译为"形体""形式""形态"。formal 为形容词。

在美术的范畴内，form 首先是"形体"的意思，也就是立体的、三维的形体（three-dimensional form）。三维立体的形体或形体的三维性（three-dimensionality）是传统西方艺术的本体（entity）。这可以上溯至文艺复兴（Renaissance），那个时代的两个"发明"——透视（perspective）和明暗法（chiaroscuro）——奠定了造型艺术的基础。随着时代的发展，出现了种种以写实为基础的艺术风格：巴洛克、洛可可、新古典主义、浪漫主义和现实主义。有人将文艺复兴至现实主义的艺术统称为"古典现实主义"，这说明这个发展历程是一以贯之的。19 世纪后半叶，随着工业化（现代化）进程的加速推进，西方社会生活和意识形态发生了剧变，这最终导致了文化艺术中现代性的萌生。这当然也体现在美术中，美术史演进的节点就包括凡·高和塞尚。凡·高使得色彩优先于形体，而塞尚使得结构（或：形式）优先于形体。本质上，凡·高的色彩与塞尚的结构都是二维意义上的（two-dimensional form）；3D—2D，勾勒出西方美术的现代转型。

form 也有"形式"的意思，一般来说，"形式"是二维意义上的。自从诞生之日起，绘画就包含了形式性。但是以形式为主体的绘画始自塞尚。他是一个后印象主义画家（postimpressionist），也是一个形式主义画家（formalist）。形式出离于形体，意味着抽象性和现代性的萌生。形容词 formal，可以理解为"形式的"，例如，formal language（形式语言）。form 理解为"形态"，多用于研究领域，

form study 是 "形态研究"。

formation 意为 "构成物", land formation 可以用来翻译中国山水画中的土石结构。information 是 "信息", information design 是 "信息设计"。前缀 uni 是 "一" 的意思, uniform 是 "统一的服饰", 即 "制服"。

performance art 是 "行为艺术"。performance 的前缀是 per, 意为 "完全" "通透"。在行为艺术中, 艺术家往往极力充当另一种角色, 即 "完全" 成为另一种 "形", 在身份与时空的错位中, 达到一种谐谑或荒诞的效果, 同时也带有观念性。

funct: 活动 = perform

设计强调功能 (function) 或功能性 (functionality), 这是它与艺术的区别, 也正因如此, 它在美学表现上是受限的。

依据功能划分, 设计可分为三大类: 环境设计 (environmental design, 居住的功能)、视觉传达设计 (visual communication, 传达的功能)、工业设计 (industrial design, 使用的功能)。

以功能为先的理念可称为功能主义 (functionalism)。它主要有两重含义: 1) (设计) 以功能为先, 形式次之; 产品能够很好地发挥功能, 这本身就是一种美; 甚至在一定程度上, 为了功能, 可以牺牲形式。2) 形式要依功能而展开。路易·沙利文 (提出 "Form follows function.") 和柯布西埃都是典型的功能主义者 (functionalist)。功能主义和机械美学, 是现代工业催生的新的设计审美观念。

functional 是形容词, 意为 "功能的"。后现代主义设计刻意忽略功能, 作为对功能主义的一种反动, 即所谓 "非功能的" (nonfunctional), 或 "反功能的" (anti-functional), 这可以上溯至 20 世纪 60 年代的意大利激进设计 (Radical Design)。当时设计的沙发, 一反传统的功能性, 人们在上面根本无法正襟危坐。80 年代孟菲斯学派的许多设计也体现出非功能的特征。

fus: 熔化; 浇注 = melt, pour

这一词根与古代冶炼和铸造技术有很大的关联。动词 fuse 是 "融合" 的意思, 常用于词组 fuse into, 可以用来描述某些工艺。例如, 陶瓷在烧制过程中, 黏土

（clay）会融合为一种坚硬的物质；彩色玻璃（stained-glass）在烧制过程中，也可以融合在一起，形成丰富的色层。绘画中的色彩可以是融合在一起的，也可以像印象派那样彼此分离，但在远观时又看似融合在一起，如莫奈的绘画。这就是所谓"视觉融合"（optical fusion）。名词 fusion 可以用来描述不同类型与风格的融合，例如，著名的泰姬陵是伊斯兰、印度和拜占庭风格的融合；巴洛克宗教艺术，则体现出建筑、雕塑和绘画之间的互动与融合。

前缀 pro 是"向前"的意思，形容词 profuse 和名词 profusion 给人以（铁水）"倾泻而出"的意象，往往可以用来描绘纹饰（尤其是花卉和藤蔓纹饰）的丰富和繁盛，如洛可可时代的花饰或植物纹样。动词 confuse 最常见的意思是"使……混淆"，可以指艺术中不同类型或风格之间的混淆，例如，素描中的中心光点与高光不能相互混淆。其名词形式为 confusion。动词 infuse 和名词 infusion 常常用来表述一种东西对于另一种的融入和注入，如中国艺术史上的"以诗入画"（the infusion of poetry into painting）、"以书入画"（the infusion of calligraphy into painting）。前缀 suf 等同于 sub，意为"下面的""下层的"，动词 suffuse 和名词 suffusion 让人联想到铸造时的浆液倒入容器，注满底部的状态，因此，它们的意思是"弥漫""布满"，但它们也可以使用得非常空灵，如表述印象派绘画那种弥漫着光（suffused with light）的感受。

gen: 生，生成

后缀 ics 表示某种学术，genetics 是"遗传学"。gene（基因）是"遗传因子"，gene sequence 则是"基因序列"。genius 是天才的意思。艺术史上的天才往往很短命，他们犹如火焰，在照亮世界的同时也在燃烧着自己。另一种人被称为"大师"（master），他们往往深沉老到，生命的成熟和岁月的积淀使他们的作品更加深沉厚重。

前缀 home 相当于 same，homogenization 意为"同质化"。现代主义设计容易造成同质化或千篇一律，于是催生了力求多样的后现代主义设计。

genre 是指（文艺的）类型，如风景画、人物画。在 19 世纪中叶之前，历史绘画和宗教绘画被认为是高贵的类型（prestigious genre）。genre painting 是"风俗画"的意思。卡萨特、罗克威尔在一定程度上都是风俗画家。

grad = to go, to walk（走）

前缀 de 表示"向下"，degrade 和 degradation 就是"走下坡路"，译为"降级""降格"，但这个词也可以表示可持续设计中的"降解"，产品"可降解"（degradable/biodegradable）是可持续设计的追求。upgrade 是"升级"的意思，如 industrial upgrading（产业升级）。动词 gradate 可以指色调的渐次变化，gradation 是名词形式。grade 和 gradient 还可以指建筑中的坡度或倾斜度。

graph: 文字，图形

graphic 可以是名词，意为"图形"，CG 是计算机图形（computer graphic）；也可以是形容词，意为"文字的""图形的"，graphic design 是"平面设计"，其根本要素正是图形和文字。平面设计有三种基本形态：图形 (graphic)、字体 (font) 和版式 (typography)。

photo 原本是"光"的意思。photography 则是以感光的方式将图形记录下来的技术，即摄影术。摄影的关键词是"曝光"（exposure）。photographer 是摄影师。摄影术的发明对于绘画产生了巨大的冲击，但它也对绘画有过启示。摄影时常有抓拍（snapshot），而抓拍中的人物常常是不完整的，如同切下去一部分。但以现代的审美视角看，这种残缺也可以是美的、有趣味的。于是在绘画中有人着意表现这种残缺，德加就是其中之一，另外还有雕塑家罗丹，他的许多作品都是"片段式的人体"（fragment）。

前缀 bio 是"生命"的意思，对一个人生命的文字记录就是传记（biography）。最为著名的画家传记是《渴望生活》(Lust for Life)，这是欧文·斯通关于凡·高的传记。还有《月亮和六便士》(The Moon and Six Pence)，是毛姆所作关于高更的传记体小说。pictograph 指"象形文字"。人类最为古老的三种文字（甲骨文、楔形文字、埃及象形文字）都是象形文字。paleography 是"古文字学"。epigraphy 是"铭文学"，可以用来翻译"金石学"这个概念。"古文字学"和"金石学"在清代被称为"小学"。清代的许多文人学者对此都有深厚的学养，他们可称为 paleographer 或 epigrapher。calligraphy 指"书法"。calli 表示"美""美丽"。calligraphy 的含义是"美书"——西方所谓的"书法"，实际上只是一种装饰性字体。lithography 是"平版印刷术"和"石版画"。词根 lith 是"石头"的意思，例

如，Neolithic（新石器时代的）。

graffito 这个词的出现涉及考古学。被火山灰掩埋的庞贝古城于 18 世纪被发现。考古学家们看到城墙和立柱上刻有一些东西，说不清是文字还是图形，于是就把它们笼统地称为 graffito。在 20 世纪 60 年代的美国，一些叛逆青年在墙上、汽车、火车上涂满似是而非的东西，也称之为 graffito，即涂鸦。graffito 的复数形式为 graffiti。

imag: 复制，模拟

image 最为广泛的意思是"图像""形象"。此外，image 还有"肖像"的意思。imagery 是"图像""形象""肖像"的总称。

东、西方的诗歌中都有形象（image）的概念，但在中国诗歌中它就成了"意象"，是意和象的合一与感应，体现了中国文化独有的神韵。"意象"在英文中一般用 image 这个词来翻译。20 世纪初，受到中国和日本诗歌的启示，西方曾兴起意象派诗歌（imagism），意象派诗人则称为 imagist。

afterimage（余象）是一种神奇的色彩现象：盯着一块颜色看一段时间，而后再将视线移至一面白墙，你会觉得这面墙上出现了它的补色。印象派画家常利用这种色彩现象表现生动的、瞬间性的色彩。imagine 是"想象"；imaginary 是"假想的""想象的""虚构的"；imaginative 是"富于想象力的"；imagination 是名词"想象""想象力"。

lect，leg: 选择 = select，gather

前缀 co, col, con, com 基本上都是"共同""一起"的意思。collect 是"将选择的东西放在一起"，即收藏。collector 是"收藏家"。collection 是名词"收藏"，也可以指"藏品"。collectible 是形容词，意为"有收藏价值的"，作名词时意为"有收藏价值的物品"。

前缀 se 表示"分开"，select 则是"选择""挑选"。ant 是形容词后缀，elegant 是"选出的"，也就是"高雅的""优雅的"。elite 也是"选出"，但它的意思是"精华""精英"。eclectic 仍然是"选出的"，但这个词可引申为"折中的"，即"各种风格都有所摄取"。Eclecticism 是"折中主义"。维多利亚时代的一些建筑和产

品往往呈现出折中主义和历史主义（Historicism）倾向，将过往的风格和样式集于一身。这为工艺美术运动的艺术家所诟病，但折中主义倾向在后现代设计中又得以显现。

lig: 捆绑

词根 lig 是"捆绑"的意思，前缀 re 表示"着重"或"加强语气"。religion 意为"宗教"，意味着人和神的某种"契约关系"（基督教教义）和人对于神的敬候。说到契约，我们可以想到《圣经》的《旧约》(Old Testament) 和《新约》(New Testament)。这里的词根 test 是"证明""见证"的意思。基督教对西方美术有着巨大的影响，自中世纪至 19 世纪，它一直是绘画与雕塑的重要题材和主题。

佛教对于中国美术也有着深刻的影响。在古代，人们将开窟、造像和壁画作为一种修行的方式，从而产生了莫高窟、龙门石窟等艺术集群。当然，更为深刻的还是佛教思想对于艺术审美的潜移默化。在中唐之后，中国的诗、书、画在整体上形成了一种注重体悟与性灵的趋势，这与禅宗的注入有着莫大的关系。

line: 直线，线条 = line

line 是"线条"，它还可以指"一行诗""诗行"。形容词 linear 译为"线性的"，如果绘画有严整的造型与边线，则可称之为 linear；其反义词是 painterly，指"挥洒自如、注重表达的"。linear perspective 是"线性透视"。linearity 是名词，意为"线性""线条感"。前缀 rect 表示"直的""正的"，rectilinear 意为"直线的""由直线而成的"，用这个词来形容蒙德里安的绘画可谓恰如其分。前缀 curv 表示"弯曲的"，curvilinear 意为"曲线的""由曲线而成的"。

line drawing 是"线性素描"，可以用来翻译中国画"线描"的概念。outline 作名词时有"轮廓"的意思，作动词时可以是"概括地画"之意。以凡·高的色彩表现为例，他以平面化的、概括的方式来画色彩。前缀 de 可以表示向下，有"用力""着意"的意思，delineate 就是"用线条着意刻画"，可译为"描绘"。underline 是"在……下面画线"的意思，要与 underlie 区别开来。

loc, loco: 位置，地方 = place

　　形容词 local 意为"地方的""当地的"。它还可以指"固有色"（local color）。一般来说，固有色是指物体在常态光源下呈现出来的色彩，也可以说是人们对于色彩的一种认知定式。在物体上，最能体现固有的区域是所谓"半色调"区域，尤其是离明暗交界线和中心光点都比较远的区域。在西方绘画史上，印象派大胆地"质疑"了物体的固有色，从而揭示出颜色的丰富性。locale 意为"绘画""故事、小说的场景或环境"，接近于 setting。动词 locate 意为"定位""找到……的位置"；location 是名词"位置"。

log, logu: 说话 = speak

　　log 表示"说话"，monologue 就是指"一个人说话"，即"独白"，dialogue 则为"对话"。Logo 一词源于 logograph（语标），后来逐渐具有了（平面设计中的）"标志"的意思。前缀 cata 相当于 downward，catalogue 则是"一路说下去"，即为"目录""一览表"。这个词还可以专门指展览名录和产品名录。logic 的意思是"逻辑"，原指"说话的技巧"。建筑设计和室内设计都讲求"空间逻辑"（spatial logic）。前缀 chron 是时间的意思，chronological 就是"按照时间顺序的"，如对于艺术作品的 chronological study。

lustr, lumin: 光，亮

　　词根 lustr 是"光""亮"的意思，前缀 il 相当于介词 to，那么 illustrate 就是"给予光"，引申为"阐明"的意思，进一步可引申为"以图画或图像来阐明"，也就是"图解""图说"，往往译为"为……画插图"；illustration 是名词"插图""插画"；illustrator 是"插图画家"。（此外，illustrate 还有"说明""表明"这样一般性的意思。）

　　动词 illuminate 是"照射"的意思，如物体的背光面受到来自于环境的反光的照射。名词 illumination 常常可以指建筑的采光。luminous 是"明亮的""有光感的"，在绘画中往往指那种透光的、体现光照感的形体或色块，如伦勃朗和德加的素描，温斯洛·霍默和莫奈的色彩绘画。luminosity 是名词，指这种透光的

画面效果和感受。

master: 首领

master 作名词时，最常见的意思是"大师"，old master 指"历史上的大师"，可以用来翻译中国文化中"古人"这个概念。master 还有"硕士"的意思，Master's Degree 是"硕士学位"，Master of Fine Arts (MFA) 特指"美术硕士"（或"艺术硕士"）。作动词时，master 意为"精通""掌握"。mastery 则为名词"精通""掌握"。masterpiece 是"杰作""代表作"的意思。 masterful 和 masterly 都是形容词，意为"熟练的""高超的""精湛的"。词组 master touch 意为"妙笔""神来之笔"。

mater，metro: 母亲 = mother

mater 是"母亲""母性"的意思，形容词形式为 maternal。maternal love 是玛丽·卡萨特的绘画主题。卡萨特笔下的母亲和孩子，并非是那种类型化的（stereotyped）、理想化的母子关系，孩子与成人之间的愉悦、拒斥和疏离在她的画面上都有呈现。paternal 是"父亲的"，fraternal 是"兄弟的"。fraternity 意为"弟兄之爱"，引申为"博爱"。alma mater 是"母校"。

mater 的变体是 metro。古希腊人以城市为中心开拓和统辖周边地区，称为城邦（metropolis）。这个词到了现代用来指大城市。纽约就是这样一个大城市。而纽约有著名的大都会博物馆（The Metropolitan Museum of Art）。

在法语中，metro 是地铁的意思。新艺术运动时期建造的地铁站（metro station）成为巴黎的地标和法国新艺术运动的标志，它有着贝壳状的（shell-like）顶棚和茎状的（stem-like）立柱，这是有机形在新艺术运动中的使用。

medi: 中间

medium 的根本含义为"中间物"，引申为"媒介"，再引申为"艺术创作的方式、材料"，其复数形式是 media。此外，medium 也可以是形容词，意为"中等的""中间的"，如 medium tone（中间色调），medium green（中绿）。Medieval 是

"中世纪"的意思。在文化层面上，工艺美术运动是一次"中世纪复兴"（Medieval Revival），正如文艺复兴是对古希腊古罗马文化的复兴。词根 terr 是"土地"的意思。Mediterranean 则是"位于陆地中间"，引申为"地中海的"。mediocre 意为"平庸的""一般的"。intermediate colors 可译为"居间色"，是指色相环上位于元色 (primary colors) 与间色（secondary colors）的空当处的色相，也称"复色"（tertiary colors）。

metr: 测量 = measure

geometry 是"几何"的意思（geo：大地→几何学最原始的功能是土地丈量）。geometric 是"几何的"，geometric shape 是"几何形"，有别于 organic shape（有机形）。此外，Geometric Period 指古希腊艺术的早期阶段——几何图案时期，得名于这个时代陶瓶上的几何图案。

前缀 sym 的读音近似于 same，意思是"等同"，如果两边的测量值等同，那就是 symmetry（对称）或 symmetrical（对称的）；asymmetrical 是"非对称的"。文艺复兴之前的绘画和建筑是注重对称的，之后逐渐出现了"非对称"。symmetrical balance 是对称平衡，asymmetrical balance 是非对称平衡，这是画面视觉重量（visual weight）的一种辩证的排布。人的身体充满着对称与非对称。人体的正面观（front view）和背面观（back view）显现出人体的对称性；而侧面观（side view / profile view）则显现出非对称性。此外，人的四肢（limbs）也充满非对称性。正是这种非对称性，使得力在人体中得以生发和传动。这对于理解人体解剖（anatomy）是十分重要的。书法的行笔也充满着力的非对称、动态的非对称，这在书法中称为"倚侧"。

metr 的变体是 mens，例如，dimension 是"分面测量"，进而有"层面""维度"的意思。2-dimensional 是二维的，平面的；3-dimensional 是三维的，立体的；3-dimensionality 指三维性或立体性。

migr: 迁移

migrate 是动词，意为"移居""迁居""迁徙"；immigrate 是向内的迁移；emigrate 是向外的迁移。migration 是名词。文化史、美术史上的迁移现象是很值

得研究的。文化艺术的繁荣往往伴随着移民现象，如中国历史上的"晋室南渡""宋室南渡"，近代江南士子向上海的移民，"二战"期间包豪斯的成员向美国的移民等。migrant artist 指"旅居海外的艺术家"；migrant worker 可以用来翻译"农民工"这个词。

miss: 送出去 = send

mission 是"使命"，missionary 是"心怀使命的人"，他们要走遍世界，去传播上帝的福音，这就是传教士。明清之际，曾经有两位西方的传教士来到中国，将西方文艺复兴之后的宗教、科学以及艺术传播到中国，他们就是利玛窦和郎世宁。

把某个使命委托给某人，就是委任（commission）。在欧洲历史上，教会和贵族委任艺术家画壁画、做雕塑，艺术家收入的多少，取决于 commission 的多少。transmission 的意思是"传输"，有时也可以理解为"传达"，动词是 transmit。那么，"视觉传达"中的"传达"就有了三个词汇可以表述：communicate，convey 以及 transmit。

mob, mot, mov: 运动

ate 是动词后缀，motivate 是"使……动"的意思，引申为"推动"，motivation 是名词。locomotive 是"火车头""机车"。motion 也译为"运动"，但它更强调"非静止"的状态。前缀 e 是"出离"的意思，emotion 则是"情感"，似有内心的涌动，溢于言表，emotional 是形容词。前缀 pro 意为"向前"，动词 promote 则是"推进""促进"的意思，promotion 是名词。ile 是形容词后缀，接近于 ible，mobile 意为"移动的""可动的"，如 mobile phone。前缀 auto 是"自己""自身"的意思，automobile 则表示"可自动的物体"，即汽车。automobile design 是"汽车设计"，相近的说法是 vehicle design。

movement 意为"运动"。在画面语言（pictorial language）中，movement 指画面中由形式因素所引发的"视觉运动"（visual movement）。以下是几种常见的运动：1）线或线性因素引发的指向性运动 (directional movement)；2）对比引起的视觉（心理）运动；3）斜线或倾斜的物体引发的视觉（心理）运动。在画面中，

运动常伴有"反运动"(counter-movement)，起到中和 (neutralize)、抵消（offset）的作用。

mod: 模式，样式 = mode, manner

单词 mode 是"模式""样式"的意思，如手机的"振动模式"（vibration mode）。model 可以是名词"模特"，也可以用作动词，指形体的"塑造"，如说形体塑造得很结实（solidly modeled），常用动名词 modeling（塑造）或 3D-modeling（三维塑造）。modeling clay 指"雕塑用黏土"；modeling stand 是"雕塑用转盘"。

module 是"模块"的意思，也就是"标准尺度的单元"。这个词常用于设计领域。modularize 是"模块化"，其名词形式为 modularization。modulus 译为"模度"。柯布西耶通过模度理论（modulus theory）建立起传统美学和现代设计之间的关系，为机械美学在建筑和产品中的应用铺平了道路。

modern 原指"时髦的"，后引申为"现代的"。modernize 是"（使）现代化"；modernization 是名词；modernity 是"现代性"；Modernism 是"现代主义"；modernist 是"现代主义者"；Postmodernism 是"后现代主义"。美术中的"现代主义"包含三个板块：1）源于凡·高的表现主义（Expressionism）；2）源于塞尚的抽象主义（Abstractionism）；3）源于戈雅，成于达利的超现实主义（Surrealism）。人类历史进入现代的原因无疑是工业化（industrialization）。在工业化之前，并没有所谓"现代性"的概念。艺术史中"现代性"的形成伴随着如下一些现象：1）印象派和后印象派对于色彩的发现，使色彩出离于形体；2）塞尚对于形式的发现，使形式出离于形体；3）罗丹对于特征、形式和运动的发现（如《巴尔扎克像》），使形式和运动出离于形体；4）建筑师和设计师们对于材料、结构、色彩和形式的发现，使其具有表现力，并取代了传统的装饰。这一切都在指向某些现代意识：分离（secession）、自由、迅捷、直接、个体……设计中的现代主义源于 19 世纪末到 20 世纪初工业的发展和各种设计思潮，成于包豪斯的设计实践。设计的现代主义包含以下特征：1）在形态上趋于简单、平直、线性、几何；2）去除装饰，转而发现和体现产品本体的美（的潜力），包括结构、比例、材料、色彩等；3）功能主义，功能与形式相结合；4）体现机械美学（工业美学）。如果我们将绘画中的现代主义和设计中的现代主义加以对照，会发现前者中的抽

象主义（Abstractionism）与后者是极为相通的。实际上，抽象主义大师康定斯基和蒙德里安都曾任教于现代设计重镇包豪斯。与包豪斯现代主义同时出现了北欧设计风格（Scandnavian Design），也称为有机现代（Organic Modern）。后现代主义设计（postmodernist design）始于"二战"之后，是对现代主义设计的一种反叛和弥补。

modify 一词常用于语法的讲解中，意为"修饰"。但它也可以指光对于固有色的改变：在光的照射之下，物体的固有色会发生变化，幻化出其他的色相。

mon: 告诫，提醒；单独，一个

mon 的第一个意思是"告诫""提醒"，monument 则是"向公众或后世进行的提示"，即所谓"纪念碑"，也可以指"纪念性雕塑和纪念性建筑"。与绘画相比，雕塑更"受制于"功能性。在罗丹之前，大多数的雕塑是"装饰性"（ornamental）和"纪念性"（monumental）的，立于广场、庭院和建筑物之上，而罗丹使雕塑走出这两种功能，成为自由表达的媒介。此外，monumental 可以引申为"不朽的""丰碑式的"，用来形容一些古老的、有历史意义的雕塑和建筑。mon 的第二个意思是"单独""一个"，monochrome 是"单色画"或"单色色彩关系"，是指只有一种色相，在明度等方面有所变化的色彩构成；monochromatic 是形容词。

nat，naiss: 出生 = to be born

前缀 in 表示"里面"，innate 意为"内生的"。中国书法讲求力的运用，而这种力是一种"内生力"，是在毛笔的辩证运动之中产生的。naiss 是 nat 的变体，Renaissance 意为"文艺复兴运动"。nation 是"国家""民族"；national 是形容词。"国家美术馆"可译为 National Art Gallery。native 是形容词，意为"本土的""本国的"，例如，书法是我们的"本土艺术"（native art）。名词 nativity 有一个特定的含义：耶稣降生。这是西方宗教绘画的一个重要题材。

nature 是"自然"。当这个词表示"大自然"时，是不加冠词的。natural 是形容词。Naturalism 是"自然主义"。它有两方面的含义：1）崇尚自然，对自然的表现与赞美；2）一种"极致的现实主义"，力图将生活和人性的一切都呈现在作品之中。naturalist 可以指"自然主义作家""艺术家"等。在罗丹之前，雕

塑的主题往往是崇高的、英雄主义的，而罗丹为雕塑注入了自然主义内容，他往往着力表达人性中的矛盾、挣扎、欲望，如著名的《加莱义民》。凡·高那幅《吃土豆的人》也有很强的自然主义倾向。他并没有以某种"审美的"、风俗画式的视角表现吃土豆的农民，而是呈现出他们拙朴、粗粝、困顿的一面。在凡·高的眼里，他们是靠诚实的劳动生存的人类，因而以这种方式将对他们的情感和感受表现出来。

neutr: 中

形容词 neutral 意为"中性的"，neutral color 是"中性色"。将两种补色调和在一起，会成为中性色，如褐色、赭石、土红等。此外，neutral 也可以作名词，专门指"中性色"。类似的词汇还有 complementary（补色），straight（直线），curve（曲线），horizontal（水平线），vertical（垂直线）。视觉艺术中往往会有方向的呈现，而方向需要被"中和"（neutralize，neutralization）。"中和"不是单纯的方向的不同，而是一种有趣的、辩证的方向的排布。

ori: 升起 = rise

orient 是太阳升起的地方——东方，形容词为 oriental（东方的）。18、19 世纪，西方人喜欢东方艺术，这种美学倾向可称为东方主义（Orientalism）。orientation 是"定向""定位"的意思，常用来指"学术方向"。名词 origin 是"起源""由来"；形容词 original 是"原初的""原创的"；名词 originality 是"原创性"。

part: 部分，分开

形容词 partial 意为"部分的"，在艺术中常译为"不完全的"，如素描中的"半色调"就是由于光的"不完全照射"形成的。动词 depart 意为"离开"，其名词形式为 departure。词组 depart from 经常用来表达一种对于旧的风格的脱离。前缀 de 基本的意思是"向下""在下面"，在这里引申为"脱离"。但是在名词 department 中，de 的意思则是"从属"。counterpart 是指"在另一个范畴内的对等物"，例如，中国画中的"留白"（empty area）和西方绘画或设计中的虚空间

（empty space）互为"对等物"。port 是 part 的变体，proportion 意为"比例"，是重要的视觉原理。proportion 也可以作动词，意为"形成比例""调节比例"。participate 是"参与"的意思，名词形式为 participation。在道—禅审美系统中的中国艺术，常常是一种"体悟"式的艺术，可以用 participate 和 participation 来表述。

pend: 挂

前缀 sus，sub，suf，suc 基本都是"下面"的意思。这样，suspend 就是"挂在下面"，引申为"悬挂""悬垂"。欧洲的古典建筑常带有 suspending ornament 或 suspending sculpture，意为"垂饰"或"垂雕"。中国书法非常生动地将"竖"比作"悬针"，可译为 suspended needle。此外，在写字时要"悬肘""悬腕"，这都可以用 suspend 来翻译。

前缀 per 是"全部""整个"的意思。把一种东西整个悬挂起来，由于重力的原因，它一定是垂直的（perpendicular）。

pict: 画

后缀 ture 表示一个动作或行为的结果、效果。picture 是"图画""画面"的意思。形容词 pictorial 是"画面的"，pictorial language 是"画面语言"；pictorially 是副词，可译为"在画面意义上"或"从画面的角度看"；picturesque 是形容词，意为"如画的""具有绘画感的"。esque 是个古老的后缀，相当于 isc，如 Romanesque（罗马风格的）。esque, isc, ique, ic 这四个形容词后缀都是"具有……的特征"的意思。

pictography 是"象形文字"；pictographic 是形容词。前缀 de 有"着重""刻意"之意，那么，"着重、刻意地画"则是"描绘"（depict）；depiction 是名词。pict 的变体是 pig，可以形成 pigment（颜料），pigmentation（着色）。

ple: 满，填满

前缀 com 是"共同""一起"的意思，那么，当两种东西放在一起，呈现

出"满"的状态时，这两种东西一定是互补的。最能说明这个意思的也许就是 complementary（互补的）了；complementary colors 意为"互补色"。此外，complementary 也可作名词，本身即表示"互补色"。互补色可以定义为色相环上"对过"的两种颜色，如蓝—橙，红—绿。当互补色在画面上并置，它们会使彼此显得更为强烈，因而"补色构成"（complementary scheme）往往显得比较强烈，如凡·高的画。但补色调和在一起时，会形成纯度很低的中性色。如果想要使一种色相的纯度降低，最直接的办法就是调入它的补色。

前缀 sup 表示"下面""后面"，supplement 则是"后补""弥补"。与包豪斯同时出现的"有机现代"（organic modern）是对工业形态的冷漠和缺少情感的一种弥补。

ply: 折叠

ply 是"折叠"的意思，可引申为"贴合"，前缀 ap 相当于介词 to (=ad, af, ag, ac)，那么，apply 即为"贴附到……之上"。由此可以引出它的几个含义：1）（将方法和理论）贴附于具体的东西，即"应用""实用"。Applied Art 是"实用艺术"，包括设计（design）和工艺 (crafts)，有别于"纯艺术"（fine art）。application 有"计算机应用程序"的意思，其缩写是 App。2）将颜料敷在画面上，即"上色""涂色"（apply pigments）。3）将装饰附加于产品和建筑的"母胎"或"毛坯"之上。传统的装饰都称为 applied decoration（外加装饰），另一种说法是 surface decoration（表面装饰）。

plywood 意为"胶合板"，是北欧设计所青睐的材料，它既可以规模化生产，又以其质感和形态突破了现代主义的刻板与冰冷，具有温暖、舒适、有机的感受。

此外，ply 的变体 plic, plex 也都是"折叠"的意思。replicate 意为"复制"；replica 意为"复制品"；implicit 意为"含蓄的"；形容词 complex 意为"复杂的"；名词 complexity 意为"复杂性"。

pos: 摆，放

我们常常说"摆个 pose"，pose 可以是动词"摆姿势"，也可以是名词"姿势"。词组 pose for 可以指"为……做模特"。pose 也可以作及物动词，意为"摆

（模特的）姿势"。unposed 指"未摆姿势的自然状态"，这种状态为自然主义艺术家所青睐。据记载，卡萨特的作品《蓝色扶手椅中的小女孩》（*The Little Girl in the Blue Armchair*）中模特（小女孩）的姿态就是画家在女孩玩耍时偶然捕捉到的。contrapposto（对立式平衡）是重要的雕塑原理，指人在站立时重心、方向和力的对立平衡关系，这种原理有利于表现人体内在的活力和力量。

前缀 com 是"共同""一起"的意思。compose 的含义则是"放到一起"，引申为"构图""构成"，这让我们想到在一个画面或空间之内的各个块面、元素之间的相互关系。中国古人也有同样的概念，如"经营位置"（谢赫），"置陈布势"（顾恺之）。compose 的名词形式为 composition。就文字而言，这个词表示"作文"；就音乐而言，表示"作曲"；而就美术而言，表示"构图""构成"。compositional 是形容词，意为"具有构成感的""在构图上起作用的"。

前缀 op 是"相反"的意思，相当于 against, opposite 则是"对面的""对立的"。在色相环上相对的两种色相互为补色。前缀 dis 是"分开"的意思，dispose 则是"分开放置"，可以引申为"处理"。disposable 可以用来指一次性产品。在可持续设计的背景下，disposable 是受到诟病的一个概念。前缀 ex 是"出来""到外面"的意思。expose 则是"放到外面"，引申为"展示"，名词形式为 exposition，可缩写成 expo，用来指"展览会""世博会"。可见人类早期的展示行为只不过是"拿出来（给人家看看）"，而今天的展览会则具有了经济、文化、政治的多重意图。在摄影专业里，exposure 可以指"曝光"。

impose 是"放进去"的意思，可引申为"强加"。imposing 是它的现在分词形式，引申为"强势的""咄咄逼人的""壮丽的"，可以用来描述建筑。superimpose 是"放在上面"，引申为"叠加"。在课文中是指素描中的"交叉排线"。

press: 挤压

动词 press 有"按""压"的意思，可以用来翻译书法中的"按（笔）"。impress 是"留下印象""使感动、震撼"的意思，impression 是名词。Impressionism 是"印象派"，这个说法源于莫奈的作品《日出印象》（*The Impression of Sunrise*）。Impressionist 是"印象派画家"；形容词 impressionistic 是"印象主义的"或"具有印象主义特征的"。Post-impressionism 是后期印象派。Neo-impressionism 是新印象派，代表人物是修拉。

ex 是"向外"，由于内在的某种压强，"胸中块垒"向外喷发，则是表达（express，expression）或表现。19 世纪末出现的表现主义（Expressionism），不能简单地与"表现"二字挂钩。表现主义的关键词是主观性，以及由此产生的夸张、放大、激情。后印象主义画家凡·高是表现主义的先驱，在 1889 年进入精神病院（休养院）之后，他的绘画呈现出明显的表现主义倾向，如著名的《星夜》（*Starry Night*）。而后出现了德国表现主义（German Expressionism）。Expressionistic 可译为"具有表现性的""具有表现主义风格的"。Abstract-expressionism 是"抽象表现主义"，也称为"哈普宁"（happening）艺术，强调绘画的过程和艺术表现的即时性。

prim (pri)：第一 = first

prime 可以作形容词，即"首位的""主要的"；也可以作动词，意为"（油画）打底色"。primary 可以作形容词，形成词组 primary colors（元色），但这个词作名词时，本身就可以指"元色"。元色（红、蓝、黄）可以定义为"最初的色相"（未经调和的色相）。primitive 是"原始的""远古的"，如 primitive art（原始艺术）。Primitivism 是"原始主义"，其代表人物是法国画家亨利·卢梭，其画面追求一种稚拙与天真。此外，primitive 和 primitiveness 还可以指艺术中的"浑朴之美"，如碑派书法。

rat, ratio：推定 = to reckon；理由，道理 = reason

理性（rationality）的观念源发于古希腊文化，在文艺复兴后贯穿西方文化的发展。到 19 世纪末期，非理性（irrationality）的因素开始浮出水面。对此，文学艺术是先知先觉的，表现主义—达达—超现实主义形成了艺术中的非理性潮流。从设计史的角度看，19 世纪中叶至"二战"之前，设计一直在向理性行进。以包豪斯为代表的现代主义将理性推向极致，可以说理性是现代主义设计的灵魂。20 世纪 60 年代之后，设计中的后现代运动可以定义为一种"反理性"（anti-rationality）。工具理性（instrumental rationality）是现代文化的重要依据，但现代文化最大的问题也在于以工具理性取代 / 覆盖了价值理性（value rationality）。

re: 再次；向后；施加；去除

re 是前缀，不是词根，可以表示"重复"，如 reuse。文化史中常有复兴（revival）的现象，人们通过对过往文化的再发现，返本开新，建立新的、适于当世的文化，如设计史上的哥特复兴（Gothic Revival）和手工艺复兴（Craft Revival）。

re 也可表示"向后""向回"。动词 recede 有"（在空间中）推远"的意思。一般来说，冷色较之暖色有视觉推远的效果。recede 的名词是 recession，可以指"经济衰退"。

revolution（革命）是一个熟悉的词汇。这里的前缀 re 表示"着力""施加"，也就是"通过人为的方式使历史向前运转"。

此外，re 还有"去除"的意思，如 remove，removal。现代主义设计讲求"去装饰"（the removal of decoration）。

rect: 正，直 = straight, right

在画面构成中，direction（方向或指向）是一个很重要的问题。一般说来，不同的方向在视觉上需要"中和"（neutralize），我们也可以利用方向的暗示来激活（activate）空间。形容词 directional 意为"方向的""指向的"。在视觉语言中，线条的 directional movement（指向性运动）和 visual leading（视觉引领）是"一枚硬币的两面"。

线条和形状都会有方向的暗示。从方向上划分，线条可以分为水平线（horizontal）、垂直线（vertical）、斜线（diagonal）。形状也可以按照方向来划分，例如，三角形有着最强的方向暗示，正三角形会暗示一种上指的方向，斜三角形会形成向左或向右的牵引；矩形会有水平矩形和垂直矩形；较小的圆形往往没有方向的暗示，而较大的圆形有着向心的指向。

rectangle 实际上是"正角形"，我们习惯上将其译为"矩形"。rectangular 是形容词。rectilinear 是"直线的"，与 curvilinear 相对。rectilinear shape 意为"直线形"（矩形和三角形）。在新艺术运动时期,各地的设计风格有"曲线形"和"直线形"之分，在西班牙、法国、英格兰和美国，新艺术设计都布满了曲线形，而在苏格兰、奥地利和德国，则以直线形为特征。苏格兰的格拉斯哥学派（Glasgow

School）的设计就是典型的直线形设计。

reg 是 rect 的变体，形容词 regular 意为"规则的"，regular shape 是"规则形"，反义词为 irregular。regular script 意为"楷书（正书）"。楷书最早出现在东汉末年，人们一般认为钟繇是楷书的鼻祖。晋室南渡，王导将钟繇的《宣示表》等作品带到南方，成为南朝楷书的典范。其主要继承者是王羲之。源于汉隶的北朝碑刻在类型上也属于楷书（或者说介于隶楷之间）；规范严整的唐楷正是在北朝碑刻的基础上形成的，这样就和魏晋的楷书有所不同。宋人尚意，求新求变；宋徽宗的"瘦金体"、苏黄的楷书都是这种追求的体现。元代赵孟頫的楷书则又回归了晋唐法度。

scape: 形貌

landscape 一般指风景画，在中国绘画里，它用来翻译"山水画"；在环境艺术设计中，指"景观设计"（landscape design）。下面是一些由 scape 构成的词汇：cityscape（城景）；seascape（海景，海景画）；waterscape（水景，水景画）；snowscape（雪景，雪景画）。nightscape 是"夜景"。

sci: 知，知道 = know

science 是"科学"，scientist 是"科学家"，scientific 是"科学的"。sci-fi 是 science fiction（科幻小说或电影）的缩写。由于科学和理性的引入，西方艺术在文艺复兴—印象主义这个漫长的历史阶段取得了辉煌的成就。

con 是"共同"的意思，认知主体与认知客体内外印证，即是意识、觉悟（consciousness），conscious 是形容词，consciously 是副词。unconscious 是"无意识的"。建于 1851 年的水晶宫采用了现代材料和现代建筑方法，但那种现代性仍是一种"无意识的现代"（unconscious modern）。sub-consciousness 是"下意识""潜意识"。现代主义绘画的一个支脉是以表现潜意识为主旨的超现实主义，其代表人物是达利。现代主义文学中有"意识流"（stream of consciousness）的叙事方式。

scrib: 刻写

前缀 manu 是"手"的意思，manuscript 意为"手书"，可以用来翻译书法的

手迹、手泽。晋室南渡，南方的文人士子以手书来唱和诗文、记录生活，无形中产生了许多优秀的书法作品；后来，名家手迹逐渐成为尚佳的收藏品（colliectible）以及人们争相临习的"法帖"（model script）；此后，这种趋势一直延续，形成中国书法"帖学"（The Study of Manuscripts）的脉络。动词 inscribe 是铭刻的意思；名词 inscription 是"铭文"（刻出的文字）。此外，书画作品的"旁款"也可以用 inscription 来表示。在盛行占卜的商代，人们将卜辞（oracle）刻在龟甲和兽骨之上，称为甲骨文（oracle bone inscription）。在商代以后的两千多年里，甲骨文从人们的视野中消失，直至 1899 年，一些学者才从药材（龙骨）中发现了甲骨文。在注重礼仪的周代，文字铸造在青铜器上，称为金文（bronze inscription）。东汉盛行"树碑立传"，产生了很多隶书的石刻铭文（stone inscription），主要分为两种：碑版（stele inscription）和摩崖（cliff inscription）。北魏、北齐时，佛教大兴，教徒们以石刻铭文来记录功德、镌刻佛经，于是形成了书法史上很有价值的北朝碑刻。在一定程度上，石刻铭文也是刻工（inscriber）以其特殊的工具和材料对书法进行的再创造（recreation）。金文和石刻铭文，由于其文化背景和材料、工具等原因，显得苍莽古厚、奇崛雄健，即所谓"金石气"。到了清代，随着考古学和训诂学的发展，人们对古代的"金石"之美进行了"再发现"（rediscovery），促成了书法史上的"尊碑抑帖"运动（The Appreciation of Inscriptions and Depreciation of Manuscripts）以及"碑学"（The Study of Inscriptions）的盛行，书画家纷纷"以金石入书""以金石入画""以金石入印"，为作品注入刚健古朴的"金石气"。这种潮流为近现代中国美术精神的自我更新做好了笔法上的准备。

　　Buddhist Scripture 是"佛经"的意思。在隋唐时期，人们雇佣"写经手"（可译为 scribe）抄写经文，作为一种修行的方式。script 是"字体"，但与 font 和 type 不同的是，前者是指手写的"字体"，而后者指印刷的字体。所以，书法中的"字体"（书体）都用 script 来表示，如：seal's script（篆书）；clerical script（隶书）；cursive script（草书）；regular script（楷书）。

secul: 尘世

　　secular 是形容词，意为"世俗的"，secularize 和 secularization 意为"世俗化"。由于商品经济和城市化的发展，西方和中国的艺术在 15、16 世纪都经历了世俗化的过程。西方的文艺复兴被定义为"对于人性的解放与肯定"，但从另一

个角度看，这也是"世俗化"的开始。这种世俗化的进程到了工业时代似乎变得无以复加，产生了许多问题。于是就又有了"中世纪复兴"，以求重建精神与道德。中国绘画的"世俗化"始于明代中期，原本清高的、非职业化的文人画走向通俗化和职业化（vocational），历史上的扬州画派、海上画派就是这一历程的样本。

secut, sequ: 跟随 = follow

persecution 意为"迫害"。历史上的"宗教迫害"（religious persecution）常对宗教美术造成影响。中国有过数次"灭佛"运动，佛教称之为"法难"，劫难过后，许多宗教艺术（壁画、造像等）都遭到毁坏。"法难"可以用 persecution 来翻译。在纳粹统治下的德国，许多前卫艺术家也遭到迫害。

sequence 意为"序列""顺序"，黄金分割形成的"斐波那契数列"（Fibonacci sequence），常常用于构图之中。

sens, sent: 感觉 = feel

由 sens 和 sent 构成的词汇向来是不好区分的。在这里，我们可以看一下它们在艺术领域中的区分：

sense 是泛指的"感觉"，如"色彩感"（sense of color）、"空间感"（sense of space）；此外，这个词也有"理性"的意思。形容词 sensitive 是"敏感的"，名词 sensitivity 指人的"敏感性"，如画家对于色彩的敏感性。sensation 常常指客观物象对于人形成的感受；此外，它也有"轰动"的意思。形容词 sensational 是"轰动的"，如"一场轰动的展览"（a sensational exhibition）。sensibility 可以理解为"感悟""感悟力"，如画家对于文学的感悟力。sentiment 常常指"带有人文色彩的感怀、情感、伤感"。sentimental 是形容词。在艺术领域中，sensory 可以指"感性的""带有美感的"。

serv: 保持 = hold

前缀 ob 的含义相当于介词 toward，语气比 ac, ad, af（相当于介词 to）要重。动词 observe（观察）会让人联想到"蹲守"；observation 为名词，如果一个人对

于物象有很细微、深入的观察，会被赞为 good observation。

preserve 和 reserve 可以前缀区分开来。pre 是"以前""之前"的意思，preserve 则强调"保持事物的原状"，这对于文物保护（preservation of cultural relics）似乎显得很重要。re 有"向后""回去"的意思，reserve 则强调"留住""储备""不消耗"，reservoir（水库）一词可以形象化地说明 reserve 的含义。书法要"藏头护尾，力在字中"（《九势》），这一含义可以用 reserve 表示。此外，作名词时，reserve 还有"沉默寡言"的意思。

simil，simul(t)，sembl: 相似，一样 = alike，same

动词 assemble 意为"集合""装配"，assembly 是名词，assembly line 是"装配线""流水线"，这是福特主义（Fordism）的标志。

形容词 similar 意为"相似的"。在视觉原理中，相似形（similar shapes）可以产生统一感。名词 simulation 意为"模仿"。鲍德里亚在《消费社会》一书中指出，大众传媒的泛滥导致了一个"拟像"（simulation）世界的出现，人们迷失在符号和影像之中。在这种情况下，生产商会用设计来制造一种符号（社会身份、生活方式、时尚），以吸引人们购买，而消费者也因为迷恋这种身份、生活、时尚不断地消费。因而，消费时代的设计具有符号性。此外，符号（symbol）一词的前缀 sym 也是"相似""一样"的意思。

形容词 simultaneous 意为"同时发生的"。色彩有一种"同时对比"（simultaneou scontrast）现象：（在明度、纯度、冷暖、互补色等方面有差距的）色彩并置于画面，会使得彼此显得愈加不同（dissimilar）。此外，还有一种"接续对比"（successive contrast），属于"视觉余像"（afterimage）的问题。

spect: 看 = look，see

前缀 per 是"完全""通透"的意思，perspective 是"透视"。这个词还有一个含义："视角"，相当于 point of view。透视的关键是"灭点"（vanishing point）。常见的透视有两种：线性透视（linear perspective）和空气透视（atmospheric perspective）。中国历史上郭熙和韩拙分别提出了"三远"之说，前者（高远、深远、平远）似乎接近于线性透视，后者（阔远、迷远、幽远）接近于空

气透视。尽管如此，中国山水画（landsacpe painting）并没有明确的透视观，它是在营造一种"意境空间"，是在"造境"。就写实性而言，宋代的院体花鸟画已经达到了很高的程度，其形体塑造在很大程度上符合单点透视（one-point perspective），但与之并立的文人画却有意识地抛弃了写实性，转而追求精神、意趣。

retro 是一个比较"古老"的前缀，是"向后""向回"的意思，相当于 re，retrospect 是"回顾"的意思，引申为"回顾展"。凡·高的首次回顾展是在他逝世两年后，即 1892 年。spectrum 意为"色谱"，是依据波长排列的色相的序列；将色谱弯成一个环，就是"色环"（color wheel）。名词 aspect 原本的意思是"看待事物的方式"，前缀 a 的含义相当于介词 to。aspect 和 respect 作为名词都有"方面""层面"的意思，但前者更偏重于在观察、看待意味上的"方面"，而后者更偏重于在研究、操作意味上的"方面"。

由于种种历史与文化原因，视觉艺术中的女性形象，往往是被欣赏、被消费的对象，是"被观看者"（spectacle），而观看者（spectator）被预设为男性。观看与被观看，反映出文化深处性别歧视的痕迹。

spher: 球，球状物

sphere 意为"球体"，spherical 是形容词，意为"球形的"；前缀 hemi 等同于 semi，都是"半"的意思；hemisphere 是"半球"。形容词 hemispherical 意为"半球形的"。古典建筑中的拱顶 (dome) 大多都是半球形的。

（传统的）西方绘画是对物理世界的描绘和提取，涉及形体、光和空气（atmosphere）等因素。一幅有"空气感的"（atmospheric）素描是非常动人的。atmospheric 还可以构成 atmospheric perspective（空气透视）这一概念，即我们常说的"近实远虚"。中国山水画对于云气有着特殊的偏爱，显示出古人对于世界的理解——"气化的世界"（atmospheric world）。气化的世界也包括固态的物质，于是山水画中的山、石、树木也是流动的、升腾的。

sta: 站，立 = stand

作名词时，stand 意为"架子"。挂毛笔可以用笔架（brush stand）。"钟和墨水瓶架"（Clock-and-ink Stand）是 1851 年伦敦世博会中的典型展品，体现出追

求奢华与装饰的维多利亚风格。

stable 意为"稳定的（能站住的）"，名词 stability 意为"稳定性"。等腰三角形在视觉上会产生稳定感，水平线、垂直线、水平矩形也会产生稳定感，它们在画面语言中常常被称为 stabilizer（稳定工具）。distant 是"有距离的""远的"，distance 是名词"距离"，这两个词有时也用来指画面中的空间纵深。statue 是"雕像"的意思，一般是指人或神的塑像。中国古代雕塑主要体现在佛造像（statue of Buddha）。static 意为"静止的"，其反义词为 dynamic。

sume，sumpt: 拿，取 = take

consume/consumption 是"消费"的意思；consumer 是"消费者"；consumer society 是"消费社会"。消费社会的产生可以从 20 世纪初形成的福特主义讲起。通过系统化、标准化的生产方式，福特主义大大提高了效率、降低了成本，使得许多工业产品成为大家买得起的日用消费品。此后，为了形成供需平衡与经济的良性运转，社会生产／社会生活日益以消费为导向（consumption-oriented）。这种社会形态被称为消费社会。随着消费社会的发展，意识形态中出现了消费主义（consumerism）。消费社会和消费主义成为设计的推力，产生了许多制造符号的设计。同时，消费大众（consumer mass）和消费文化（consumer culture），也消弭和解构着原先的精英意识，导致后现代设计的形成。自消费主义／消费社会诞生之日起，一些知识分子就对其持有批判态度。这始于 20 世纪 40 年代的法兰克福学派，他们最早提出了消费异化（consumption alienation）的概念（100 年前的拉斯金和莫里斯所关注的是生产异化。）

assume/presume (assumption/presumption) 都可以译为"假定""假设"，它们的区别在：assume 通常用于指在毫无依据的情况下作出假设，往往带有想当然的意思；而 presume 是在有依据的情况下作出假设，可译为"推定"。

tain: 持有，维持，把握 = hold

词根 tain 的意思是"支撑""维持"；前缀 sus 是"在下面""从下面"，引申为"从根本上"；动词 sustain 意为"支撑、维系"。在当今时代，sustainable/sustainability 指在资源、环境和人文这些根本性方面来支撑人类文明的存在与发

展，译为"可持续的/可持续性"。sustainable development 译为"可持续发展"；sustainable design 是"可持续设计"，它的另一个说法是 green design（绿色设计）。enter 在拉丁语中相当于 between，而 entertain 则指在众人之间维持一种热闹的氛围，这是古代人对"娱乐"的解释。entertainer 则是在众人之间插科打诨，做些滑稽表演的人，类似于宫廷小丑。entertainment 是名词形式。

tech: 技术，技艺

technique 常常指人所掌握和发挥的技巧，艺术方面的"技巧"要用 technique 表示，而非 technology。20 世纪 50 年代以后，科学技术突飞猛进，高技术审美（high-tech aesthetic）甚嚣尘上，这也可以说是现代主义运动中机械美学的延伸。当然，高科技也可能带来使用不便的问题。因此，解决这个问题的"易用设计"（easy-to-use design）也应运而生。

前缀 arch 有"统治"的意思。古希腊人认为建筑是"百技之首"（占统治地位的技术），因此，建筑这个词的构成就是 architecture；architectural 是形容词。而建筑师则是 architect。

tem, tom: 切割

tem 是"切割"的意思。temple 原指古罗马人为了占卜在空中或地面划出（分隔出）的一块区域，后来指罗马人的"神庙"，也用来翻译中国的"寺院""庙宇"。前缀 con 有"加强""聚合"的意思，contemplate 就是对着一片天空"沉思""冥想"。此外，temple 也有太阳穴的意思，太阳穴是确定人头部侧切面（side plane）的重要节点。tem 的变体是 tom。由否定前缀 a + 词根 tom 构成的 atom 意为"原子"，即"不可切割之物"。

前缀 ana 是"完全""彻底"的意思，anatomy 则是"解剖学"。真正的艺术解剖产生于文艺复兴时期。由于对解剖的研究，文艺复兴时期的艺术家能够更贴切、更微妙地表现人体的力与运动，如米开朗基罗的《大卫》就要比《里亚切青铜武士像》更能够表现人体内在的活力与力量。文艺复兴之后，anatomical accuracy 成为绘画、雕塑的专业追求。anatomist 是"解剖学家"，绘画史上的一些写实主义大师都是优秀的解剖学家。anatomically 是副词。

tend, tent, tens: 伸展 = stretch

　　词组 tend to 表示"有……（的）倾向"，与 have a tendency of 同义。动词 intend 意为"打算"，词组（be）intended to do 可以表示"有……的意图"或"意在……"。名词 intensity 可以表示（色彩的）纯度，与 hue（色相）、value（明度）一起构成色彩的三个基本属性。名词 tendon 意为"人体的肌腱"。名词 tendril 意为"（植物的）藤蔓"，常用于装饰，如新艺术运动时期的诸多装饰和设计。

　　名词 tension 的意思是"张力"。这在艺术表达中是一个重要的概念，可以理解为某种辩证意味。其方式是多样的，如米开朗基罗的《大卫》，塑像的姿态是静立不动的，但人体的筋脉、肌肉都充满动势与活力，似有待发之势。卡萨特的《信》也形成了某种张力：画面处在一个狭小的、私密的空间中，人物的姿态似乎加重了这种感受。然而，人物的动作和神态，以及这封信本身，都在暗示出这个空间之外的延展的世界。

termin, term: 完成，终结 = finish, end, limit

　　Terminus 是古罗马神话中的边界之神，termin 是"边界"的意思。de 是"向下"的意思，可以引申为"着重"，determine 则是"决定"的意思。

　　动词 terminate 是"终结"的意思。词组 terminate in 是"以……为结尾"，一件产品或器物以某种东西为端，可这个短语来表示，例如，中国古代的礼器"觥"的盖子往往一头是鸟，一头是兽。Terminator 一般是指行星的明暗界限（或白昼与黑夜的界限），也称为"晨昏线"，在素描中指"明暗交界线"。这个词的后缀是 or，表示工具或尺度。

terr: 土地 = earth

　　ace 是名词后缀，terrace 是"露台""柱廊"的意思。凡·高的作品 *Café Terrace at Night* 译为《夜间露天咖啡馆》，准确地说，应该是"夜色中的咖啡馆柱廊"。medi 意为"在……中"，Mediterranean 是"地中海的""地中海区域的"。前缀 sub 表示"下面"，subterranean 意为"地下的"。古代帝王的陵寝往往都会设计成为一个地宫（subterranean palace），以备"来世"（afterlife）使用。terracotta

的意思是"陶土""土红色"。Terracotta Soldiers 为"兵马俑"。

text: 编织 = weave

text 是"编织"的意思，课文（text）也可以说是一种文字的编织。textology 意为"考据学"。清代考据学的发达是书法"尊碑抑帖"的一个缘由。texture 是"肌理""纹理"的意思。textile 是"编织物""纺织品"。textile design 是"染织设计"。

context 这个词多译为"语境"。狭义上指文章的上下文关系；广义上则可以形成许多意思：历史语境（historical context）、文化语境（cultural context）、色彩语境（color context）等。当今时代是一个建筑扩张的时代，许多建筑看似华美，却都割裂了城市的历史语境和文化语境。

ton: 声音

tone 常常指"音调"，在美术中指"色调"。色调可以是素描意义上的，也可以是色彩意义上的。后者往往指画面上的色彩统一于某种色相或某种色彩属性。例如，怀斯的颜色往往以栗色为主基调（色相，hue）；莫奈的风景画中可以找到许多强光下的亮调子（明度，value）。tonal 就是"有色调的""色调的"。tonality 是调性。

halftones（常用复数）指的是在素描关系中的中间色调，即中心光点和明暗交界线之间的色调。这一部分的色调是最为多变的，也是最为精彩的。monotone 为"单色调"，monotony 意为"单调（感）"。此外，tone 还有"灰色"的意思，toned paper 指"绘画用灰色纸"。

tract: 拉，拖

tract 表示"拉"，用来进行"拉，拖"的工具，则是 tractor（拖拉机）。名词 traction 意为"牵引力"。斜三角形在视觉上可以产生很强的牵引力，常被用于史诗性题材的作品中，如籍里柯的《梅杜萨之筏》。

前缀 ab 表示"偏离""出离"，abstract 即为"拽出来"，引申为形容词"抽

象的"。在美术领域，抽象的概念始于 19 世纪后期，体现出某种现代性、理性和工业社会的痕迹；原始艺术中也有非具象的东西，但那不是现代意义上的抽象。abstractionist 和 abstractionism 分别是"抽象画家"和"抽象主义"的意思。康定斯基是抒情抽象主义（lyrical abstractionism）的代表；蒙德里安创建了几何抽象主义（geometric abstractionism）。"二战"之后，美国画家波洛克创建了抽象表现主义（abstract expressionism）。抽象表现主义又称"哈普宁"艺术，意在突出一种行动性和即时性。此外，作名词时，abstract 还有"摘要"的意思。

subtract 是"减去""扣除"的意思，可以指色彩的"减色"现象：物体呈现某种色相，是因为它反射（reflect）某种特定波长的光束，并吸取/扣除（subtract）了大多数的光束。

trans: 横过，越过 = through，across；变换，改变 = turn

名词 transparency 意为"透明"，这是水彩的属性。其形容词形式为 transparent，反义词为 opaque。词根 it=go，表示"行走"；transition 是"过渡"的意思，可以指色彩、明暗以及形体的过渡。transition 也可以用作动词，其形容词形式为 transitory，与 transient 含义相近，都可以指"转瞬即逝的"。transitory feeling（瞬间感受）是印象派的"关键词"。translate 和 translation 最常用的意思是"翻译"，但这个词也可以指艺术种的"转化"。中国艺术注重"意在笔先"，先有精神意趣的生成，而后转化为形象、画面。

tribute: 给予 = to give，to pay

名词 tribute 可以指古代的"供奉""朝贡"，词组 pay tribute to 有"向……致敬"的含义。有的美术作品是作为向前辈的致敬而创作的，如俞晓夫的《我轻轻地敲门》。

前缀 at 相当于介词 to，动词 attribute 的基本含义就成了"给某人某物"，经常用于词组 attribute... to...，可以表示"认为某作品出自某人之手"的意思。这对美术史有着特殊的意义：史家常常会将很多"不具名作品"（anonymous works）归于某位名家。这种行为可被称为 attribution（作品归属），例如，将《历代帝王图》归于唐代画家阎立本；将《瘗鹤铭》（碑刻）归于陶弘景，甚至是王羲之；将《叙

画》（画论）归于王微。油画《波兰骑兵》（*The Polish Rider*）原本被认为是伦勃朗的作品，但在 1982 年，一些学者推翻了这一认证（disattribute）。他们的结论是，此画为伦勃朗的学生威廉·德罗斯特（Willem Drost）所作。

前缀 dis 是"分"的意思，动词 distribute 是"分配""分布"的意思，在构图语言中，to distribute weight 或 the distribution of weight 表示"视觉重量的分配"，关乎画面的平衡。

tut: 监护，指导

tutor 就是我们常说的家教，其本意是"指导者"。后缀 or 的对立物就是 ee，这两个后缀一个表主动，一个表被动，tutee 则是"被指导者"。类似的例子还有 employer，employee 等。

tuition 是"指导费"，即"学费"。intuition 本意是"没有指导""未经指导"，也就是"直觉"。intuitive 是形容词，intuitively 是副词。

uni: 单一，一个 = one

unit 是"单元"的意思；unity 是"统一性"，可以指画面各个元素呈现出的统一，其反面是 variety（多样性）。unity 和 variety 是重要的构图原理（compositional principle），它们的辩证关系形成视觉趣味，画面应追求多样中的统一和统一中的多样。unify 是动词，意为"使……统一"。

unique 是形容词，意为"独特的""独一无二的"；后缀 ique 等同于 ic。日本服装品牌 uniqlo 实则是 unique 与 clothing 的合成，意为"独特的服饰"。cycle 可以指"轮子"，unicycle 则指独轮车；以此类推，bicycle 是两轮车（自行车），tricycle 是三轮车。unicorn 是"独角兽"，其形象常用于纹章或建筑装饰。

universe 是我们再熟悉不过的一个词。vers（=var）是"变化""多样"的意思，uni-verse 则暗示宇宙是统一和多样的综合。这可以让我们想起"八卦"的源起：单一的一根线条，一分为二；伏羲氏以这两种线条分别象征阴、阳，并由此演化出八种卦象（乾坎艮震巽离坤兑），后来周文王又演化出六十四卦。卦象是易学的基础，而 vers 的含义也合乎"易"的精神。university 是我们更为熟悉的一个词。它与 universe 是如此相似，好像是在暗示宇宙与大学在精神层面是同构的。

大学，应该有着一以贯之的对于永恒价值的追求，也有思想自由带来的多样性和创造性。

us: 使用

user 是 "使用者" 的意思。20 世纪中期，功能主义（functionalism）的设计盛行一时，这往往造成对使用者的忽略。于是，人们又渐渐回归到了以使用者为中心的设计（user-centered design）、用户友好型设计（user-friendly design）、用户体验设计（UE design）、易用设计（easy-to-use design）。dis 是 "分开" 的意思，引申为 "解除" "消解"。disuse 则是 "解除使用"，即 "不再使用" "废弃"。过去分词 disused 是 "废弃了的"。在可持续设计的理念中，废弃了的东西应该使它 "起死回生"，被 "重新利用"，即 reuse，reusable。

useless 和 useful 互为反义词。现代人非常注重有用性（usefulness），做什么事情都力图以 "有没有用" 来衡量、评估。这往往形成认知和感受的 "蔽障"，使我们失去了很多本该属于我们的自由、灵感和美。《庄子》中的一些寓言可以起到 "去蔽" 的作用，告诉我们 "有用" 和 "没用" 之间是可以相互转化的，即所谓 "无用之用"（the usefulness of the useless）。

val: 价值 = worth；强壮的 = strong

valid 是 "有效的" "正当的"。加上否定前缀 in 则是 invalid，意为 "无效的" "病弱的"；作名词时，有 "病人" "病弱之躯" 之意，可以用来形容缺少力度的书法（见第 8 单元）。名词 validity 意为 "正当性" "合法性"。1648 年，《韦斯特伐利亚公约》（The Treaty of Westphalia）的签订使得基督教新教获得了合法性，并促成现代民族国家的形成。这使得欧洲的商业和贸易得以长足的发展。欧洲人手里有了更多的余钱，就开始收藏艺术品。于是，艺术市场开始生成，小幅的适于家庭装饰的油画开始泛行于世，艺术也进一步走向世俗化（secularized）。

value 可以指 "明暗" 以及色彩的 "明度"。色相本身有明度差，黄色最高，紫罗兰最低。在画画时，我们往往会利用这种属性降低或提高明度，而不是加黑或白。人类对色彩的认识和表现，在总体上是不断进步的。在文艺复兴时期，绘画似乎只注重明度的呈现，而缺少对于色相、纯度和冷暖关系的表达，其色调

被称为"酱油调子"。随着时代的发展，人们对于色彩的丰富性有了更多的认识。巴洛克—浪漫主义—印象主义的演变历程见证了色彩表现渐趋丰富的历程。印象主义一劳永逸地解决了色彩的问题。

value 还有"价值观念"的意思。古希腊、中世纪和文艺复兴时期的艺术作品往往都是为价值观念而创造，因此才具有永恒意义。文艺复兴之后开始的世俗化过程意味着艺术中"价值观念"的消解和淡化。

e-valuate 是"将价值提取出来"，也就是"评估""评价"。evaluation 是名词。re-evaluation 则是"重估"。伴随着新的考古发现，以及人们认识上的改变，美术史上常有"重估"现象。清代中期到民国以来的"尊碑抑贴"运动就是对于汉碑和北朝碑刻的价值重估。

var: 变化 = change

与 change 相比，vary 更是指一种"有关联的变化"，因此后者会更多地用于艺术的描述之中。名词 variety 的结尾是 iety，相当于 ity，意为"多样性"。variable 作形容词是"可变的"，作名词是"变量"。色彩就是一种变量，因为它常常会受到周边色彩的影响而产生色变（一种视觉幻觉）。因此，课文中会用 unpredictable 或 vibrating 这样的词来说明色彩的视觉效果。在画面语言中，视觉重量（weight）常常是变量，因为在不同语境中，或在被赋予不同意义时，元素的视觉重量都会有变化。variation 是"变体""变奏（音乐）"。词根常常会有变体，var 的变体是 ver。

var 和 ver 都有"流转""变化"的意思，而"变化"又衍生出"多样"的意思，例如：version（版本），diversity（多样性），versatile（多才多艺的），versicolored（因光的不同而颜色多变的）。

vibr: 摇动 = to shake

ate 是常见的动词后缀，vibrate 意为"振动"，是一个常见的动词，例如，手机的振动。但用这个词来描绘色彩时，可以让我们想到色彩的两种基本属性：1）受光与空气的影响，户外的色彩常常给人一种颤动的感觉。在印象派画家中，莫奈是最典型的例子，他的风景画常常表现空气中或光线中颤动的色彩。2）

（在一幅画面上或一个视野中，）色彩彼此之间相互影响，从而在彼此的映衬下，呈现出灵动的、瞬间性的色彩变化。形容词 vibrant 可以表示"振动的""颤动的"，但也可以泛指"灵动的""充满生机的"。

vis：看 = see

形容词 visual 可以组成一些重要的词组：visual arts（视觉艺术），visual communication（视觉传达），visual language（视觉语言），visual identity (VI)（视觉识别系统）。美术、设计、工艺以及建筑都可以笼统地称为 visual arts。visual language 是研究、解读视觉艺术的通用手段，与 pictorial language，formal language 大同小异。曾经的 graphic design，现在称为 visual communication。这反映了设计发展的趋势——以功能为先。功能在于传达，设计的成功与否在于传达。同时，这也体现出媒介的变化：graphic design 更多地是纸媒印刷时代的产物；进入电子时代，传达的手段都迅速发展，graphic design 的意象显得有些过时了。视觉传达中的一个门类是 visual identity (VI)，也称为 visual identity system (VIS)。它与 behavioral identity (BI)，mind identity (MI) 共同构成 corporate identity (CI)。

曾经的 fine art 和 artistic design 成了 visual arts，曾经的 composition 成了 visual language，曾经的 graphic design 成了 visual communication，这反映了它们在方法和含义上的"扩围"和变迁。

vision 指"视觉""视力""视像"。视像可以定义为艺术家眼中 / 头脑中的景象。艺术家往往会先有视像，然后才会形成具体的作品。动词 envison 意为"预想"，例如，在建成一座建筑之前，事先预想出它的样子。相关词汇有 visible（可见的）；invisible（不可见的）; visibility（可见性）; invisibility（不可见（性））。在西方美术史中，印象主义之前的绘画的笔触是不可见的（invisible），这是因为，在古典—写实主义 (classical-realism) 的体系之中，为描绘形体 (form) 和空间 (space)，形成自然的过渡，笔触必然要消失在块面、形体和空间之中。而自印象主义之后（包含印象主义），为表现瞬间性的、支离的、个人化的感受，笔触开始"浮出水面"，成为"可见的"。此外，笔触有着自身的方向与形态，"可见的"笔触在画面构成中也起着一定的作用。

voc，vok: 呼唤 = call

vocation 一词源于基督教，指神对于人的"召命"，后来有了"职业"的意思。vocational 为形容词。前缀 a 可以表示否定，avocation 则是"副业""非职业性的爱好"，与名词 amateaur 有关联。在唐代以后，文人画逐渐成为纯粹的精神寄寓，因而也是"非职业性的爱好"，这与职业性的院体画形成对照。这种局面在明代中期之后逐渐有所改变。随着商品经济的发展，艺术逐渐变得世俗化、职业化。

前缀 e 表示"出""出来"，evoke 则是唤起的意思。evocation 为名词。中国山水画是一种带入性、写意性的绘画，它不是要描摹物理性自然的某个部分，而是要将人带入某种情境、某种意境空间之中。这种含义常常可以用 evoke 和 evocation 表示。

volv: 卷，转，滚动

evolve 意为"滚动而出离于原有位置或范围"，引申为"演进""演变"。evolution 是名词。revolution 意为革命。re 表示"着力""施加（外力）"。从构词的角度来解释，革命即通过施加外力推动历史的前进。

Industrial Revolution 意为"工业革命"，它是现代设计史的引擎。现代工业所产生的大量产品需要被购买、使用和贸易，于是就需要有优良的产品设计。产品需要让人了解和识别，于是（现代的）视觉传达应运而生。社会化大生产导致城市的兴起和大量人口涌向城市，这就需要大面积廉价而注重功能的居住空间和工作空间，于是,（现代的）建筑设计、环境设计（environmental design）逐渐形成。工业化的本质是社会化大生产（或规模化生产）。社会化大生产有两个核心条件：系统化和标准化。只有通过系统化和标准化，才能最大限度地提升效率，节约成本。这是工业的逻辑，也是在现代设计的演变过程中，简单、平直的现代主义设计最终胜出，并成为主流的内在原因。从这个角度说，工业化左右了现代设计的形态（form）。随着工业革命和社会化大生产对生活方式，以及视觉环境和空间环境的改变，人们的审美意识正在发生微妙的变化。简单、快捷、直接、灵活、自由等因素进入人的心理，成为现代审美的元素和尺度，造就了所谓的工业美学（industrial aesthetics）。现代主义设计是这种审美的体现与合法化。

volume 意为"卷""册"。西方古代书籍的形态是羊皮书；在中国是竹简或帛书（恰巧也是"卷"）。此外，volume 也有"体积"的意思。相比于其他艺术类型，雕塑的特性就在于其所展现的体积感（voluminosity）和量感。

revolver 是"左轮手枪"的意思。著名的柯尔特（Colt）左轮手枪的生产者发现，由各地分别生产手枪的部件再集中组装是非常能够提高效率的。这在工业史上是一个创举，成为后来福特主义的先声。

Key to Exercises

Unit 1

I

1. He arrived in Arles in February 1888 and left there in May 1889.
2. Violet and yellow.
3. The easy conviviality of the southern summer evenings.

II

1. mute 2. studies 3. tranquil 4. easels 5. offset
6. strokes 7. vibrating 8. prolific 9. masterpieces 10. hues

III

1. live (*adj.*), *Life*, alive
2. creative, creativity, creations, created
3. radioactivity, radium, radio, radiate
4. comparable, comparison, compared, Comparatively
5. friends, friendly, befriended
6. intensity, intensive, tension

IV

1. "Thousands upon thousands of pear trees burst into bloom."
2. People will have the impulse to become artists at the sight of van Gogh's works.
3. The night sky is alive with stars, like "the streets in heaven".
4. In the 19th century, scores of young artists flooded into Paris from all over the world.
5. By contrast, the Latin peoples are more sensitive to colors.
6. The demands for market and resource pitted the two nations against each other.

V

1. B 2. A 3. D 4. A 5. A 6. B

Part B

I

1. He thought that the night is more alive and more richly colored than the day.
2. In a subjective, exaggerated and expressionist manner.
3. It creates a flame-like connection between the earth and sky.
4. 略。

II

1. "夜晚比白天更加生动鲜活，色彩更加丰富。"
2. 其他人看来也许只是宁静平凡的景致，凡·高却以起伏搅动的波浪来描绘它。
3. 文森特·凡·高通常被认为是继伦勃朗之后最伟大的荷兰画家；他有力地影响了现代艺术中的表现主义潮流。

Unit 2

Part A

I

1. They can provide directional movement in the work, leading the eye through the image. Together, they can form shapes, patterns, and texture, and can help lead the eye back into space in an image. They can form empty or filled shapes. They can also be used in hatching and cross-hatching to shade forms.
2. Because it doesn't refer to the physical weight, but visual or psychological weight.

3. Warm colors tend to come forward, and cold colors tend to recede in space.

II

1. spatial 2. orchestration 3. Optical 4. geometric 5. patches
6. value 7. placement 8. organic 9. modernism 10. perpendicular

III

1. Cursive, curved, curve
2. underlining, delineate, line
3. portrayal, *Portrait*, portrays
4. neutralize, neutralization, Neutral
5. direct, directions, directional, director
6. United, unity, unify, units

IV

1. The interior of the bar is designed in a nostalgic manner.
2. Indoors, in natural light, the color of dark sides of objects tends to be warm.
3. Relative to (the color of) the sky, the color of the house looks even brighter.
4. Only by making the background recede, can you fully represent the sense of space.
5. This is the cultivation in the sense of color, rather than the training in the ability of (three-dimensional) modeling.
6. Put the feather and pottery on top of the table; then they will be more than feather, pottery and table.

V

1. D 2. B 3. C 4. B 5. C 6. D 7. B

Part B

I

1. Areas of most contrast (of dark and light) seem to come forward in space.

2. Van Gogh made great use of texture in his ink drawings.

3. They use linear and atmospheric perspective to depict the illusion of spatial depth.

II

1. 色彩也有着明暗的变化；要想脱离开色彩属性来看到这种明暗（变化）是需要一些练习的。

2. 在现当代艺术中，视觉肌理已被用于"平面"的画面构成之中，也就是说，并非是以前的艺术那样的（三维的）幻象空间。

3. 这些艺术家对于画面的"平面"的真实更感兴趣，甚于对"真实"空间的模仿。

Unit 3

Part A

I

1. In the tenth century.

2. To form the structure and define the craggy land formations and the textures of leaves and rocks, as well as create rhythmic, abstract patterns.

3. Chinese artists received extensive training in calligraphy, and Chinese painting was nurtured by the freedom and fluency of Chinese script.

II

1. calligraphy 2. indication 3. boundless 4. craggy 5. landscape

6. pictorial 7. evoke 8. nebulous 9. oriental 10. shrouds

III

1. fineness, refined, refinement
2. complementary, complete (or completed), complement
3. total, tone, tonal, tonality
4. nature, Nurtured, natural
5. cleansed, clean, clear
6. composition, compositional, composed, compose

IV

1. In his opinion, the flourish of painting in Song Dynasty is due to the migration of people.
2. The "area of empty paper" is not applied with any stroke (or ink stroke), but endowed with ideas (or spirit).
3. In addition to the identity of painter, he is also a calligrapher, poet and musician.
4. Western painting relies on form and color, while Chinese painting on the stroke (or brushwork).
5. This picture hints at the existence of temple in the depth of mountains with an old monk fetching water.
6. It is an interesting process to translate texts into images.

V

1. B 2. D 3. C 4. B 5. C 6. A

Part B

I

1. Landscapes, figures and bird-and-flower.

2. The blue-and-green landscape used bright blue, green and red pigments derived from minerals to create a richly decorative style. The ink-and-wash landscape relied on vivid brushwork with varying degrees of intensity of ink to express the artist's conception of nature, his own emotions and individuality.

3. Flowers, fruits, insects and fish.

II

1. "清初四僧"——朱耷、石涛、髡残和弘仁——削发以明志，不侍新朝，并通过绘画寂寥的山水聊以自慰。

2. 水墨山水依赖生动的运笔和浓淡有致的墨色来表达艺术家的自然观、情感和个性。

3. 在宋代，许多著名的艺术家都画这种画，他们的主题包括各类花果鱼虫。

Unit 4

Part A

I

1. Five. Poster, letter, business logo, magazine ad., album cover.

2. The main tools are image and typography.

3. To designers, what the words look like is as important as their meaning.

II

1. audience 2. poster 3. messages 4. wrappers 5. letterform

6. album 7. loudspeaker 8. gum 9. particular 10. billboard

III

1. calligraphy, graphic (*n.*), graphic (*adj.*), photography, typography
2. designer, design, sign
3. communication, communicates, communicative
4. Identity, identify, identifier
5. representation, represent, presented
6. printed, printer, printout

IV

1. He is an experienced designer, and has designed a variety of letterforms (typefaces).
2. In the case of logo design, we have to pursue simplicity.
3. He emphasizes hand-painting, and seldom uses the computer if any.
4. Relying on limited equipments, they worked out exquisite images.
5. We should communicate messages with visual devices like images, typefaces and typography.
6. The business philosophy and corporate culture of this company seem to have been condensed into this logo.

V

1. B 2. A 3. C 4. D 5. A 6. B 7. A 8. C 9. B

Part B

1. 略。

2. Graphic designers are asked to translate and transmit their messages in a clear, clever, and situationally relevant way.

3. 略。

II

1. 平面设计是一种艺术，它将文本和图形结合在一起，并在标志、图形、手册、传单、招贴、标识以及其他种类的视觉（传达）手段中传达（一个）有效信息。

2. 在平面设计中，如果风格变得过于"喧宾夺主"，作品将失去有效性并变得杂乱，同时（因而）妨碍了传达。

3. 这种合作于我而言是一件美好的事情。

Unit 5

Part A

I

1. In 1853–1854, when Matthew Perry and American naval forces exacted trading and diplomatic privileges from the Japanese court, Europeans became familiar with Japanese culture and Japanese art.

2. He emulated Japanese compositional style and the distinctive angles that Japanese printmakcrs employed in representing human figures.

3. Those artworks intersected nicely with two fundamental Arts and Crafts principles: art should be available to the masses, and functional objects should be artistically designed.

4. Their affordability and the ease with which they could be transported.

II

1. flatness 2. Ukiyo-e 3. woodblock 4. coined 5. emulate

6. exoticism 7. merchandise 8. garnered 9. album 10. feature

1. colony, colonization, colonial
2. naval, navy, navigation
3. exact (*adj.*), exactly, exacted (*v.*)
4. industry, industrialization, industrial, industrialized
5. intersection, intersected, sections
6. present (*adj.*), presentation, represent, representational

IV

1. After Japan began trading abroad, the Western people became familiar with the ukiyo-e prints of the Edo period.
2. He was intrigued with everything, including architecture, mechanical devices and art.
3. The lacquer cabinets made in Japan in particular appealed to European people.
4. This brochure called attention to this printmaker.
5. The works of Degas were always associated with the following subject matters: theater, ballet, washerwomen, etc.

V

1. D 2. C 3. D 4. C 5. A 6. B

Part B

I

1. Degas was not concerned with outdoor light and atmosphere, and he specialized in indoor subjects.
2. *The Rehearsal* is the antithesis of a classically balanced composition. The center is empty, and the floor takes up most of the canvas surface. At the

margins, Degas arranged the ballerinas and their teachers in a seemingly random manner.

3. Japanese woodblock prints.

II

1. 他迷恋巴黎歌剧院上演的古典芭蕾那种形式化的运动模式，也陶醉于剧院舞蹈学校芭蕾舞女的基训。

2. 与其他印象主义绘画一样，画面左侧和右侧人物的剪切增强了一种感受，那就是观者正在目睹着那白驹过隙的一瞬。

3. 由于对运动式样的兴趣，德加迷恋摄影，并常常使用一台相机来拍摄创作小稿。

Unit 6

Part A

I

1. People with good taste are those who exhibit sound aesthetic judgment and thoroughly understand the needs of their individual lifestyle.

2. The criteria of good taste and style.

3. Simplicity.

II

| 1. sound | 2. cliché | 3. extraneous | 4. distinctive | 5. accessory |
| 6. fad | 7. abhorred | 8. conformity | 9. furniture | 10. essentials |

III

1. aesthetics, aestheticism, aesthetic

2. elevate, elevation, elevator

3. intuition, Intuitively, tuition, intuitive
4. simplicity, simple, simplify
5. consciously, consciousness, conscious
6. residents, residential, nonresidential, residence

1. Paying too much attention to the form may lead to a mechanical formalism.
2. Due to the invention of 3D printing, the execution of design comes easy to them. (Or: it comes easy to them to execute their designs.)
3. This kind of design idea is out of the ordinary, breaking people's general understanding about design.
4. In favor of France, she applied to work in the branch in there.
5. They successfully made the new library tuned into the old one.
6. For the sake of the integrity of design, they deleted these decorations.

V

1. B 2. A 3. C 4. A 5. C 6. D

Part B

1. Yes, they can.
2. The moment a man starts to beautify something, in that very instinct he has ceased to be selfish. He is giving without receiving.
3. No, all men have it in them to beautify anything somewhat.

II

1. 即使它们将全部从这个世界上消失，房屋也照旧可以栖身，火车照旧可以奔驰，电梯照旧可以升降，餐馆照旧可以生火做饭。
2. 一个人开始美化事物的那一刻，在那种本能之下，他已不再自私。

3. 他会很在意自己的心灵，自己的文字和言语，自己的家园，自己的朋友，以及自己生活的土地。

Unit 7

Part A

I

1. It was taught with much academicism when Cézanne was young.
2. His early style was the complete opposite of the official, academic style—it was rough, unrefined, a riot of thick brushstrokes and color, with rather passionate, even somewhat erotic, themes.
3. Pissarro.

II

| 1. lofty | 2. riot | 3. subdue | 4. session | 5. category |
| 6. convinced | 7. forged | 8. estate | 9. facility | 10. erotic |

III

1. structure, structural, construct
2. aptitude, attitude, altitude
3. academic, academy, academicians
4. miss, commission, mission
5. Fine, unrefined, refined
6. valuable, evaluate, value (*v.*), value (*n.*)

IV

1. She urged the collector not to sell this work.
2. In Cézanne's paintings, the structure itself is the subject matter.

3. He made the acquaintance of a lot of critics in the cafes of Paris.

4. The colors and canvas is not his cup of tea, and he likes to express himself with the clay.

5. He tries to soak up nutrition from folk arts.

6. The still lifes of Cézanne are not necessarily realistic enough, yet they show the solidness of forms.

V

1. A 2. B 3. C 4. A 5. B 6. B 7. C

Part B

I

1. Impressionist painters did not create paintings that were compositionally strong, and they were not interested in endowing painted objects with three-dimensional solidity.

2. He used the richness of color to represent the solidity of form.

3. In Cézanne's work the visual "inaccuracies" reveal the moving viewpoint of the artist relative to objects being painted.

4. Cézanne has sacrificed the ravishing, momentary subtlety of color that forms the foundation of Monet's accomplishment in his attempt to create a landscape that has an enduring strength and power.

II

1. 塞尚在绘画中给自己布置了一个不可能完成的任务：在鲜活的色彩，坚实的形体，以及二维性的画面之间建立一种均衡。

2. 那一颗颗果实画得呼之欲出，这在一定程度上是由于色彩极为丰富充盈，这印证了塞尚的那句格言："当色彩最为丰富充盈的时候，形体也是最为坚实饱满的。"

3. 那种迷人的、瞬间性的色彩的微妙感是莫奈艺术成就赖以形成的根基；

而塞尚却将其舍弃，只为创造出具有恒久力量的风景画。

Unit 8

Part A

I

1. The stroke that is full of life and movement.
2. These metaphors imply the dialectic correlation and interaction between the upper part and lower part of the Vertical Stroke; they may also imply the importance of ending up the stroke in time.
3. Powerful and sinewy calligraphy.

II

1. brushwork	2. character, character	3. lifeless	4. dew
5. slightly	6. bony, sinewy	7. vertical	8. resilience
9. fundamental			

III

1. calligraphy, calligrapher, calligraphic
2. symmetrical, asymmetry, symmetry
3. readers, read, readability, misreadings
4. flex, flexibility, flexible, flexors
5. approximate, approximately, proximity
6. live (v.), lively, life, liveliness

IV

1. Wen Yiduo was not only a poet, but also was skillful in painting and seal-carving.
2. The beauty of calligraphy not only lies in stroke and composition, but also in

vitality (or rhythm).

3. Qin Shi Huang attached importance to the unification of scripts, which led to the evolution from the Big Seal Script to the Small Seal Script.

4. This character looks unstable, yet it obtains stability in relation to other characters.

5. This stroke starts with the tip of the brush being concealed and ends with the tip of the brush being revealed.

6. Starting from Eastern Jin, calligraphy was invested with more cultural connotation.

V

1. B 2. A 3. A 4. A 5. C 6. D

Part B

1. Negative force and positive force.

2. The Daoist philosophy of yin and yang has nurtured and fundamentally determined the character of calligraphy.

3. Lift versus press, square versus round, curved versus straight, guest versus host, and so forth.

1. 从古典的书论到现代的字帖，对于书法技法的描述都以各种相对的概念为依据，包括提与按、方与圆、曲与直、宾与主等。

2. 当一幅字有了律动，它就会带有某种内生的气韵，这种气韵对于作品的艺术品质至关重要。

3. 只有充分理解了阴阳观念及其在书法中的体现，你才能掌握这种艺术的要旨。

Unit 9

Part A

I

1. The infusion from popular art and the new restless spirit in the coastal cities added to the vigor of his art.
2. Bamboo, flowers and rocks.
3. He is best known for his late paintings, chiefly of birds and flowers, crabs and shrimps.

II

1. refreshing 2. abroad 3. reassertion 4. coastal 5. paralysis
6. vines 7. connoisseur 8. survivals, surrender 9. restless

III

1. subconsciousness, consciousness, conscious, unconscious
2. emphasis, emphasizes, emphatic
3. invalid, validity, valid
4. expressionism, expressionistic, expression, express
5. transliteration, literati, literature, literate
6. miraculously, miracle, miraculous

IV

1. "Wildfire cannot burn it out; spring breeze will let it burst forth anew."
2. With this oil painting, Mr. Yu Xiaofu is paying a tribute to a handful of Shanghai School artists.
3. The invasion of Japanese provoked them into creating for the War of Resistance.
4. Rembrandt was known for painting self-portraits, and it's said that he had painted more than ninety.

5. Industrialization reduced the worker to a subordinate of machine.

6. To some degree, the flourish of art owes to urbanization and cultural consumption.

V

1. C 2. A 3. A 4. D 5. B 6. C

Part B

I

1. Because Wu had had a great reputation in the art of seal carving.

2. Asakura Fumio, a prominent Japanese sculptor.

3. Merchant and supporter of artists.

II

1. "南吴北齐"——这个说法在某种程度上是非常得当的，因为吴昌硕和齐白石在他们自己的艺术领域中都起到了决定性的作用。

2. 一天，他们同游西泠山，也就是他助建的著名印社的所在地，他们很惊奇地发现人们在一尊铜像之前焚香叩拜。

3. 他的有些作品体现出任伯年的影响，其他一些又体现出吴昌硕的影响；他对吴关照有加，甚至为其养老送终。

Unit 10

Part A

I

1. The manufacturers wanted to make more profit and lower the cost; besides, they had little competition throughout the world, so they didn't have to design

their products well to excel others.

2. It was not practical, not suitable for mass production and was only available to the wealthy.

3. The lamps made by Louis Tiffany in America and the Paris Metro Stations by Hector Guimard.

4. By the time of the First World War (1914—1918).

II

1. wallpaper 2. manufacturer, dealer 3. process 4. elaborate

5. metalwork 6. popularity 7. catalyst 8. alienation 9. fade

III

1. handicraft, Crafts, craftsmen, craftsmanship

2. meditated, media, Medieval

3. compete, competitive, competition

4. historic, historical, prehistoric, History

5. modern, Modernist, modernism

6. product, produced, productive, Mass production

IV

1. Some people say that the building of Eiffel Tower was to show off the steel industry of France to the world.

2. John Ruskin wrote a lot of books to react against the alienation of industrialization to man.

3. They started up a design school to develop new design talents.

4. Art Nouveau is characterized by naturalism and oriental sentiment.

5. The organic shape tends not to be suitable for mass production.

6. Fordism was applied to almost all industrial productions.

V

1. D 2. B 3. B 4. D 5. A 6. B

Part B

1. The study of materials, color theory, and formal relationships in preparation for more specialized studies.
2. The steel-frame construction, a glass curtain wall, and an asymmetrical, pinwheel plan, throughout which Gropius distributed studio, classroom, and administrative space for maximum efficiency and spatial logic.
3. Marcel Breuer.

II

1. 而后，学生会进入专业工作室，这包括金属工艺、家具制作、编织、陶艺、版式，以及壁画。
2. 自1924年至1928年，在马塞尔·布劳耶的指导下，该工作室对于家具的本质做出重新认识，他们常常力图将椅子之类的家具的传统形态损之又损，删繁就简。
3. 染织工作室制作出的织物在商业上是很成功的，为包豪斯提供了不可或缺的资金。

Unit 11

Part A

1. 略。
2. They were afraid of their daughter being alone, in a faraway country, in a city widely known for its immoral character, and fraternizing with some of the most notoriously immoral types on earth—artists.

3. Baroque, impressionism and Japanese print (woodcut).

II

1. woodcut 2. has been awarded 3. decent 4. stiff

5. enrolled 6. mentors 7. pursue (are pursuing) 8. mandolin

9. concession 10. recognition

III

1. hostel, hostile, hospitable

2. scan, scandal, scandalous, scanner

3. maternal, fraternize, fraternity

4. mortal, immortal, immoral, moral

5. forward, rewarded, Award

6. appearance, apparent, apparently

IV

1. Having drifted for so many years, he finally settled down in that small town.

2. No doubt, Cassatt was ever influenced by Hals, Degas, and Japanese Print.

3. The students are always afraid of choosing the wrong specialty.

4. At any rate, in the 19th century, America was a learner in front of European culture.

5. She gave up the subjects of history and mythology in favor of (painting) interiors.

6. This book enabled him to solve the problem of forming (or: modeling) once and for all.

V

1. B 2. A 3. B 4. D 5. D 6. A 7. B

Part B

I

1. She studied privately in Philadelphia and attended the Pennsylvania Academy of the Fine Arts.

2. They both painted impressionistically. In particular, they both preferred unposed asymmetrical compositions.

3. Under the influence of Japanese print, her emphasis shifted from form to line and pattern.

4. She urged her wealthy American friends and relatives to buy impressionist paintings.

II

1. 如同德加一样，卡萨特展现出对于素描的精熟，而且两位艺术家都喜欢未经（刻意）摆放的非对称的构成（构图）。

2. 在这些蚀刻版画中，结合凹铜版、铜版和软基底蚀刻，她的版画技巧臻于完美。

3. 这样，她对于美国的艺术品位施加了持久的影响，这超乎了她自己的作品所形成的影响。

Unit 12

Part A

I

1. The Renaissance and neo-classicalism.

2. Rationalism is a philosophy in which knowledge is assumed to come from reason alone, without input from the senses. This is not to say that Greeks were wholly without emotion.

3. 略。

II

1. city-state 2. assert 3. flourished 4. decline 5. accepted

6. utmost 7. spanned 8. vital 9. cycle 10. manifested

III

1. Revival, VIVE, revived
2. Demo, democratic, democracy
3. intellect, intellectuals (*n.*), intellectual (*adj.*)
4. rational, ration (*v.*), rationalism
5. idealizing, idealist, ideas (*n.*)
6. perfection, perfect (*adj.*), perfected (*v.*)

IV

1. On the eve of the War of Resistance, they moved the cultural relics collected by the Palace Museum to Southwest China.
2. During his presidency, he placed emphasis on the educational independence of China.
3. What other viewed as a placid scene, van Gogh rendered with wavy forms.
4. In the field of architecture, the International Style has already been widely adopted.
5. As with Greek philosophy, the Chinese philosophy in the Axial Period is also thought to be eternal and irreplaceable.
6. In Greek mythology, every god corresponds to a kind of virtue.

V

1. A 2. C 3. A 4. D 5. B 6. B 7. D

Part B

I

1. The dialectic between motion and stability, between emotion and restraint.
2. They pull together the priest and his sons, who otherwise thrust away from the center of the pyramidal composition.
3. On one hand, it is very realistic and emotional; on the other hand, it is highly idealistic.

II

1. 这是一位风华正茂的青年，此刻，他的手臂极近后旋（之势），正欲将铁饼掷向前方。艺术家准确地捕捉到了这个身姿。
2. 那种此消彼长的挣脱与缠缚在增加着紧张气氛，在说明着人与神的战斗是多么徒劳。
3. 这位"希腊化时期"艺术家逼真的写实和澎湃的情感在精神上与这种静雅和高度理想化的形体真的是相去甚远。

Unit 13

Part A

I

1. Naturalism, individuality, features, fragment.
2. 略。
3. Instead of setting up a traditional pyramidal composition, he placed the six men on the same level.

II

1. Misery　　2. feature　　3. meditation　4. autonomous　5. toe
6. contemporary 7. pedestal　　8. fragments　9. flesh, sack

III

1. monument, moment, monumental
2. proposition, proposed, pose
3. idealized, idealism, unidealized, ideals
4. aestheticism, aesthetic (*n.*), aesthetics
5. natural, nature, naturalist, naturalism
6. individual, Individuality, Individualism

IV

1. For the sake of successful modeling, Rodin made a lot of studies of heads, hands, torsos, etc.
2. This freestanding work is derived from *The Gates of Hell,* instead of *The Burghers of Calais.*
3. He speaks of Rodin's admiration (reverence) for Michelangelo in this book.
4. Being different from the ancient Greek sculptors, Rodin is more concerned with the features and the individuality.
5. Although he turned away from the tradition, he didn't turn away from beauty.
6. He focused on the eyes and brows of this tramp.

V

1. C　2. A　3. D　4. B　5. A　6. D　7. C　8. A

Part B

I

1. The way of expressing the effort of thought through the contraction of each and every muscle.
2. *The Three Graces Dancing.*
3. It rejected servile imitation and realized the simplification of form.

II

1. 《思想者》的意义从表现但丁发展成为一个更为广义的人的形象，这个人在冥想，他拼命想要挣脱动物属性，他受到一种神秘的启示，并使第一宗思想得以诞生。

2. 形体塑造是写意的，因为它要表现的东西不是情感，而是动作，是运动，即舞蹈。

3. 在这件作品中，罗丹对于作家的外形记录远不及对于其内在个性的描绘那样登峰造极，淋漓尽致。

Unit 14

Part A

I

1. Unity. / Rhythm, unity, and so on.

2. To create a center of interest (focal point); also to highlight the emotional or narrative significance of a work.

3. The former lays more emphasis on anatomical accuracy and the latter on the beauty in the ratio between pictorial elements.

II

1. principles	2. rhythm	3. proximity	4. compatible	5. focal
6. ratio	7. narrative	8. commercial	9. cohesive	10. highlight

III

1. Various, variety, variation, vary

2. Symmetry, asymmetrical, meters

3. pleasing, pleases, pleasure

4. regular, irregular, regulation

5. Theoretically, theory, theoretical, theorized

6. equality, equivalent, equal, equilibrium

IV

1. In this still life, the bottle, the fruits and the jar combine into a triangle.

2. In a sense, modernism is an emancipation of form.

3. The spiritual wound of World War I resulted in the birth of Dada.

4. We must think about the visual elements and the visual principles as a whole.

5. Colors opposite to one another on the color wheel are called complementary colors.

6. Asymmetrical balance can be categorized into horizontal balance, vertical balance and diagonal balance.

V

1. B 2. A 3. D 4. B 5. A 6. D 7. C

Part B

I

1. Photography influenced painting, with its snapshot effects of figures accidentally being cut off at the edges, and the feeling that the image continues beyond the edges of the picture.

2. Because this tends to divide the image in half.

3. 略。

II

1. 摄影以其抓拍效果影响了绘画，人物陡然在边缘被切掉，图像有延续到画面边缘之外的感觉。

2. 反之，斜线则是更为动态的，更加暗示运动。

3. 通常，形体的"重量"在某种程度上应该均衡分配，而不是堆积在某一个区域。

Unit 15

Part A

I

1. The terminator is located just before the surface of the form starts to face away from the light.
2. Because light bounces off objects in the environment and is reflected back into the shadows.
3. The center light is the plane (area) facing the light source perpendicularly, whereas the highlight is a reflection of the light into the artist's eyes.
4. A glossy surface will have brighter highlights whereas a highlight on a mat surface might not be visible at all.

II

1. terminator 2. center light, light source 3. core shadow
4. hit, bounced 5. blocks 6. captured 7. glossy 8. mat

III

1. dimension, 3-dimensional, 3-dimensionality
2. product, byproduct, has produced
3. illuminate, illusions, illustrate
4. *Party*, partially, part
5. reflectivity, reflection, reflect, reflector
6. toned, halftone, tone

IV

1. The surface starts to face away from the light source upon the terminator.
2. The highlight and the center light shouldn't get confused with one another.
3. The definition (location) of the terminator depends on the structure of form and the angle of lighting.

4. The torso is constructed from the rib cage, spine and pelvis.

5. The angle by which the ball hits the table falls close to that by which it bounces off the table.

V

1. A 2. C 3. D 4. A 5. B 6. A

Part B

I

1. Because the Renaissance artists wanted to show the importance of individual person with realism, yet the flat medieval style couldn't show this level of reality and the artists needed a new technique.

2. Somewhere above the eye level.

3. It indicates that the artist should flexibly deal with basic forms (structure) of the object in his mind, to combine them, to modify them, or to deform them.

II

1. 那种平面的中世纪风格无法将写实性表现到此种程度，画家们需要一种新的技巧。

2. 实际上，大多数的线似乎都汇聚到了视平线上：建筑物的顶线，窗户的顶线和底线等。

3. 你也可以拉伸或弯曲这些形态，以便更契合于主体物的特征。

Unit 16

Part A

I

1. 略。

2. In the 1960s.

3. 略。

II

1. nuance 2. nostalgia 3. carriages 4. inviting 5. dimly

6. permanent 7. bountiful 8. feast 9. momentous 10. utopian

III

1. hesitated, hesitant, hesitance

2. security, insecurity, secure

3. mistakes (*v.*), mistakes (*n.*), unmistakable

4. clear (*adj.*), clarify, clarity

5. mythology, mysterious, mythical（后两个可以互换）

6. psychological, psychology, psyche

IV

1. He tucked brushes, pigments and water into his traveling bag, getting ready to set off.

2. In a sense, Rockwell's paintings extended and enriched Roosevelt's speech about the "Four Freedoms".

3. Human history is filled with contradictions, absurdities and mystery.

4. Gauguin longed for natural and rustic life, therefore he left Paris.

5. In response to the calling of the Party, he went to the west to support education.

6. This book deals with World War II and the Cold War.

V

1. A 2. B 3. B 4. D 5. A 6. B

Part B

I

1. A Parisian fireman's helmet.
2. The gentleman leaning down behind the woman and attempting to be persuasive.
3. Usually his work is designed to be seen to maximum effect on the printed page.

II

1. 如果我们看看桌子和地面上的狼藉，（我们会得知）这是一场持久而又艰难的辩论。
2. "己所不欲，勿施于人。"
3. 在这个例子中，我可以想见，这种构图如果以壁画呈现出来也会很成功，甚至会更成功。

Unit 17

Part A

I

1. Italian designers tried to establish themselves as leaders in the international market place for domestic design to revive their depressed postwar economy.
2. A group of artist-designers who were interested in keeping alive the time-honored practices of hand-working traditional materials.
3. Some designers chose to conform to modernism; some designers developed a postmodernism; some designers abandoned the creation of useful objects in favor of nonfunctional design.
4. Contemporary and historical meanings as well as high and low cultures.

II

1. conviction 2. unbridle 3. time-honored 4. embrace 5. domestic

6. vernacular 7. employs 8. surge 9. Neoclassical 10. supersede

III

1. Consumerism, consumer, consumption, are consuming
2. historically, historical, historicism, history
3. function (*n.*), function (*v.*), functional, functionalism, nonfunctional
4. energy, energize, energetically
5. personality, impersonal, impersonality
6. dictate, *Contradiction*, contradictory

IV

1. German design is always characterized by rationality and rigorousness, which is especially embodied in its product design.
2. In reaction to their blockade and sanction, we made an effort to build up our heavy industry and drill for oil.
3. They spared no efforts to keep this time-honored handicraft alive.
 (Or: They spared no efforts to keep alive this time-honored handicraft.)
4. Venturi claimed "Less is bore" in opposition to Mies's architectural philosophy.
5. Historicism often means looking to previous styles and forms for inspiration.

V

1. D 2. A 3. A 4. C 5. B 6. B

Part B

I

1. The creation of incomprehensible works of art, soulless objects, and unwanted

buildings that people could not bear to live with.

2. Past decorative styles, such as Art Deco, Constructivism, and De Stijl.

3. Because they sensed that the modern aesthetic no longer held relevance in postindustrial society.

Ⅱ

1. 在早期的后现代主义者们看来，现代主义者们所拥趸的那种装饰缺乏与几何抽象是对建筑的非人性化，并且最终异化了建筑。

2. 现代主义者对于装饰和色彩的恨有多深，后现代主义者对它们的爱就有多深。

3. 现代主义者排斥历史主义、装饰和地方特色，而后现代主义设计师却要利用这些资源，以拓展其设计创造性的范围。

Unit 18

Part A

Ⅰ

1. 略。

2. Their simplicity and freedom, their transparency and luminosity, their extraordinary color sense, and their celebration of physical sensations.

3. More sense of light, the appearance of bright colors and a figure in the foreground.

Ⅱ

| 1. watercolor | 2. dinghy | 3. wilderness | 4. foliage | 5. flicks |
| 6. pack, outdoors | 7. denied | 8. conjure | 9. swells | |

Ⅲ

1. wide, wild, wilderness

2. illumination, luminous, luminosity, illuminate
3. celebrate, celebration, celebrities
4. reservoir, preserved, reserve (*n.*), reserved (*v.*)
5. sensitive, sensitivity, sensation
6. turbulent, turbulence, disturbing

1. The lecture was very dull; I found an excuse and slipped away.
2. Chicago has a lot of classic architectures, which sets it apart from all the other American metropolises.
3. He built up the sense of volume of the head and all the facial features with the brush strokes of Chinese painting.
4. In contrast with his early frontier poetry, Wang Wei's late works are ingenious/ delicate and meditative.
5. Those Buddhist masters often interpreted Chan by means of poetry.
6. "I raise the cup towards the moon; along with the shadow, we make a party of three."

V

1. A 2. B 3. D 4. B 5. A 6. C 7. B

Part B

1. 略。
2. Wang Wei's painting is based on ink and water, being achromatic, while Li Sixun's painting is richly colored.
3. He incorporated (introduced) poetry into painting in the same way that Wu Tao-tzu incorporated calligraphy into it.

II

1. 在王维生活的唐代，禅宗盛行，它引导人们通过静虑获得个人觉照。

2. 尽管他并不是一位像杜甫那样的巨匠（大匠），也不是一位像李白那样的天才，但他在意象的运用上逸群出众。他的诗常常蕴涵着一种禅机玄理，这成为他长期修行的印证。

3. "吴生虽绝妙，犹以画工论。摩诘得之于象外，有如仙翮谢龙樊。"

Glossary

A

abhor *v.* 憎恶，痛恨；拒绝　　　　U6TA

abroad *adj.* 到处的，广泛的 *adv.* 到国外，在海外　　　　U9TA

abrupt *adj.* 突然的；陡峭的；生硬的　U2TB

absorption *n.* 吸收　　　　U3TA

academic *adj.* 学院的，学院派的　　U7TA

academician *n.* 学会会员；院士；学院派画家　　　　U7TA

academy *n.* 学院　　　　U7TA

accepted *adj.* 一般承认的，公认的　U12TA

accessible *adj.* 易接近的，可到达的；可理解的　　　　U1TB

accessory *n.* 附件，零件；附加物，饰物　　　　U6TA

accomplishment *n.* 成就，完成　　U12TA

achromatic *adj.* 消色差的，非彩色的　　　　U18TB

acquaint *v.* 使熟悉，使了解　　　U5TB

acquaintance *n.* 相识，熟人　　　U7TA

address *v.* 从事，忙于　　　　U16TA

administrative *adj.* 管理的，行政的　U10TB

aesthetic *adj.* 美学的，审美的，有审美感的 *n.* 美学观念，美感　　　　U6TA

aesthetics *n.* 美学，审美　　　　U4TB

affordability *n.* 廉价　　　　U5TA

album *n.* 集邮本，照相簿，签名纪念册　　　　U4TA

alienation *n.* 异化　　　　U10TA

alive *adj.* 活着的；活泼的，有生气的　U1TA

almond *n.* [植]扁桃树　　　　U1TA

alternating *adj.* 交替的，交互的　　U14TA

ambiguity *n.* 歧义；不明确，模棱两可　　　　U17TB

amid *prep.* 在……中　　　　U9TA

analogous *adj.* 相似的，类似的　　U8TB

anatomical *adj.* 解剖的，解剖学的　U13TB

annual *adj.* 一年一次的，每年的　　U11TB

antithesis *n.* 对立，对立面　　　U5TB

apocalyptic *adj.* 启示录的，天启的　U1TB

apparently *adv.* 显然地，表面上地　U11TA

apply *v.* 申请；应用；上（涂）颜色　U2TA

appropriateness *n.* 适当，适宜　　U6TA

approximately *adv.* 近似地，大约　U8TA

aptitude *n.* 天生的能力；天资　　U7TA

archaic *adj.* 古老的，古代的，陈旧的　　　　U12TA

ascend *v.* 攀登；上升　　　　U6TB

aspiration *n.* 热望，渴望　　　　U16TA

assert *v.* 断言，声称　　　　U12TA

assimilation *n.* 吸收；接受　　　U17TB

asylum *n.* 救济院，精神病院　　　U1TB

asymmetrical *adj.* 不对称的　　　U14TA

asymmetry *n.* 不对称；倚侧　　　U8TA

atmospheric *adj.* 大气的，空气的　　U2TB

atypical *adj.* 非典型的　　　　U16TB

audacious *adj.* 大胆的，大胆创新的　U17TB

audience *n.* 听众，观众，受众　　U4TA

autonomous *adj.* 自发性的　　　U13TA

available *adj.* 可获得的；可购得的；买得起的　　　　U5TA

avidly *adv.* 渴望地，热心地　　　U5TB

award *v.* 授予　　　　U11TA

awareness *n.* 知道，晓得　　　　U6TA

azure *adj.* 蔚蓝的　　　　U1TA

B

ballerina *n.* 芭蕾舞女演员　　　U5TB

barn *n.* [农]谷仓；畜棚　　　　U6TB

Baroque *n.* 巴洛克式 *adj.* 巴洛克式的 U6TB

bather *n.* 沐浴者 U5TA

bearing *n.* 举止，做派 U9TA

befriend *v.* 待人如友，把……当朋友 U1TA

bespeak *v.* 证明 U12TB

betterment *n.* 改良 U4TB

billboard *n.* （户外）布告板，揭示栏，广告牌 U4TA

bland *adj.* 温和的，柔和的 U7TA

bleed *v.* （颜色）渗开，弥散 U18TA

blend *n.* 混合，混合色 *v.* 混合 U1TA

block *v.* 阻挡，阻塞 U15TA

bloom *n.* 开花期；最盛期 U1TA

blossom *n.* 花，花开的状态 U3TB

blunt *adj.* 钝的，生硬的 U7TA

boldness *n.* 大胆，泼辣，粗豪 U7TA

bony *adj.* 多骨的 U8TA

bounce *v.* 反跳，弹起，弹跳 U15TA

boundary *n.* 边界 U4TB

boundless *adj.* 无限的，无边无际的 U3TA

bountiful *adj.* 慷慨的，宽大的 U16TA

breakthrough *n.* 突破 U18TB

bristle *n.* 鬃毛；笔毫 U8TA

brochure *n.* 小册子 U4TB

broiling *adj.* 酷热的，炽热的 U1TA

brushwork *n.* （画家的）笔触，画法 U8TA

Buddhism *n.* 佛教 U18TB

Buddhist *n.* 佛教徒 U16TB

bureaucracy *n.* 官僚机构 U9TB

burial *n.* 下葬；葬礼 U9TB

burly *adj.* 魁伟的，结实的 U12TB

byproduct *n.* 副产品 U15TA

C

cabinetmaking *n.* 家具制作 U10TB

caddy *n.* 茶叶罐；小盒子 U5TA

calligraphy *n.* 书法 U3TA

canvas *n.* 帆布；油画，油画布 U1TA

captivate *v.* 迷住，迷惑 U6TB

capture *v.* 捕获，捕捉到 U15TA

carriage *n.* 马车，客车 U16TA

carver *n.* 雕刻匠，雕工 U9TB

cast shadow *n.* 投影 U15TA

catalyst *n.* 催化剂 U10TA

category *n.* 种类，类别；[逻]范畴 U7TA

celebrate *v.* 庆祝；称颂 U17TA

celebration *n.* 赞扬，赞美，颂扬 U18TA

center *v.* 置于中心，居中 U14TB

center light *n.* 中心光点 U15TA

champion *v.* 支持；为……而斗争，捍卫 U17TB

chaos *n.* 混乱，混沌 U1TB

character *n.* 性格，人物；汉字 U8TA

characteristic *n.* 特性，特征 U4TA

château *n.* （法语）古堡 U11TB

Christian *n.* 基督徒，信徒 *adj.* 基督教的 U1TB

chrysanthemum *n.* 菊花 U3TB

churn *v.* 搅拌，搅动 U1TB

city-state *n.* （古希腊的）城邦 U12TA

clarify *v.* 澄清，阐明 U16TA

cleanse *v.* 使纯净 U3TA

clench *v.* 紧握，（拳头）牢牢地抓住 U13TA

cliché *n.* 陈词滥调 U6TA

client *n.* 客户 U4TA

coarse *adj.* 粗鄙的 U6TB

coastal *adj.* 海岸的，沿海的 U9TA

code *n.* 代码，代号，密码，编码 U4TB

cohesive *adj.* 紧密结合的；呼应的 U14TA

coin *v.* 创造（新词语） U5TA

colonization *n.* 殖民，殖民地化 U5TA

combine *v.* （使）联合，（使）结合 U14TA

commence *v.* 开始，着手 U10TB

Glossary

commercial *adj.* 商业的 U14TA

commercially *adv.* 在商业上 U10TB

commission *n.* 委托；（艺术作品制作的）委托 *v.* 委托；委托制作（艺术作品）U13TB

communicate *v.* 传达 U4TA

communication *n.* 传达 U4TA

comparatively *adv.* 比较地，相当地 U1TA

compatible *adj.* 谐调的，一致的；兼容的 U14TA

compelling *adj.* 强制的，强迫的；引人注目的 U4TA

competition *n.* 竞争，竞赛 U10TA

complement *v.* 补足，互补 U3TA

complementary *adj.* 补充的，补补的 U2TA

compose *v.* 组成；写作，作曲；构图；（使）安定 U3TA

conceal *v.* 隐藏 U8TA

conception *n.* 观念，概念 U3TB

concession *n.* 让步 U11TA

concreteness *n.* 具体 U13TA

condense *v.* （使）浓缩，精简 U4TA

cone *n.* 圆锥体 U7TB

conformity *n.* 一致，符合 U6TA

conjure *v.* 变魔术般地创造出 U18TA

connoisseur *n.* （艺术品的）鉴赏家，鉴定家 U9TA

consciously *adj.* 有意识地，有知觉地；故意地 U6TA

consumerism *n.* 消费主义 U17TA

contemplation *n.* 沉思 U18TB

contemporary *n.* 同时代的人 U13TA

context *n.* 上下文，文章的前后关系，语境 U4TB

contradictory *adj.* 对立的；互相矛盾的 U17TA

convey *v.* 传达 U4TA

conviction *n.* 确信；信念 U17TA

convince *v.* 说服；使……确信 U7TA

conviviality *n.* 欢宴；高兴，欢乐 U1TA

convulsive *adj.* 抽搐的，痉挛的 U13TB

copywriter *n.* 广告文字撰写人，文案 U4TB

core shadow *n.* 核心暗影 U15TA

counter- （前缀）表示"相反，相对"之意 U14TA

couplet *n.* 对句，对联，联 U18TB

court *n.* 法院；庭院；朝廷，宫廷 U3TB

courtly *adj.* 王室的，宫廷的 U3TB

craft *n.* 工艺，手艺 U10TA

craftsman *n.* 工匠，手艺精巧的人；巨匠 U18TB

craftsmanship *n.* 技能，技术 U10TA

craggy *adj.* 嶙峋的，崎岖的 U3TA

creativity *n.* 创造力，创造 U1TA

credo *n.* [宗]信条 U16TB

cripple *n.* 跛子 *v.* 削弱 U9TA

critique *n.* 批评 U13TA

cross-hatching *n.* 交叉排线法 U2TA

crouch *v.* 蜷缩；蹲伏 U15TB

crystallize *v.* 结晶，晶化 U18TB

cube *n.* 立方体，立方 U15TB

cue *n.* 暗示，提示 U2TB

culmination *n.* 顶点；高潮 U13TB

cult *n.* 狂热的崇拜；宗教信仰 U6TB

current *n.* 潮流，趋势 U1TB

curriculum *n.* 课程，课程设置 U10TB

curve *n.* 曲线，弯曲 *v.* 弯，使弯曲 U2TA

curving *adj.* 弯曲的 U10TA

custody *n.* 保管；掌控 U9TA

cuteness *n.* 装腔作势，矫揉造作 U6TA

cycle *n.* 周期，循环 U12TA

cylinder *n.* 圆筒；圆柱 U7TB

cypress *n.* 柏树，丝柏 U1TB

D

dab *n.* 少量，一抹 　　　　　U1TB

dazzling *adj.* 耀眼的 　　　　　U6TB

deal *v.* 给予 　　　　　U9TA

dealer *n.* 经销商，商人 　　　　U10TA

debris *n.* 碎片，残骸 　　　　U16TB

decadent *adj.* 堕落的，颓废的 　U17TB

decent *adj.* 像样的 　　　　　U11TA

decline *n.* 下倾，下降；下垂 　U12TA

deconstructionism *n.* 解构主义 U17TB

decorative *adj.* 装饰的 　　　　U3TB

deform *v.* （使）变形 　　　　U15TB

dehumanize *v.* 使失去人性，使非人化
　　　　　　　　　　　　　　U17TB

deliberation *n.* 熟思，商议，考虑；从容
　　　　　　　　　　　　　　U16TB

delineate *v.* 描绘，用线条画 　U2TA

deliver *v.* 递送；传达 　　　　U4TB

dematerialize *v.* 消解；非物质化 U10TB

democracy *n.* 民主政治，民主主义 U12TA

deny *v.* 拒绝给予 　　　　　U18TA

depart *v.* 离开，起程；不按照 U13TA

depressed *adj.* 情绪低落的，沮丧的；萧
条的 　　　　　　　　　　　U17TA

determination *n.* 决心 　　　　U3TB

detritus *n.* 碎石 　　　　　U16TB

dew *n.* 露水 　　　　　　　U8TA

diagonal *adj.* 斜的，斜向的 *n.* 斜线，角线
　　　　　　　　　　　　　　U14TA

dictate *n.* 命令；规定，规则 　U17TA

dictum *n.* 宣言；格言 　　　　U7TB

differentiation *n.* 区别 　　　U13TA

dimly *adv.* 微暗地，朦胧地 　U16TA

dinghy *n.* 小艇 　　　　　U18TA

directional *adj.* 方向的 　　　U2TA

discernible *adj.* 可辨别的 　　U3TA

discernment *n.* 识别力，眼力，洞察力
　　　　　　　　　　　　　　U6TA

discus *n.* 铁饼 　　　　　U12TB

dismay *v.* 使沮丧，使惊慌 *n.* 沮丧，惊慌
　　　　　　　　　　　　　　U11TA

dissemination *n.* 散播 　　　　U5TA

distend *v.* （使）扩大，（使）扩张 U13TA

distill *v.* 提取……的精华；提炼 U18TA

distinctive *adj.* 与众不同的，有特色的
　　　　　　　　　　　　　　U6TA

distinguish *v.* 区分，辨别；（使）杰出
　　　　　　　　　　　　　　U18TA

distribute *v.* 分发，分配，分布 　U2TA

distribution *n.* 分配；分布；分销 U5TA

diverge *v.* 分开，叉开 　　　　U5TB

divine *adj.* 天赐的；极好的；神圣的 U8TA

domestic *adj.* 家庭的，家的；国内的 U17TA

dominant *adj.* 有统治权的，占优势的，支
配的 　　　　　　　　　　　U2TB

downright *adv.* 全然，完全，彻底 U11TA

draftsmanship *n.* 绘画技巧 　U16TB

dressing-gown *n.* 睡衣，睡袍 U13TB

drift *v.* （使）漂流；滑翔 　U18TB

durable *adj.* 耐用的，耐久的，持久的 U7TB

Dutch *adj.* 荷兰的 　　　　　U1TB

dynamic *adj.* 动力的，动力学的；动态的
　　　　　　　　　　　　　　U2TB

E

easel *n.* 画架，黑板架 　　　U1TA

eclectic *adj.* 折中的；多元的 　U9TB

economy *n.* 经济；节约；简约 U3TB

effective *adj.* 有效的 　　　　U4TB

effectiveness *n.* 效力，有效性 U4TB

elaborate *adj.* 精心制作的；详细阐述的
　　　　　　　　　　　　　　U10TA

Glossary

elevate *v.* 举起；提拔；振奋；提升　　U6TA

embrace *v.* 欣然接受　　U17TA

emigrate *v.*（使）移民　　U10TB

emphasis *n.* 强调，重点　　U14TA

emphatic *adj.* 用力的；显著的；断然的
　　U9TA

employ *v.* 雇佣；采用，利用　　U17TA

emulate *v.* 仿效，模仿　　U5TA

energize *v.* 加强，给……以活力　　U17TA

engaging *adj.* 动人的，有魅力的　　U1TA

enroll *v.*（使）入伍（入会、入学等）
　　U11TA

equitably *adv.* 平衡地；合理地　　U14TB

equivalent *adj.* 相等的，相当的 *n.* 等价物，
相等物　　U14TA

erotic *adj.* 性欲的，色情的　　U7TA

essential *adj.* 本质的，实质的；基本的 *n.*
本质，实质，要素，要点　　U6TA

establish *v.* 建立，设立；安置，使定居
　　U11TA

estate *n.* 房产，不动产　　U7TA

etching *n.* 蚀刻版画，铜版画　　U11TB

even *adj.* 平的，平稳的；偶数的　　U14TB

ever-increasing *adj.* 不断增长的　　U10TA

evoke *v.* 唤起，引起，博得　　U3TA

evolve *v.*（使）发展，（使）进化，（使）
逐渐形成　　U6TA

exact *adj.* 精确的，确切的，严谨的 *v.* 勒
索；迫使　　U5TA

excavate *v.* 挖掘，开凿；出土　　U3TB

excel *v.* 优秀，胜过他人　　U18TB

exception *n.* 除外，例外　　U14TB

excess *n.* 过度，无节制　　U6TA

exclusively *adv.* 排他地，专有地　　U6TB

exemplify *v.* 是……的典型；举例证明　U7TB

exert *v.* 运用，施加　　U8TB

exoticism *n.* 异国情调，异国风味　　U5TA

exploit *v.* 开拓；开发，开采　　U11TB

expressionism *n.* 表现主义　　U1TB

expressionistic *adj.* 有表现派作风的　U9TA

extensively *adv.* 广泛地　　U5TB

extraneous *adj.* 支节的；无关主题的　U6TA

extraordinary *adj.* 特别的，非凡的　U10TA

F

fabric *n.* 织品，织物，布　　U6TA

facility *n.* 熟练，敏捷；设备，工具　　U7TA

fad *n.* 一时流行的狂热，一时的爱好　U6TA

fade *v.* 褪色；枯萎，凋谢　　U10TA

familiarity *n.* 熟悉；通晓　　U9TB

fantastic *adj.* 幻想的，奇异的　　U1TB

faraway *adj.* 遥远的　　U11TA

fashion *n.* 样子，方式；流行，风尚　U14TB

fashion *v.* 造，塑造　　U9TB

feast *n.* 盛宴，筵席，宴会，酒席　　U16TA

feature *n.* 特征，特色；容貌　　U13TA

feature *v.* 以……为特征；由……主演　U5TA

fervent *adj.* 炽热的，表现出极大热心的
　　U16TA

feverishly *adv.* 兴奋地　　U1TA

figure *n.* 人物，人物画　　U3TB

filmmaker *n.* 电影摄制者　　U16TA

filter *v.* 过滤；体悟　　U3TA

fitness *n.* 适当；健康　　U12TA

flat *adj.* 平坦的，扁平的；平面的，二维的
　　U2TB

flatness *n.* 平面性，平面感　　U2TB

fleeting *adj.* 飞逝的，稍纵即逝的　　U5TB

flesh *n.* 肉，肉体，人体　　U13TA

flexibility *n.* 柔韧性，灵活性　　U8TA

flick *n.* 轻弹，轻拂　　U18TA

flood *n.* 洪水，水灾 *v.* 淹没，注满　U18TB

fly *n.* 萤火虫　　U18TB

focal *adj.* 焦点的，有焦点的　　U14TA

foliage *n.* 植物的叶子（总称）；灌木丛 U18TA

forge *v.* 稳步前进；铸造 U7TA

form shadow *n.* 形体暗影；暗部 U15TA

formalize *v.* 使形式化 U5TB

formation *n.* 构成，结构，形成物 U3TA

formulate *v.* 用公式表示；明确地表达 U12TA

fragment *n.* 碎片；断片，片段 U13TA

frame *n.* 画面；框架 U14TB

fraternize *v.* 结有深交 U11TA

freestanding *adj.* 独立式的，不需依靠支撑物的 U13TA

frottage *n.* 擦，摩擦；擦印画法 U2TB

functionalism *n.* 功能主义 U17TA

fundamental *adj.* 基础的 U5TA

funky *adj.* 新潮的，时髦的 U16TB

furniture *n.* 家具 U6TA

futile *adj.* 无用的，无效果的 U12TB

G

garner *v.* 获得；贮藏，积累 U5TA

gear *n.* 齿轮，传动装置 U16TB

genius *n.* 天才，天才人物；天赋 U18TB

genre *n.*（艺术的）类型 U3TB

geometric *adj.* 几何的，几何学的 U2TA

gleam *n.* 微弱的闪光，一丝光线 U18TA

glossy *adj.* 平滑的；有光泽的 U15TA

gonna(=going to) ＜美＞将要 U11TA

Gothic *n.* 哥特式 *adj.* 哥特式的 U6TB

govern *v.* 统治，支配 U6TA

graphic *adj.* 图形的，图解的 *n.* 图形 U4TA

grip *v.* 紧握，紧夹 U13TA

group *n.* 群像 U12TB

gruesome *adj.* 可怕的；可憎的 U12TB

guideline *n.* 方针，指导原则 U14TB

gum *n.* 口香糖 U4TA

H

halftone *n.* 中间色，中间色调 U15TA

hallmark *n.* 特点，标志 U10TB

handcrafted *adj.* 手工的，手工艺的 U10TA

harbor *v.* 持有，抱有 U16TA

hatching *n.* 排线，排线法 U2TA

havoc *n.* 大破坏，浩劫 U16TB

heave *v.* 举起 U1TB

Hellenistic *adj.* 希腊风格的，希腊文化的 U12TA

helmet *n.* 头盔，钢盔 U16TB

heron *n.* 鹭 U18TB

hesitant *adj.* 犹豫的，迟疑不决的 U16TA

hieratic *adj.* 僧侣的；神圣风格的（构图） U16TB

highbrow *adj.* 文化修养高的；高雅的 U17TB

highlight *v.* 加亮；使显著，突出 U14TA

Hindu *n.* 印度人，印度教教徒 U16TB

historical *adj.* 历史（上）的，有关历史的 U3TB

historicism *n.* 历史主义 U17TA

hit *v.* 击中；（光）直射 U15TA

holdout *n.* 坚持 U16TB

homage *n.* 敬意，尊敬，致敬 U13TB

horizontally *adv.* 水平地 U14TA

horrify *v.* 使恐怖，使惊骇 U11TA

hospitably *adv.* 亲切地 U1TA

hostile *adj.* 敌对的，敌意的 U11TA

hue *n.* 色度，色相 U1TA

humane *adj.* 仁爱的，高尚的 U6TB

humanity *n.* 人性；人类 U4TB

humble *adj.* 低微的，谦逊的 U4TA

I

i.e. *adv.* 也就是 U2TB

ideal *n.* 理想　　　　　　　　　U3TB

idealism *n.* 理想主义　　　　　　U12TA

identical *adj.* 同一的，同样的　　U14TA

identification *n.* 辨认，识别；确认　U8TB

identifier *n.* 识别方式，识别工具　U4TA

identify *v.* 识别，鉴别　　　　　U4TA

illuminate *v.* 照明，照亮；阐明，说明

　　　　　　　　　　　　　　　U15TA

illumination *n.* 照明；启发　　　U13TB

illusional *adj.* 错觉的，幻影的　　U2TB

illustration *n.* 插图，图解　　　U4TA

imagery *n.* 肖像（总称）；形象（总称）；意象（总称）　　　　　　　　　U18TB

immensely *adv.* 无限地，广大地，庞大地

　　　　　　　　　　　　　　　U3TB

immerse *v.* 沉浸，使陷入　　　　U10TB

immoral *adj.* 不道德的，放荡的　U11TA

impersonality *n.* 非人性化；缺少人情味

　　　　　　　　　　　　　　　U17TA

implied *adj.* 暗示（出）的　　　U5TB

imprint *n.* 盖印；痕迹；特征　　U12TA

inaugurate *v.* 创新，开创；举行就职典礼

　　　　　　　　　　　　　　　U13TB

incense *n.* 熏香　　　　　　　　U3TA

incomprehensible *adj.* 难以理解的，难懂的

　　　　　　　　　　　　　　　U17TB

incredibly *adv.* 难以置信地　　　U4TA

indicate *v.* 指示，暗示　　　　　U2TB

indication *n.* 指示，迹象，暗示　U3TA

individual *n.* 个人，个体　*adj.* 个人的　U6TA

individuality *n.* 个性，个人的特性　U6TA

industrialization *n.* 工业化　　　U5TA

infusion *n.* 灌输　　　　　　　U9TA

inherent *adj.* 固有的，内在的　　U17TA

innate *adj.* 内生的　　　　　　　U8TB

innovative *adj.* 创新的　　　　　U11TB

insect *n.* 昆虫　　　　　　　　U3TB

insecurity *n.* 不安全，不安全感　U16TA

inspirational *adj.* 给予灵感的，带有灵感的

　　　　　　　　　　　　　　　U5TB

instigator *n.* 煽动者　　　　　　U10TA

intangible *adj.* 不可捉摸的；难以确定的

　　　　　　　　　　　　　　　U14TA

integrity *n.* 完整，完整性　　　U2TB

intellect *n.* 智力，才智　　　　U12TA

intellectual *adj.* 智力的，有智力的　*n.* 知识分子　　　　　　　　　　　　U12TA

intensity *n.* 强度，亮度；纯度（色彩）

　　　　　　　　　　　　　　　U2TA

interior *adj.* 内部的，室内的　*n.* 室内设计；室内环境　　　　　　　　　　U6TA

interrupt *v.* 打断（正在说话或做动作的人），妨碍　　　　　　　　　　　　　U4TB

intersect *v.* 相交，交叉　　　　U5TA

intrigue *v.* 激起……的好奇心　　U5TA

intuitively *adv.* 直觉地；直观地　U6TA

invalid *n.* 病人　　　　　　　　U8TA

inventive *adj.* 善于创造的，发明的　U11TB

invest *v.* 赋予；使充满　　　　U8TA

inviting *adj.* 引人动心的，有魅力的　U16TA

irreverent *adj.* 不敬的，不惧权威的　U17TB

J

jewelry *n.* 首饰　　　　　　　U10TA

justify *v.* 证明……有理；证明合法　U18TB

juxtapose *v.* 把……并置　　　　U7TB

K

kimono *n.* （日本的）和服　　　U5TA

knit *v.* 编织，密接；皱（眉）　U13TA

knotty *adj.* （木材等）多结的，多节的

　　　　　　　　　　　　　　　U12TB

knowledgeably *adv.* 聪明地；有知识地

　　　　　　　　　　　　　　　U14TB

kowtow v. 磕头，叩头 U9TB

L

lace n. 蕾丝；透孔织品 v. 用带子穿过，
在……上穿带子 U18TA

landscape n. 风景，景观；风景画，山水画
 U3TA

lantern n. 灯笼，提灯，壁灯 U1TA

launch v. 发射；（文中指）提笔 U8TA

letterform n. 字形 U4TA

life-size adj. 与实物大小一样的 U12TB

lifeless adj. 无生命的，无生气的 U8TA

light source n. 光源 U15TA

light and shadow n. 在这里指亮部和暗部
 U15TA

likeness n. 相像；相似物 U13TA

linear adj. 线的，直线的，线性的 U2TB

literati n. 文人 U9TA

locate v. 查找……的地点 v. 定位；位于
 U4TA

lofty adj. 崇高的 U7TA

logo n. 标志 U4TA

look v. 寻找 U6TA

loom v. 隐约地出现；迫在眉睫 U17TB

loudspeaker n. 扩音器，喇叭 U4TA

luminosity n. 光感 U18TA

lush green n. 青绿色 U1TA

M

magnify v. 放大，扩大 U8TB

majority n. 多数，大半 U4TB

Manchu n. 满人；满族 U3TB

mandolin n. [音]曼陀林（一种乐器） U11TA

manifest v. 表明，证明 U12TA

manifestation n. 表现，显现；表现形式
 U8TB

mantle n.（某一职业或要职的）责任；衣钵
 U9TB

manufacturer n. 制造商 U10TA

maquette n. 初步设计的模型（或草图）
 U13TA

mask n. 面具，面部模型 U13TB

mass produce v. 大规模生产，规模化生产
 U10TA

mass production n. 大规模生产，规模化
生产 U10TA

mass-producible adj. 可规模化生产的
 U10TB

masterpiece n. 杰作，名著 U1TA

mastery n. 掌握，精通 U11TB

mat adj. 粗糙的 U15TA

maternal adj. 母亲的，似母亲的，母性的
 U11TA

maturation n. 成熟 U12TA

maximum n. 最大量，最大限度，极大
 U13TA

medieval adj. 中世纪的 U10TA

meditation n. 沉思，冥想 U13TA

meditative adj. 沉思的，冥想的（这里指
禅宗） U18TB

Memphis n. 孟菲斯（古埃及城市；美国
城市） U17TA

mentor n. [希神]门特（良师益友）；导师
 U11TA

merchandise n. 商品；货物 U5TA

message n. 消息，信息 U4TA

metalwork n. 金属工艺 U10TA

metaphysical adj. 形而上学的，玄学的
 U18TB

metro n. 地下铁道 U10TA

milieu n. 氛围，环境 U9TA

mineral n. 矿物，矿石 U3TB

minor *adj.* 较小的，次要的 U3TA

miraculously *adv.* 奇迹般地 U9TA

misery *n.* 痛苦，悲惨，不幸 U13TA

model *v.* 塑造，造型 U13TA

modeling *n.* 塑造，造型；[计]建模 U2TA

modernism *n.* 现代风，现代主义 U2TA

modify *v.* 更改，修改 U15TB

mold *n.* 模子，铸型 *v.* 浇铸，塑造 U6TB

momentous *adj.* 重大的，重要的 U16TA

monument *n.* 纪念碑 U13TA

monumental *adj.* 纪念碑的，纪念物的 U12TB

motif *n.* 主题，主旨；动机 U11TB

mount *v.* 装裱，裱（画） U9TB

mourning *n.* 哀悼，服丧 U1TB

mural *n.* 壁画，壁饰 U3TB

mute *v.* 减弱；使……变哑 *n.* 哑巴 U1TA

mythical *adj.* 想象的；神话的；虚构的 U16TA

N

napkin *n.* 餐巾，餐巾纸 U7TB

narrative *adj.* 叙述性的，叙事性的 U14TA

naturalist *n.* 自然主义者 U13TA

naval *adj.* 海军的，军舰的 U5TA

nebulous *adj.* 云雾状的；模糊的，朦胧的 U3TA

necessity *n.* 必要性，需要 U14TB

Neoclassical *adj.* 新古典主义的 U17TA

Neolithic *adj.* 新石器时代的 U3TB

neutral *adj.* （颜色等）中性的 U2TA

neutralize *v.* 中和 U2TA

newsletter *n.* 时事通讯；传单 U4TB

nobility *n.* 高贵 U6TB

nonfunctional *adj.* 非功能性的 U17TA

nonresidential *adj.* 非居住的，非住宅的 U6TA

nostalgia *n.* 乡愁，怀旧之情 U16TA

nostril *n.* 鼻孔 U13TA

notable *adj.* 值得注意的，显著的，著名的 U13TA

note *n.* 笔记，注解，注释 *v.* 注意；记录，做笔记 U4TB

notoriously *adj.* 声名狼藉地 U11TA

nuance *n.* 细微差别，微妙之处 U16TA

nurture *v.* 养育；给予营养物；教养 U3TA

O

obsolete *adj.* 荒废的；陈旧的 U10TB

ocher *n.* 赭石；赭色 U7TB

odd *adj.* 奇数的，单数的 U14TB

offset *v.* 弥补，抵消 U1TA

oil *n.* 油；油画 U1TA

ominous *adj.* 预兆的，恶兆的，不吉利的 U1TB

one-of-a-kind *adj.* 独特的；独一无二的 U17TA

opposing *adj.* 相反的，相对的 U8TB

optical *adj.* 眼的，视力的；光学的 U2TA

orchestrate *v.* 编管弦乐曲 U2TB

orchestration *n.* 管弦乐作曲法；交响 U2TA

orchid *n.* [植]兰，兰花 U3TB

organic *adj.* 有机的 U2TA

oriental *adj.* 东方的 U3TA

oriole *n.* 黄鹂 U18TB

out-of-doors *n.* 户外画家（主要指巴比松画派） U11TB

outdoors *adv.* 在户外 *n.* 户外，野外 U18TA

overcast *adj.* 天阴的，多云的 U18TA

overpowering *adj.* 压倒性的 U9TA

P

pack *v.* （把……）打包；塞进 U18TA

packaging *n.* 包装 U4TA

Glossary

professional *n.* 专业人员 *adj.* 专业的，职业的 U4TB

profit *n.* 利润；益处，得益 U10TA

prolific *adj.* 多产的 U1TA

prominent *adj.* 显著的，突出的 U14TA

prompt *v.* 提示；鼓动，促使 U16TA

prop *n.* 道具，衬景 U3TA

proper *adj.* 适当的；正确的 U14TA

proportion *n.* 比例 U14TA

prose *n.* 散文 U18TB

protagonist *n.* （戏剧、故事、小说中的）主角 U3TA

proximity *n.* 接近，亲近 U14TA

psyche *n.* 灵魂；精神 U16TA

pulsate *v.* 搏动，跳动，有规律地跳动 U1TB

pursue *v.* 追赶，追踪，追求 U11TA

pyramidal *adj.* 金字塔形的，锥体的 U12TB

R

radiate *v.* 放射，辐射 U1TA

radically *adv.* 根本地，彻底地 U17TA

rarefied *adj.* 纯净的；稀薄的 U16TA

ratio *n.* 比，比率 U14TA

rationalism *n.* 理性主义，唯理论 U12TA

rationalist *adj.* 理性主义的 U17TA

ravishing *adj.* 极其美丽的；迷人的 U7TB

reach *n.* 区域，河段 U3TB

readable *adj.* 易读的 U8TA

reassertion *n.* 再主张 U9TA

recapture *v.* 拿回，夺回，重获 U10TA

recede *v.* 后退；变得模糊，减退 U2TA

recognition *n.* 承认，认可，公认 U11TA

reconceive *v.* 重构；重新认识 U10TB

reference *v.* 引用 U17TB

refined *adj.* 精制的；优雅的 U3TB

reflected light *n.* 反光 U15TA

reflectivity *n.* 反射率 U15TA

refreshing *adj.* 提神的；使人喜欢的 U9TA

regular *adj.* 规则的；有秩序的 U14TA

reinterpret *v.* 重新解读，重新诠释 U17TA

relative *adj.* 有关系的；相对的，比较而言的 U2TB

reluctance *n.* 勉强 U11TA

render *v.* 表现，描写 U1TB

repetition *n.* 重复，循环；复制品 U14TA

representation *n.* 表示，表现 U4TA

reputable *adj.* 声誉好的 U11TA

request *n.* 请求，要求；邀请 U11TB

resentment *n.* 怨恨，愤恨 U3TB

reserve *v.* 储备，保留；预约 *n.* 寡言，矜持，内敛 U18TA

residence *n.* 居住，住处 U11TB

resilience *n.* 弹力，回弹 U8TA

respectively *adv.* 分别地，各个地 U2TB

restless *adj.* 不平静的，不安宁的 U9TA

revival *n.* 苏醒；复兴，复活 U12TA

revive *v.* （使）苏醒，（使）复兴，（使）复活 U9TB

rhythm *n.* 节奏，韵律，律动 U14TA

rhythmical *adj.* 节奏的，有节奏感的 U14TA

rigidness *n.* 坚硬，劲直 U13TA

riot *n.* （想象、感情等的）奔放；放纵 U7TA

Romanesque *n.* 罗马式建筑；罗马风 *adj.* 罗马式的；罗马风的 U6TB

rooftop *n.* 屋顶 U15TB

royal blue *adj.* 品蓝色的，藏蓝色的 U1TA

S

sack *n.* 麻布袋 U13TA

savor *n.* 滋味；口味，品位 *v.* 品味，品尝 U3TA

scandalous *adj.* 丢脸的；丑闻般的 U11TA

Scandinavia *n.* 斯堪的纳维亚（半岛）
U17TA

Scandinavian *adj.* 斯堪的纳维亚（人）的
U17TA

scent *n.* 气味，香味　　　　U18TB

scope *n.* 范围，领域　　　　U8TB

script *n.* 字体；书写　　　　U3TA

sculptor *n.* 雕塑家　　　　　U9TB

secondary *adj.* 次要的，二级的，中级的
U2TA

segment *n.* 部分，段落　　　　U5TA

semicircular *adj.* 半圆的　　　U8TA

sensation *n.* 感觉，感情，感动　U3TA

sequence *n.* 次序，顺序，序列　U15TA

serene *adj.* 平静的　　　　　U12TB

servile *adj.* 奴隶的；奴性的，卑屈的　U13TB

session *n.* 一场（一期）训练或授课　U7TA

shade *n.* 暗部，暗影；暗色，低色度　*v.* 使
阴暗，涂暗影　　　　　　U2TA

shading *n.* 画阴影，描影法，明暗法　U2TA

sheer *adj.* 全然的；纯粹的；绝对的　U9TA

shelter *n.* 掩蔽处，掩体　*v.* 掩蔽，提供掩蔽
U6TB

Shintoist *n.*（日本）神道教徒　U16TB

shroud *n.* 覆盖物　　　　　　U3TA

sign *n.* 标记，标识，标牌　　　U4TA

signal *v.* 发信号；示意；昭示　U17TA

silverware *n.* 银器，镀银器皿　U17TB

simplicity *n.* 简单，简易，朴素　U6TA

sinew *n.* 筋，腱；肌肉　　　　U8TA

sinewy *adj.* 肌腱的；有力的　　U8TA

slightly *adv.* 轻微地　　　　　U8TA

sloping *adj.* 倾斜的，有坡度的　U15TB

snapshot *n.* 快照，抓拍　　　U14TB

softness *n.* 柔和，柔和度　　U15TA

solid *adj.* 固体的；可靠的，可信赖的　U1TA

solidity *n.* 坚实感；可靠性　　U7TB

solution *n.* 解决办法，解决方案　U4TB

sophisticated *adj.* 复杂的；老于世故的
U9TA

sound *adj.* 健全的；可靠的；合理的　U6TA

sower *n.* 播种者；播种机　　　U1TA

span *v.* 横越　　　　　　　　U12TA

spatial *adj.* 空间的　　　　　U2TA

specifically *adv.* 特定地，明确地　U2TB

sphere *n.* 球（体）　　　　　U7TB

spire *n.* 尖顶　　　　　　　　U1TB

splash *v.*（使）溅起；泼（水）　U9TA

split *v.* 劈开，（使）裂开；分裂，分离
U11TB

stability *n.* 稳定（性），稳固　U8TA

starry *adj.* 布满星星的，繁星满天的　U1TB

statuesque *adj.* 雕塑般的；轮廓优美的
U5TB

steady *v.*（使）稳定，（使）稳固　U7TA

stiff *adj.* 拘谨的；呆板的；艰难的　U11TA

stoically *adv.* 坚忍地，不以苦乐为意地
U13TA

strangle *v.* 扼死，勒死　　　U12TB

strategist *n.* 战略家　　　　　U4TB

stroke *n.* 笔触　　　　　　　U1TA

stroller *n.* 散步者　　　　　　U3TA

structural *adj.* 结构的，结构性的　U7TA

study *n.* 试作，习作　　　　　U1TA

stylistic *adj.* 风格上的，创作技巧的　U17TB

subdued *adj.* 被抑制的；柔和的；减弱的
U7TA

suburbia *n.* <贬>郊区及其居民；郊区习俗
U17TA

suggestive *adj.* 提示的，暗示的　U14TB

superimpose *v.* 叠加；重置　　U2TA

supersede *v.* 取代，替代　　　U17TA

surface *n.* 表面，形体的面　　U15TB

surge *n.* 汹涌；激增　　　　　U17TA

surrender *v.* 投降；自首　　　U9TA

survival *n.* 幸存者；遗民　　　U9TA

unfiltered *adj.* 未滤过的　　　　　　U4TB

unify *v.* 统一，使成一体　　　　　　U2TA

unit *n.* 个体；（计量）单位　　　　　U2TA

unity *n.* 团结；统一，一致　　　　　U2TA

unmistakable *adj.* 明白无误的，不会弄错的

　　　　　　　　　　　　　　　　　U16TA

unposed *adj.* 没有摆姿势的　　　　　U11TB

unpredictable *adj.* 不可预知的　　　　U2TA

unrefined *adj.* 未精练的　　　　　　U7TA

upper *adj.* 上面的　　　　　　　　　U8TA

upright *adj.* 垂直的，竖式的；正直的

　　　　　　　　　　　　　　　　　U13TA

upstanding *adj.* 直立的；正直的，诚实的

　　　　　　　　　　　　　　　　　U11TA

urge *v.* 催促，力劝 *n.* 强烈欲望，迫切要求

　　　　　　　　　　　　　　　　　U6TB

utmost *adj.* 极度的；最远的　　　　　U12TA

utopian *adj.* 乌托邦的；理想化的　　U16TA

V

validity *n.* 正确性　　　　　　　　　U9TA

value *n.* 明度（色彩）；明暗（素描）　U2TA

vapor *n.* 水汽，水蒸气　　　　　　　U3TA

vastness *n.* 广阔，广袤　　　　　　　U3TA

vehicle *n.* 交通工具，车辆；媒介物，传达

手段　　　　　　　　　　　　　　　U4TB

verbal *adj.* 口头的；文字的　　　　　U4TA

vernacular *adj.* 民间风格的；当地风格的

　　　　　　　　　　　　　　　　　U17TA

versatile *adj.* 多才多艺的；博学多才的

　　　　　　　　　　　　　　　　　U9TA

vertical *adj.* 垂直的 *n.* 垂直线；竖画　U8TA

vertically *adv.* 垂直地　　　　　　　U14TA

vibrate *v.* （使）振动，（使）颤动　U1TA

Victorian *adj.* 维多利亚时代的，维多利亚

式的　　　　　　　　　　　　　　　U7TA

vigor *n.* 活力，精力　　　　　　　　U8TB

vigorous *adj.* 精力旺盛的；有力的，健壮的

　　　　　　　　　　　　　　　　　U9TB

vine *n.* 蔓生植物；藤，蔓　　　　　　U9TA

virile *adj.* 精力充沛的；刚健的　　　U6TB

virtually *adv.* 事实上，实质上　　　　U9TB

visible *adj.* 看得见的，可见的；显著的

　　　　　　　　　　　　　　　　　U15TA

vision *n.* 视力，视觉；幻想，幻影；景象

　　　　　　　　　　　　　　　　　U1TB

vital *adj.* 生命的，生机的　　　　　　U12TA

vivacious *adj.* 活泼的，快活的　　　　U7TB

W

waft *v.* 吹送，飘送　　　　　　　　　U18TB

wagon *n.* 四轮马车，货车　　　　　　U1TA

wallpaper *n.* 壁纸，墙纸　　　　　　U10TA

warble *v.* 鸟鸣；用柔和的颤声唱　　U18TB

wash *n.* 洗，洗涤，渲染，笔墨　　　U3TA

watercolor *n.* 水彩；水彩颜料；水彩画

　　　　　　　　　　　　　　　　　U18TA

well-to-do *adj.* 小康的，富裕的　　　U6TB

westernization *n.* 西方化，欧美化　　U9TA

whence *adv.* 从何处，从哪里　　　　U18TB

whereupon *adv.* 于是，因此，就此　U11TA

wight *n.* 人类，人　　　　　　　　　U18TB

wilderness *n.* 荒野　　　　　　　　　U18TA

woodblock *n.* 木版；木刻版　　　　　U5TA

woodcut *n.* 木刻，木版画　　　　　　U11TA

wrapper *n.* 包装材料，包装纸　　　　U4TA

wreak *v.* 发泄（怒火）　　　　　　　U16TB

writhe *v.* 翻腾　　　　　　　　　　　U12TB

Y

Yankee *adj.* 美国北方人的；美国佬式的

　　　　　　　　　　　　　　　　　U18TA